LIGHTHOUSES
OF THE WORLD

MARIE-HAUDE ARZUR

ADLARD COLES NAUTICAL
LONDON

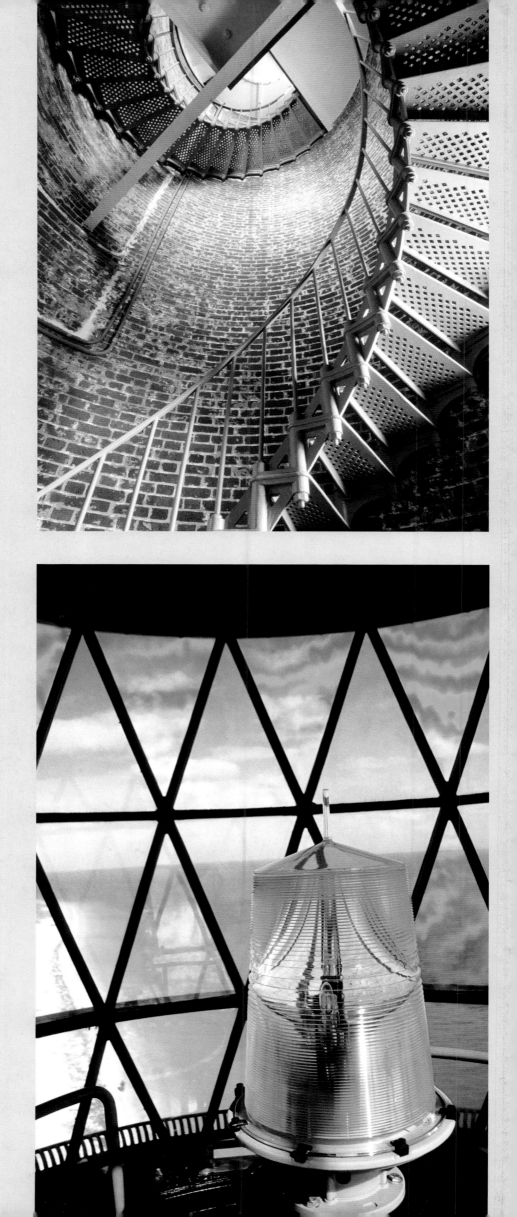

Contents

Top: Cape Blanco lighthouse staircase (Oregon, United States)
Opposite: Cape Florida light (Florida, United States)

'At sea, the principal danger is land'

INTRODUCTION

Lighthouses are the traffic controllers of the seas; the mediators of the space where the sea reaches land. Turn off the sun. Erase the stars from this cloud-lined sky. Drop the curtain of night and bring back the time when the coasts were plunged into darkness. Send in the big wind organs and the clamour of churned up fleets. Here you must do just as you please, with the elements having gone haywire, on whatever craft, for an undefined period, with or without reliable navigation instruments. It's not funny, is it? Eventually, however, a shaft of light filters through from the horizon. Open to the winds, the wood fires from the first attempts at lighting the coast – at a time when, due to a lack of sufficient nautical knowledge, prudence required ships to sail within sight of the coast – delivered the same message with their weird flashes as our modern lenses, with a rigorous promptness: Yes, I am here, to serve you, yes I am here…This is how it is meant to be, isn't it? Because if a lighthouse wasn't in the expected place or didn't emit the agreed signal, would it (still) warn of an imminent danger? And navigation via satellites or not, the very sight of a lighthouse has lost nothing of its comforting quality: 'This is where the society of man begins', repeats the lighthouse over and over again.

This is the motivation behind the following story which, helped by the internet, has amused people for some years. It roughly dates back to October 1995 and occurs in the waters of Newfoundland. It is introduced as the transcription of a radio communication between an American vessel and the Canadian Coastguard to impute a (false) air of authenticity:

US Navy:
'Could you re-route by 15 degrees north to avoid a collision. Over to you.'

Reply:
'Could you instead re-route by 15 degrees south to avoid a collision. Over to you.'

US Navy:
'This is the captain of a vessel from the American naval forces. I repeat: could you alter your course. Over to you.'

Reply:
'No, please, could you yourselves re-route. Over to you.'

US Navy:
'This is the aircraft carrier USS *Abraham Lincoln* from the United States of America fleet. We are accompanied by three destroyers, three cruisers and several escort vessels. I demand that you deviate from your course by 15 degrees north or restraining measures will be taken to ensure the safety of our vessel. Over to you.'

Reply:
'This is a lighthouse. Over to you.'

(Silence).

Enough of this idle chat...Those who are familiar with lighthouses and can show a valid 'pass' may go on through. We'll catch up with them later.

THE LIGHTHOUSE KEEPERS

Nowadays, the majority of lighthouses are automated, but in days of old, sentries had to maintain an active light against the winds and tides, constantly scrubbing the lens, cleaning the mechanism and the rest of the inner workings, and broadcasting the weather information.

This business was fraught with danger, especially in a lighthouse at sea, and especially in the British Isles. At Eddystone I, for example, the builder and his work were carried away in the single lick of a wave. At the Smalls, deprived of relief for 125 days, the keepers survived by preparing a kind of 'armchair' stew (made of leather, of course). In the Flannan islands, three keepers mysteriously disappeared in 1900. The list of tales is endless. However, the lives of lighthouse keepers seemed to be dominated by an atmosphere of monotonous austerity. Isolation dictates. Was it this element that appealed to Lawrence of Arabia late in life when he unsuccessfully applied for a position as a keeper? You'd doubtless have to be crazier still to refuse the runner's-up prize: the viceroyalty of the Indies! However, not half Irish for nothing, our hero opted instead to enlist under an assumed name in the Royal Air Force, as a simple aircraftman ..

FASHION PARADE

Lighthouses take you on a voyage across all the seas, be they continental or landlocked. The larger ones occupy the coastal plains, while the small ones are found at the summits of cliffs, benefiting from an incomparable elevation above sea level. The wildest of these are solitary towers on reefs, which reign in the open sea. Other more 'seaside-oriented' structures rise up from a dune, a rock draining away at low tide or a barely covered coral reef. Lighthouses are varied constructions. Take just one tower. It can be round, pyramidal, square, conical or structured; freestone or cobblestone, stonework, wood, brick, cast iron or steel. The material depends mainly on the specific requirements and the builder's options, the resources in the soil, the environment, the objective and the era. The tower might be inhabited. You could join it to a long string of outbuildings, starting with one or several keepers' houses. The accommodation may be adjoining the lighthouse or it may be separate. Building the latter into the roof of the structure is another solution. The models are numerous, but in every case, in every place, necessity has laid down the law.

Unintentionally, lighthouses, offspring of the Industrial Revolution, also provide a lesson in geography and colonialism. To cut a long story short, the historic lighthouses are mainly of British, German or French construction. However, the developing countries, led by India, are renowned for constructing new and increasingly numerous 'new builds', while the traditional commercial powers have put away their trowels. Is a lighthouse indicative of economic vitality? It couldn't be otherwise with three-quarters of world trade adopting maritime routes.

Fuel

Lighthouses are omnivorous, insatiable ogres. In times when they fed on wood, their gluttony created a void, which stretched far beyond them. Deforested and forever bald, certain islands still bear the cruel marks. From the seventeenth century, these 'Cyclops' gorged themselves on coal or even tallow candles mounted on the candelabras – being edible, these candles also satisfied more than one keeper when the relief was delayed! In the nineteenth century, they were fuelled in particular by vegetable oils (olive and rapeseed oil) and animal fats (fish, whale, seal, pig), depending on the country. Soon mineral oils (kerosene, petrol) were used, and then some lighthouses used coal gas. In the last quarter of the nineteenth century, compressed gas oil arrived on the scene, most often obtained via distillation of tar, coal and petrol. With the new century came the era of vaporized petrol and acetylene, followed closely by gas from liquefied petrol.

From 1858, the South Foreland lighthouse (England) found electricity to its liking, but it was still necessary to be able to produce it autonomously prior to connection to a network. However, we know which of these fuels won the vote in the end. The electricity fairy walked away with the prize of course, albeit in various stages (steam engine, diesel, grid). Today, solar or wind power has gained a foothold in lighthouses. And tomorrow...?

The Fresnel lens

This is celebrated around the world. Prior to Augustin Fresnel's invention of the lens in 1822, some parabolic mirrors, placed behind the lamps so as to turn with them, reflected the light while directing them forward. Fresnel's lenticular system formed the advent of refraction: this time, the lamp was at the centre of a drum made up of several graduated lenses. These plates of glass fitted within the arc of a circle, whose role was to refract the light, modifying its direction. In this way, the light rays are channelled and concentrated to form a horizontal beam sweeping across the horizon. The lens turns around the light source, which is fixed. The fresnel lights obey a strict hierarchy (first, second, third and fourth order), which determines their power. The large landing light is first; the port lantern, which is comparatively myopic, is fourth.

The power of a lighthouse therefore depends on its lens, its light intensity

(expressed in candelas) and its geographical range – its maximum theoretical visibility, limited by the rotundity of the Earth. The latter is expressed in nautical miles. One mile is equal to 1852m.

LIGHT SIGNATURE

Each signal has its own 'character'. The range, the number and rhythm of the flashes or occulting light, the length of the cycle, the colour and the sectors: a sailor can find all this information in Almanacs and on hydrographic charts.

At the end of the eighteenth century, the French discovered that on making the lens turn, the light was no longer condemned to being fixed in one place. Later still, by floating the lens on a bath of mercury instead of moving it about on rollers, they eliminated the friction and accelerated the speed of rotation. In this way flashing and occulting lights came about, which then enabled the light signature of the structures to be modified. Finally, the range of colours, restricted to white, green and red, still allowed the necessary variety.

Yes, land is indeed the main danger at sea, and that is why there are lighthouses. But there are light beacons too, which are particularly popular in the waters off Denmark and the eastern Mediterranean, where the dangers are underestimated.

THE INTERNATIONAL GROUP OF LIGHTHOUSE FRIENDS

Vast numbers of countries lack the financial means to care for their lighthouses as they should. A heightened awareness of heritage can sometimes counteract this, however. Take Poland, for example, which since the end of its communist regime has launched into an impressive restoration programme with the systematic opening of its historic lighthouses, the majority of which are of German origin. One could visit this country (and others) and simply go from one lighthouse to the next getting new ideas. The Germans are also very inventive.

In the United States, where 1000 or so structures are managed, volunteers compete to revamp one construction after another. Informing the public about lighthouses and getting them to visit is the aim of the enterprising American Lighthouse Foundation and the United States Lighthouse Society, two umbrella organisations that comprise an enormous array of associations. The Americans have a deep love for lighthouses. In 2000 around 500 of them (which previously belonged to the Coastguard) were transferred by the enactment of a law to various partners (towns, states, etc). The state of Michigan alone, the richest source of such constructions (at least 130) in the United States, is one such sanctuary: this is the only state to have made a yearly financial contribution to assist the efforts of the Michigan Lighthouse Conservancy, the Great Lakes Lighthouse Keepers Association and a number of other local associations.

France, profoundly land-based despite its three maritime coasts, turns its back on the sea far too often; the interest in lighthouses has awoken there much more slowly than elsewhere, and the public or private means implemented to see them valued as monuments is derisory.

But how do you save lighthouses? This isn't a new question. All that is needed is a little more focus on them each year, pretty much all around the world. It requires opening them up to the public as much as possible, which is what certain countries have done much more readily than others.

In the meantime, lighthouse enthusiasts get together on the internet. The Rolls-Royce of sites, which comes in a host of languages, is the Lighthouse Directory (http://www.unc.edu/~rowlett/lighthouse), managed by Russ Rowlett (rowlett@email.unc.edu) and set up by the University of North Carolina. It provides information (in English) on over 7400 lighthouses. This particular book has made use of it to enhance some of its technical detail.

Acknowledgements

Thank you to Catherine Laulhère for the original editorial idea; to Christian Blondel for the model, and to Claude Hascoët for the elegance of his implementation; to Michèle Cadoret and Xavier Mével for their proofreading, and to Daniel Leloup for his involvement; to Magali Galtier and Isabelle Sadys (Eyedea) as well as to Elisabeth Buffevant (Glénat Production). A big thank you must also go to the lighthouse operators for their information.

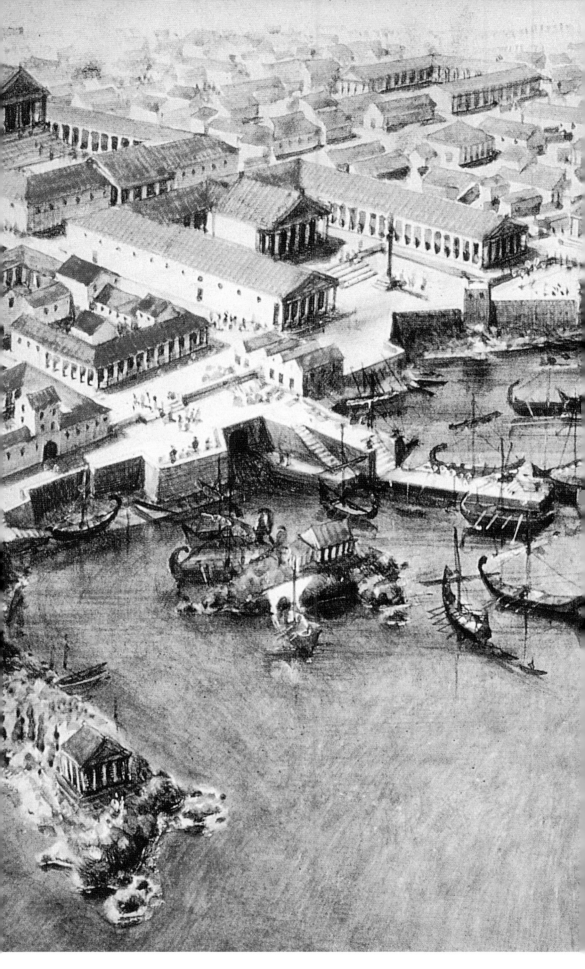

① **EGYPT, ALEXANDRIA.** Pharos (around 283 BC). There was a duty to open the family album with this lighthouse. Although not the first, this was the most magnificent of the old lighthouses. The Ancients made it one of the seven wonders of the world and those of Latin descent adopted it as a generic term: *phare* (lighthouse), *faro, farol...*

Established under the Ptolemys (I and II), on an island (Pharos) linked to Africa by a spit over 1km long, it filled visitors with wonder until an earthquake razed it to the ground in 1303. Its longevity and its size (135m) aren't its only remarkable aspects. Some 3000 blocks of limestone and granite

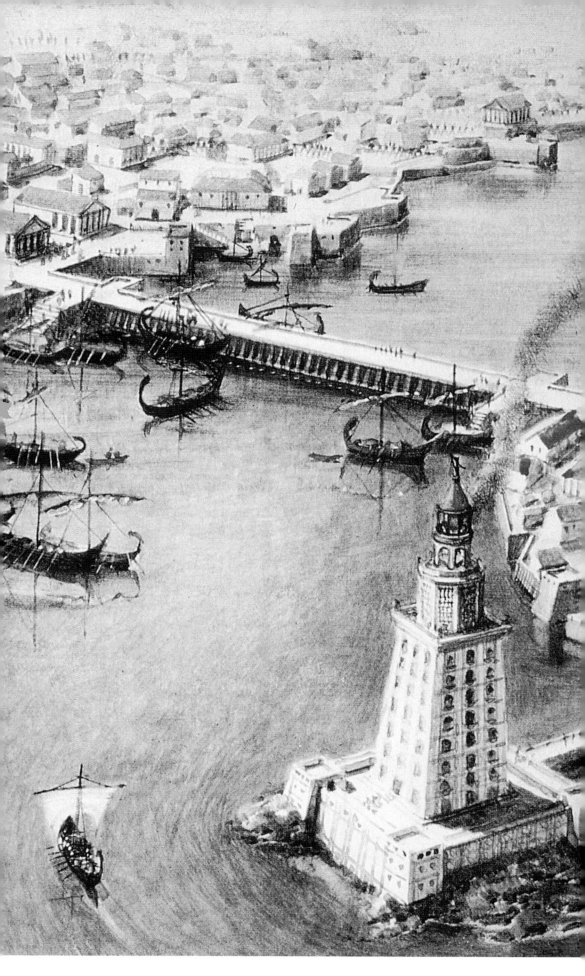

were moved to construct it, with the work taking around 15 years. The three levels were square, then octagonal and then cylindrical. The first, in addition to 50 storage rooms, housed a ramp, whereby beasts of burden fetched wood for the fire that was never allowed to go out; the other two were equipped with stairs.

In theory, its light carried as far as 100 miles, which is a day's sailing! French archaeologist Jean-Yves Empereur undertook to create the plans from the chaos of its remains, with Fort Qaitbay being built on its foundations. Pharos is still talked about today.

10

11

14

13

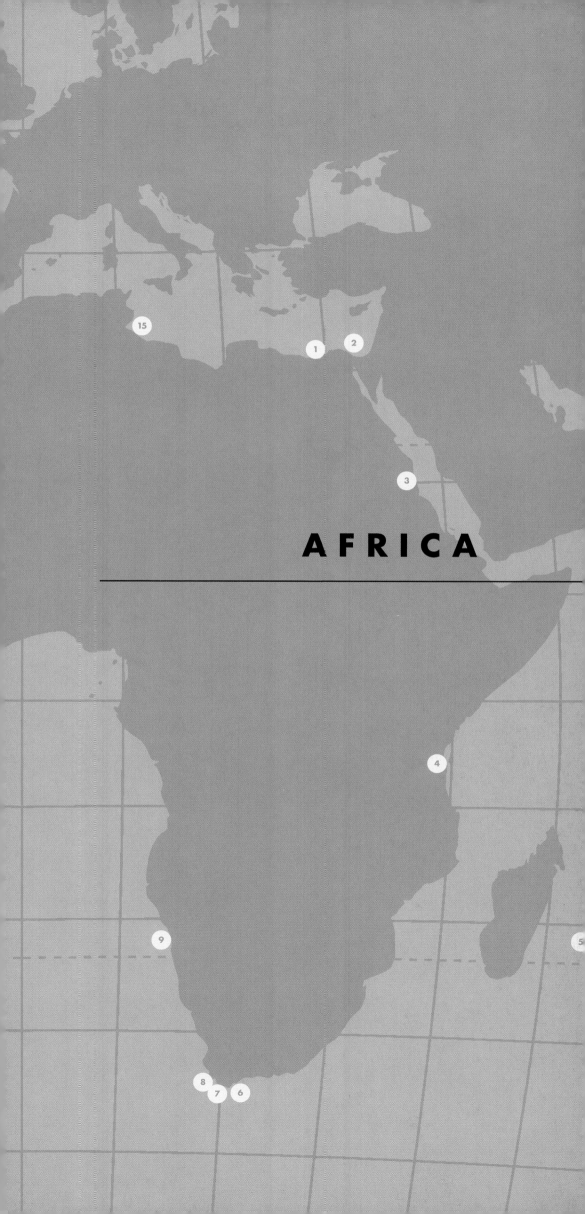

AFRICA

PORT SAID
EGYPT

Around 1869 | 57m | Inactive | Site accessible

Measuring 190km long, without locks, the Suez Canal has linked the Mediterranean to the Red Sea since 1869. Port Said emerged from the desert almost simultaneously. From 1882, the British occupied Egypt, but the canal was given international status six years later. This highly strategic route brings Asia closer to Europe. It reduces the course taken by a vessel going from, say, London to Bombay by almost half, by removing the need for it to go right around the outside of the African continent. Needless to say, it is reliant on the political climate both regionally and internationally and the canal has been closed on several occasions, as it was after nationalisation by Nasser in 1956.

Located on the west bank, the lighthouse marks the entrance to the Mediterranean. With its octagonal tower decorated with yellow bricks, and used as a model in the French town of Calais (see p. 73), the French initiated the use of reinforced concrete according to a process devised by an engineer by the name of Coignet, who may well have supervised the construction himself. The Port Said lighthouse was electrified from 1869. The building, which fits snugly round the foot of the lighthouse, was added at a later date. Most of the daymark is original.

After falling into disuse it was replaced by a metal framework tower.

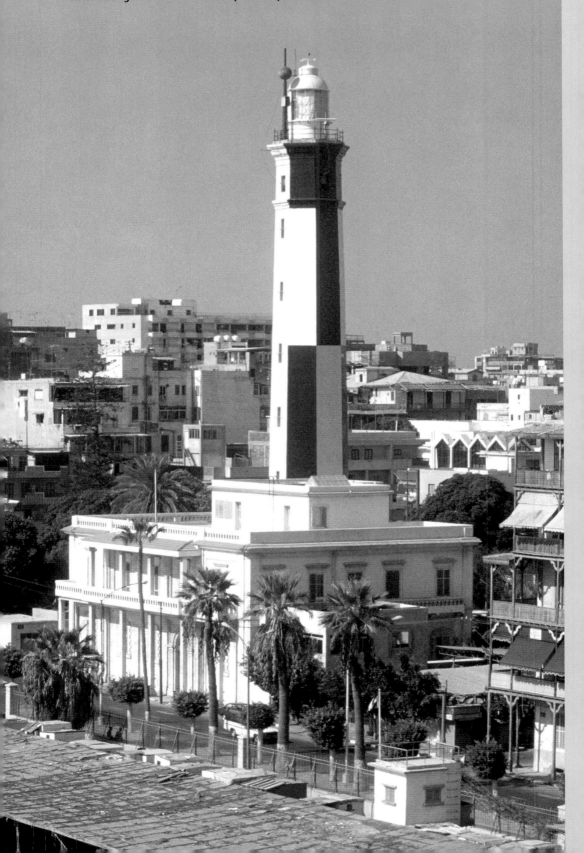

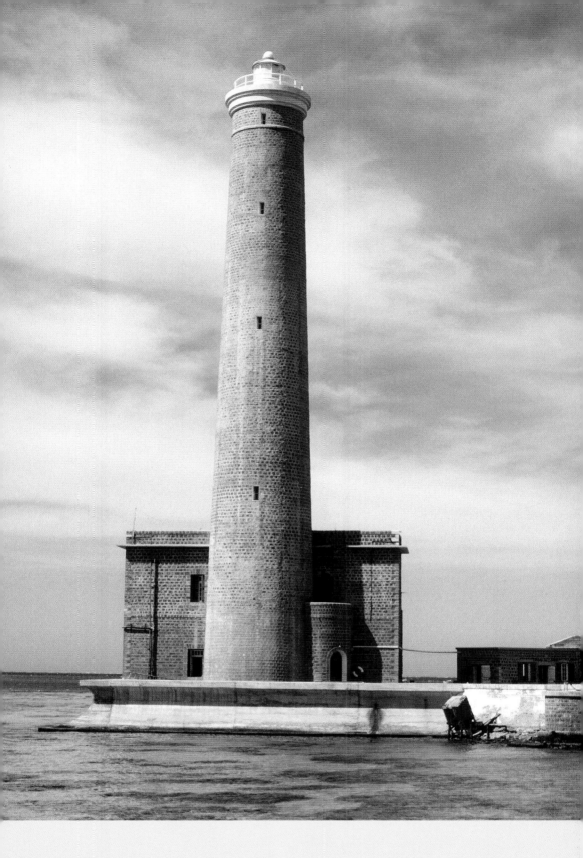

(3) SANGANEB REEF
SUDAN

1930s | 50m | White flashes | Visit

Sudan weaves its way between Egypt and Ethiopia to access the Red Sea, and its coast is defended by a formidable garland of coral reef. You have to dive to gain access to this intimidating lighthouse, which seemingly springs up from out of nowhere. Sanganeb Reef and its vertiginous heights in fact form a globally renowned diving site. Port Sudan (Bur Sudan) is around 16 miles to the south-west. Accommodation, a jetty and a platform have also been grafted onto this ocean atoll.

This concrete tower was erected at the same time as the Anglo-Egyptian joint land holding in a bid to secure the Red Sea, among other things. It supersedes a metal structure (1906), which is similar in design to Florida Reef lighthouses. It is the only inhabited lighthouse in Sudan.

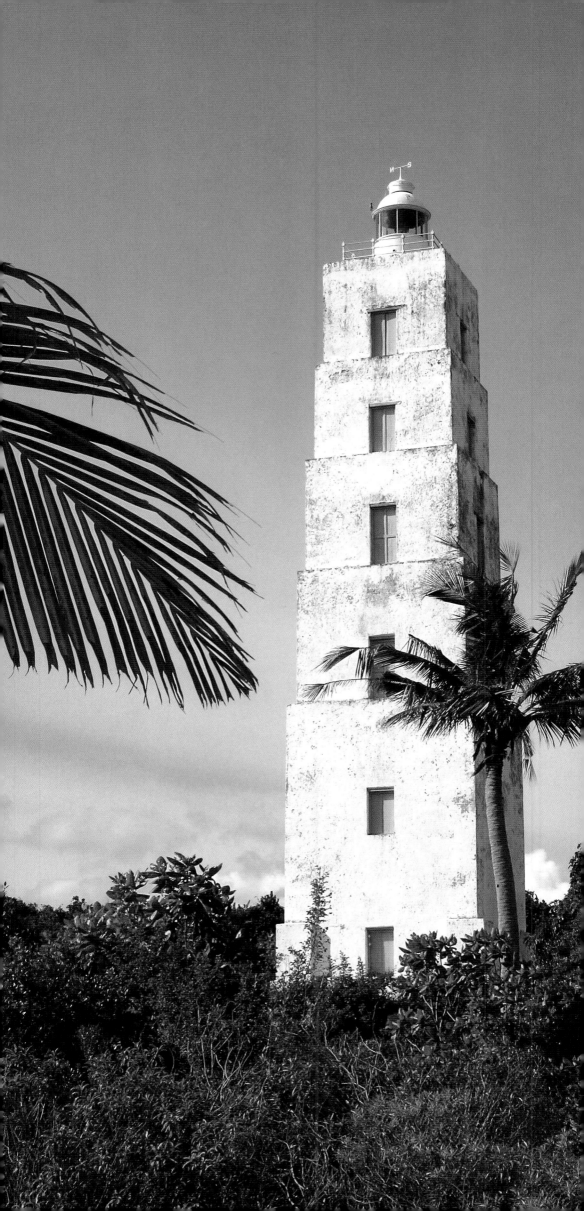

(4) CHUMBE
TANZANIA | Zanzibar
1904 | 34m | White flashes | Guided tour

From the top of this five-floor stone quadrilateral, there is a wonderful panorama across the straits of Zanzibar (Ugunja), which separate the island of the same name from the mainland: Tanzania. Chumbe is a coral reef along what was formerly part of the ivory and spice route, and is still used by graceful dhows today.

Chumbe was built under the aegis of the sultan of Zanzibar, during the British protectorate. Its fourth-order Fresnel lens is original. It is equipped with an acetylene burner that dates from 1926 and was designed by AGA, a Swedish firm founded by Gustaf Dalén. Starting out as a French inventor, this future winner of the 1912 Nobel Prize for Physics was to perfect and secure the use of acetylene gas. A photoelectric valve controlled the automatic lighting of the lighthouse at nightfall. This is still the case today and, in the event of failure, Zanzibar's port authorities organise for a ranger from Chumbe Island Coral Park to climb its 131 steps to relight it. A process of solarisation is in place.

Ecotourism is invaluable in the private marine park, which manages the island. Its rangers are former fishermen. The keepers' small mosque has been preserved and their dwelling converted into a reception centre: a restaurant and seven bungalows are provided for visitors.

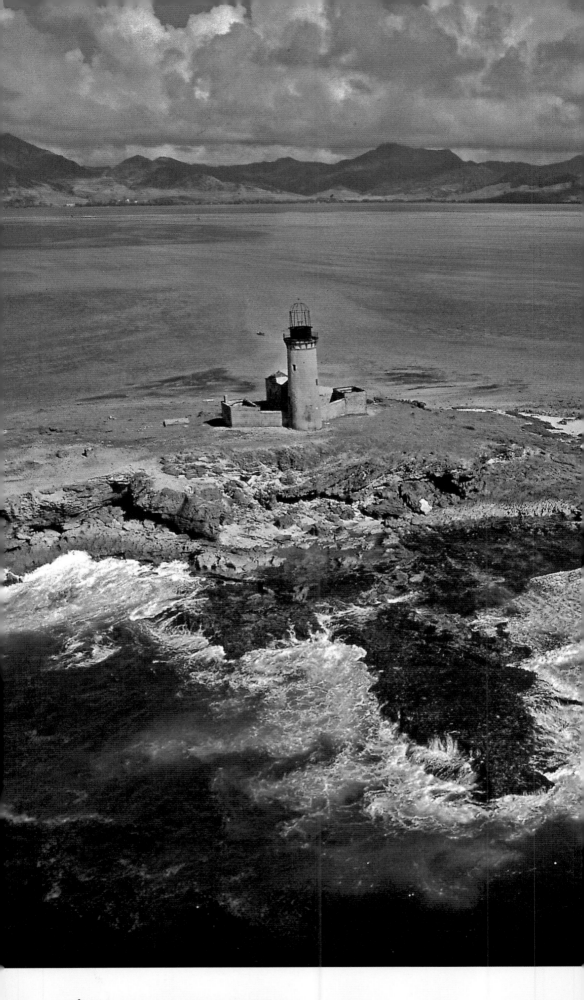

⑤ ÎLE AUX FOUQUETS
MAURITIUS

1865 | 26m | Inactive | Accessible by boat

On one side is a peaceful lagoon; on the other, a coast battered by the waves of the Indian Ocean. The île aux Fouquets (or Île au Phare/Lighthouse Island) is a section of the coral barrier which completely encompasses Grand Port Bay, on the south-east coast of Mauritius. It takes its name from a species of puffin and proved to be a welcome stopover on the spice route prior to the opening of the Suez Canal (1869).

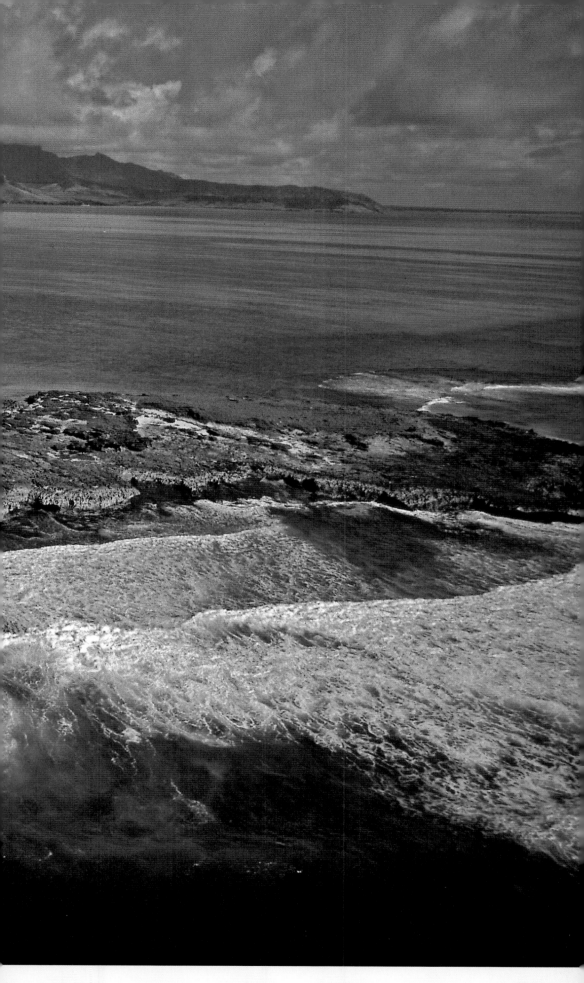

The current lighthouse dates from the British administration. That same year the railway line linking Mahébourg and Port-Louis was opened. This gradually went on to supply the whole island and open new outlets for its sugar economy. Its light guided vessels towards the port of Mahébourg, which some decades after its opening ended up replacing Port-Louis, the capital, located on the opposite coast. The lighthouse remained operational until the 1950s. The tower, and particularly all the service buildings, are now in a pitiful condition.

⑥ CAPE AGULHAS
SOUTH AFRICA
1849 | 27m | White flashes | Guided tour

Nearly 34° 49' 58'' South: this is the latitude of the 'true' southernmost cape of Africa, located 1km from the lighthouse. It officially shares the Atlantic and Indian oceans, but the arrangement is far from amicable. The origin of 'Cape Agulhas' is much debated. Its name is attributed by some to magnetic anomalies, which threw the compasses of the first Portuguese explorers into a panic. Others see it as being a reference to some very sharp rocks. Its waters, stirred up by the countercurrents both on the surface and deep down, are accused of having caused some 250 shipwrecks. The massive bicolour tower eats into the roof of the keepers' abode, flanked by turrets. In its lantern is a first-order Fresnel lens. Range: 30 miles. Does its shape remind you of another one? South Africans assert that this national monument was inspired by the lighthouse in Alexandria (see pp. 10–11). The old Cape Agulhas lighthouse was put into retirement in 1968, as its limestone was crumbling to such an extent that it was making the building dangerous. Thanks to patient, painstaking work by the Shipwreck Museum of Bredasdorp, it was able to take up service again in 1988, and is certainly the only lighthouse ever rescued by a shipwreck museum.
The keepers' house accommodates the South African Lighthouse museum and a restaurant.

7 SLANGKOP POINT
SOUTH AFRICA | Kommetje
1919 | 33m | White flashes | Guided tour

This is not a lighthouse at sea! Rearing up against the elements, which appear to be conspiring against it, the edifice adjoins a treacherous sea, with steep reefs and rocky spurs. In fact, its position marks one of the ridges, near Kommetje, on the west coast of the Cape's peninsula.
This cast iron tower, the tallest in the country, has a geographical range of 33 miles. It is connected to a national electric grid, and an emergency diesel generator – as is often the case today – is able to bridge any fault.
The inhabitants of the Cape vie for its facilities for wedding receptions. Various amenities are located here – such as a conference room, reception office, etc. The whole area is managed by Salato, the tourist subsidiary of the operator (Lighthouse Services). For some years, Salato has enabled visitors to access 13 of the 45 South African lighthouses.

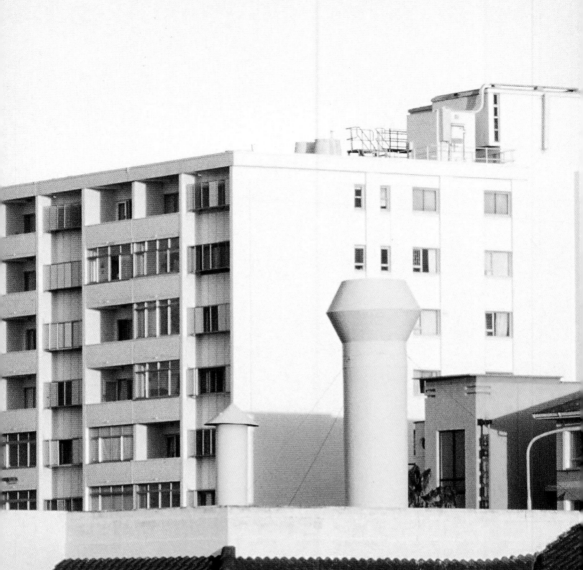

(8) GREEN POINT
SOUTH AFRICA | Cape Town
1824 | 16m | White flashes | Guided tour

Classed as an historic monument, this is the oldest lighthouse in South Africa 'built with non-temporary materials'. It watches out over Table Bay, 2km from the centre of Cape Town, a large port used for stopovers and exports. At the start of the nineteenth century, Cape Town (Kapstadt) was an important trading post along the spice route. Large yachts passed the nearby Cape of Good Hope or the Cape of Storms on their way to Australia and Asia.
Made of rock, the building is characterised by a square, white, four-floor tower, streaked with original red diagonals. In former times its lantern was fuelled by whale or fish oil, while

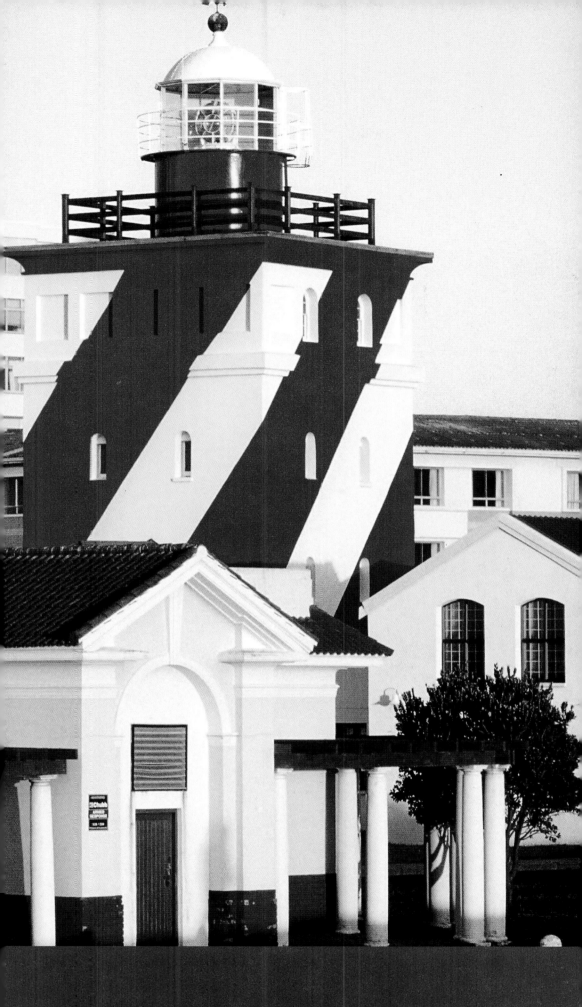

during the same period in France the most commonly used fuel was rapeseed oil. This produced two fixed white lights, which were as colourless as they were unsteady and visible just 6 miles away. Raised by an additional floor in 1865, the tower's range stretched to 25 miles. Today its lantern uses a third-order Fresnel lens. Electrification dates back to 1929. On the night of 1 July 1966, Green Point interrupted its service and pointed its light beam on the SA *Seafarer*, which had just run aground in front of it, in order to facilitate the rescue of the crew and the passengers.

The Lighthouse Services have their headquarters here.

SWAKOPMUND
NAMIBIA

1903 | 28m | White flashes |
Site accessible

This lighthouse, located on the Swakopmund seafront, dates back to the German protectorate. The port was created in 1892 by German colonists in order to cope with the increase in commercial traffic with the metropolis, and also to compete with the British port of Walvis Bay, around 30km away. It was intended to be the gateway to the ocean for the area that was referred to as the African south-west until 1968, a location rich in diamonds and minerals. This role was taken by Walvis Bay from 1915, when the South African Union conquered the country. On one side is the cold Atlantic Ocean, on the other the hot Namib Desert. The thermal impact of each meeting the other generates frequent thick mists, which have given the coast the nickname 'skeleton coast'.

Swakopmund has retained its colonial character. The crenellated lighthouse is equipped with two balconies and has a range of 18 miles. Originally a small, exposed brickwork structure, a section painted alternately red and white, the same as the service buildings (not visible in the picture), was added in 1910–11. Today it is a Court of Justice, transformed into a government residence, which forms a box around it.

1901

BEZIRKS GERICHT

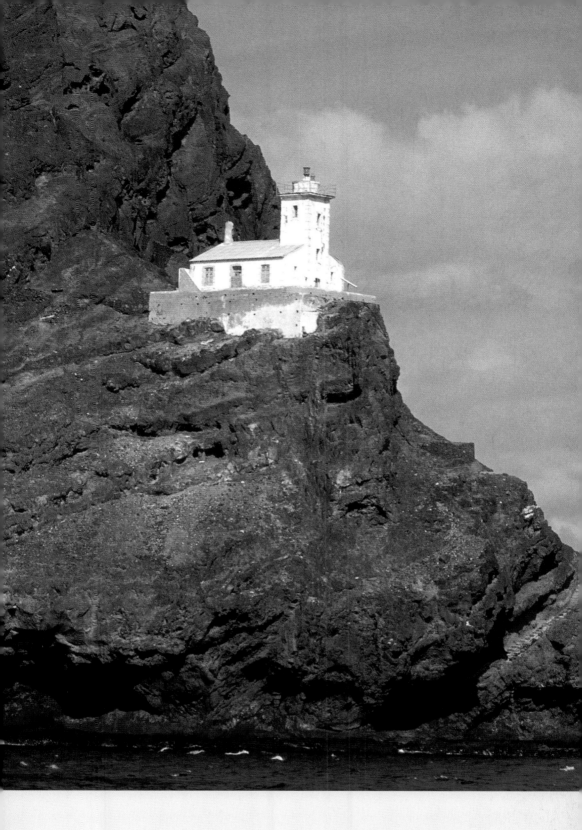

(10) # RAINHA D. AMELIA
CAPE VERDE | Island of São Vicente
White f ashes | Site accessible

Some 600km off Senegal, the archipelago of Cape Verde comprises a stream of volcanic islands and islets in the Atlantic, nine of which are inhabited.

This lighthouse was built under the aegis of the Portuguese, to the west of the island of São Vincente. Visible up to 17 miles away, its beam illuminates the south-west entrance into the large channel, which separates two islands from the wind: São Vincente and Santo Antão. It leads boats towards Mindelo, a well-protected port. The transatlantic steamships bunkered here on their way to America, Australia and India, prior to the Suez Canal opening (1869), and today's sailors willingly make stopovers here.

With its square tower centred on the façade, this lighthouse has the stature of a chapel. The door, the frames for the openings and the corners are decorated with huge stones. Solar powered, the lighthouse was recently renovated. Despite its rather impregnable appearance, it is located just half an hour's fairly gentle walk from the village of São Pedro, accessible via a winding and predominately cliff path. The other lighthouse on the island watches over Mindelo Bay.

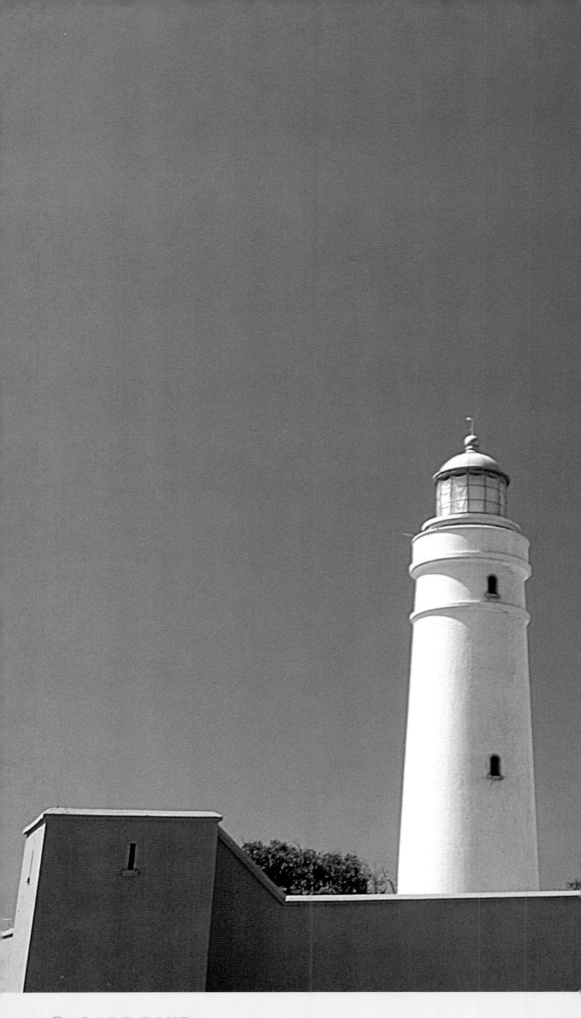

⑪ CAPE RHIR
MOROCCO | Agadir
1932 | 41m | White flashes | Site accessible

The Atlantic coast of Morocco is rather tame compared to the rocky Mediterranean coast. However, several promontories provide a contrast to this gentle geography. Cape Rhir (or Ghir) is one such. The High Atlas Mountains disappear into the sea here, giving the promontory an impressive altitude of 360m and protecting the harbour of Agadir from the Atlantic swells. The landing light

of Cape Rhir was turned on two years after the port of Agadir opened to international trade, the latter situated around 30km south. The development of Agadir from the 1920s to 1930s brought about the decline of Mogador (Essaouira). Not dissimilar to a *caravanserai* in layout, the surrounding wall, which fortifies the establishment, conceals various service buildings.

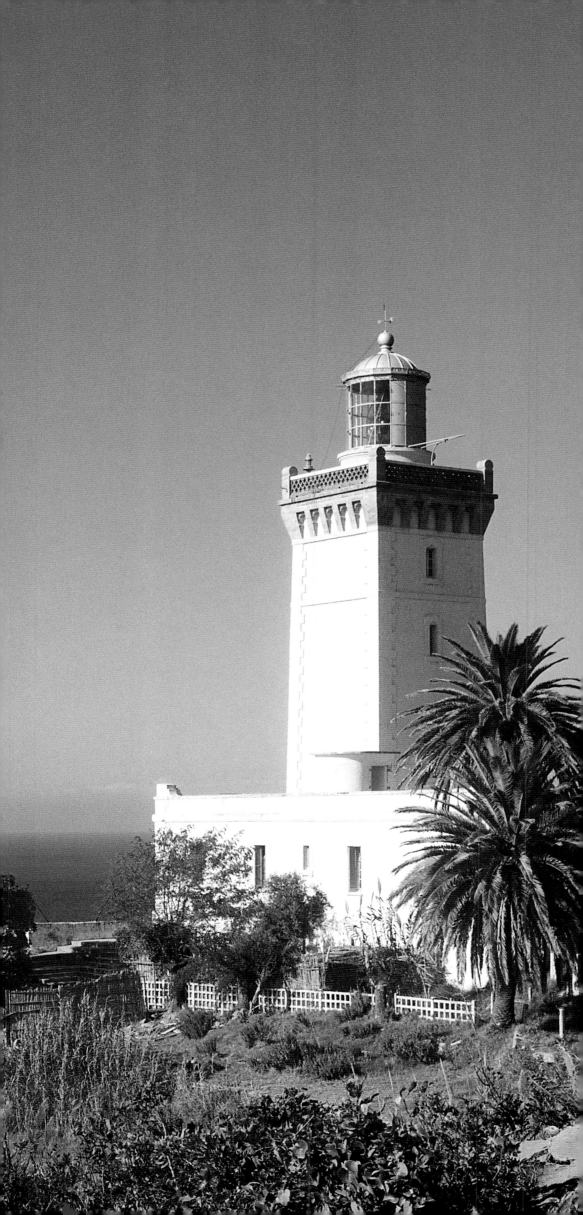

(12) RAS SPARTEL
MOROCCO | Tangier
1864 | 24m | White flashes | Site accessible

Here we are near Tangier, at the intersection between the Atlantic and the Straits of Gibraltar, the neck of the Mediterranean. On the other side is Spain.

Several representatives of European powers joined together to 'pressurise' the sultan Mohammed Ben 'Abd-Er-Rahman to agree to the principle of a lighthouse on the ras (cape) Spartel. Until Tangier's independence (1956), its upkeep was ensured by a group of businesses bringing together the English, the French and the Spanish in particular. At least this way the lighthouse was to remain protected from the 'war of possession' of the territory, which the aforementioned protagonists were already involved in with the Germans. Tangier is the gateway to Morocco and an essential link in a maritime artery that was vital to everyone. It was finally declared an 'international zone' in 1923 and then a free port in 1962.

The square tower stands apart from the two-floor keepers' house. The lantern contains a first-order Fresnel lens and stands on a projecting balcony supported by some powerful cantilevers. The accommodation is white, and the tower ochre yellow, with darker corner pieces, topped off with a reddish-brown open-design parapet: this is set off by the ornamentation and sweet tones of the Maghreb!

⑬ PUNTA LANTAILLA
SPAIN | CANARIES | Fuerteventura
1954 | 12m | White flashes | Site accessible

This is what you call a work of art...in its raw state. You might think it was the result of an (impossible) encounter between the Catalan architect Antoni Gaudi and the French architect Picassiette, a polisher of broken crockery mosaics. The reality is rather different. Quite simply, as is often the case, local resources were used. Made from reddish lava rubble and fitted together with lime mortar, this lighthouse is in harmony with its volcanic environment, from where stems this impression of organic decoration, so cherished by Gaudi. The corner sections and protruding stone mouldings have split facings. The whole U-shaped building houses an

interior patio, and its main façade is slashed with openings that alternate between vertical and horizontal. The lantern, its glass dome and its semi-circular arches are attractive.

This construction is hidden away on the cliff edge, on the south-east coast of Fuerteventura, an island in the eastern province. Its elevation above sea level is impressive: 195m. Its range reaches 21 miles. It has been restored with a view to converting it into a maritime signalling museum.

14 PUNTA DEL HIDALGO
SPAIN | CANARIES | Tenerife

1994 | 50m | White flashes |
Site accessible

In Spanish hands for five centuries, the Canaries archipelago is less than 60 miles from the Moroccan coast. Ever since the discovery of America, it has been a transoceanic intersection – or, to put it another way, a kind of giant service station where vessels make stopovers both for pleasure and refuelling. Today the surrounding area is powerfully illuminated by about 20 lighthouses. Tenerife (western province) is the largest of the main islands.

This slender lighthouse to the north-east of the island has an audacious design comprising staggered concrete columnar structures. The impression sought by the project engineer Ramiro Rodriguez Bolardo y Olavarrieta is that of 'a crystal emerging from the bowels of the earth, thrusting its way up through the volcanic lava'. There is a lift that takes you to the summit. The structure announces the port of Santa Cruz in Tenerife, which was coveted by the British – though they never managed to appropriate it. Furthermore, having lost an arm here, Nelson also suffered his only defeat in the Battle of Santa Cruz de Tenerife (1797).

⑮ RAS TAGUERMESS
TUNISIA | Djerba

1895 | 49m | White flashes | Site accessible

Ras or Rass (cape) Targueness, Taguerness, Tourgueness, Ta Guermess – the spelling is variable. Measuring 49m, the height of this lighthouse gives you an idea of the flatness of Djerba, a maritime oasis bathed by the Mediterranean. The island, linked to the continent by a 7km roadway, is just 52m at its highest point.

The tower stands not far from Midoun, to the east of the island. Slotted into the keepers' accommodation, the conical tower with its splayed foot was constructed during the French protectorate (1881–1955). Its light carries up to 24 miles. The same year, Ras Thyna, a smaller twin by just a handful of metres, was installed to the south-west of the port of Sfax on the mainland; it too is still going strong.

EUROPE

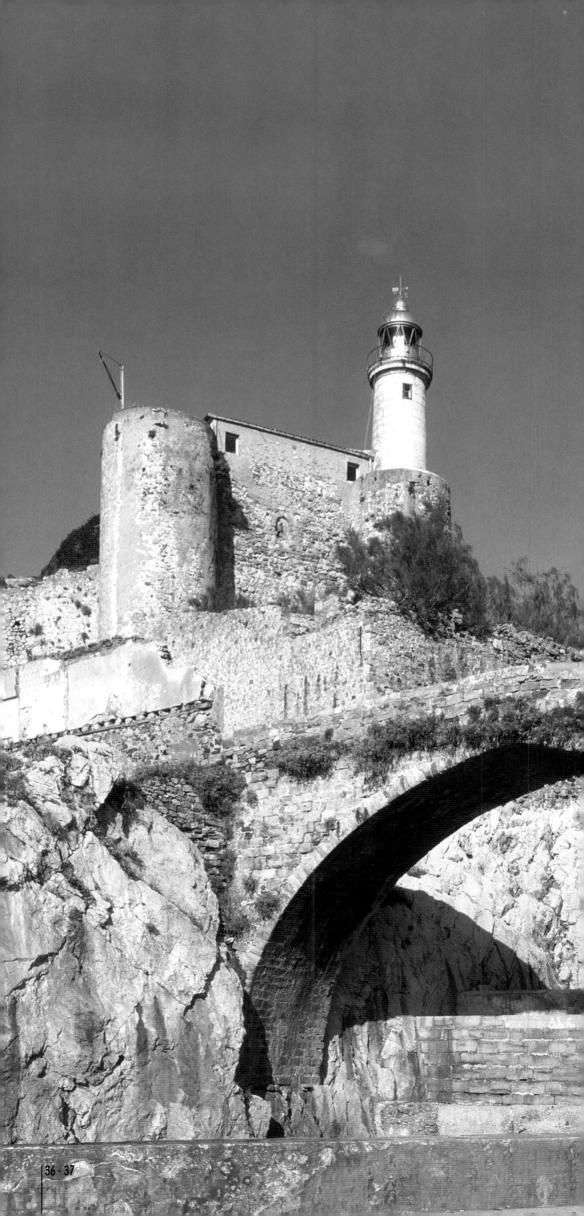

CASTILLO DE SANTA ANA
SPAIN | Cantabria
1853 | 16m | White flashes | Site accessible

The Atlantic coast of Spain is not lacking in dangers. Consequently, it has around 40 light-houses of varying sizes built along a coastline that is sufficiently steep to be able to provide a comfortable elevation in relation to the sea level, and therefore a good geographical range.
The medieval south-east tower of Santa Ana is perched on a cliff face to better defend an old port thriving from its exploitation of mines and fishing, and is surmounted by a conical light tower. Electrified in 1919, this stone lighthouse is equipped with a balcony and a lantern with a metal dome. The former keepers' accommodation emerges over the ramparts.
The inhabitants of neighbouring Bilbao enjoy walking around Castillo de Santa Ana.

IGUELDO
SPAIN | San Sebastián |
Basque country

1855 | 13m | White flashes |
Site accessible

Perched on a 134m cliff to the north-west of
Donostia/San Sebastián, this lighthouse has
been the fortunate spectator of the comings and
goings of the successful fishermen that are the
Basques: whales harpooned in the Bay of Biscay,
cod hunted down in Newfoundland, shoals of
sardines and tuna pursued in their Atlantic
migrations. The Basques have (almost) tried it
all – and with great success.
With a range of 26 miles, the lighthouse marks
the western entrance into Concha bay, a crescent
encompassing Monte Igueldo, the island of
Santa Clara and the Monte Urgull, and where
there are still some fantastic horse races. The
cylindrical tower, with its lantern and balcony, is
enclosed in a classic main building with a terrace
roof. Igueldo, though integrated into an amuse-
ment park, is still inhabited and is the main light
installation along the Basque coast.

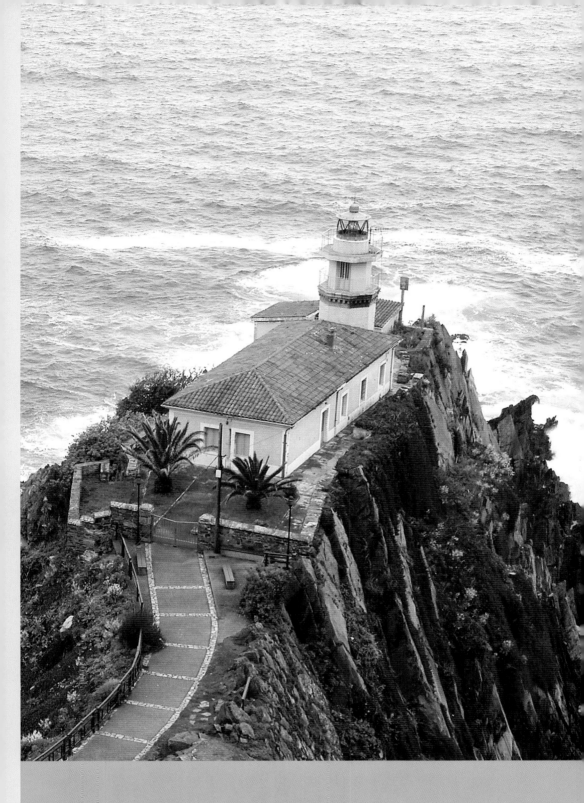

③ PUNTA ROBALLERA
SPAIN | Cudillero | Asturias

1853 | 10m | White occulting light | Site accessible

In the Basque country in Galicia, there are a vast number of squat structures that play at being tightrope walkers on the rocky crests. 'El guardián del vertigo' (the vertigo keeper) is the nickname given to this lighthouse at the extreme edge of Roballera Point near La Nueva España, to the east of the pretty port of Cudillero, close to Gijón.

The brickwork tower is octagonal with a double balcony. Raised in height in 1921, it leans up against the keepers' house. In 1984 the original lantern was changed to accommodate a more high-performance lens. This much awaited improvement was put into words in a song by a certain Mr Riera: 'El faro de Cudillero lo van a poner más alto / Pa que alumbre a San Esteban y no se pierdan los barcos' ('The Cudillero lighthouse, we're going to make it bigger / So that it illuminates San Esteban [a neighbouring port equipped with a modest seawall light] and the boats don't lose track of where they are'). Its range, increased from 10 to 25 miles, makes it one of the most remarkable lighthouses of the Asturias. Lower down, a powerful foghorn roars and the sheer 75m cliff ends in a trident, gnawed like a bone by the sea. A footpath has recently been laid between the lighthouse and Cudillero port.

(4) ISLA ONS
SPAIN | Galicia

1926 | 12m | White flashes | Site accessible

The coast of Galicia is indented with sheltered rias like the one in whose depths Pontevedra nestles: its entry is barred by the island of Ons, which stretches out to around 7km. The largest of the islands along the Atlantic coast, it forms part of the Maritime and Terrestrial Nature Reserve of the Islas Atlánticas. In the 1970s, it was emptied of its inhabitants, and therefore its fishermen, who previously hunted down octopus and crustaceans in the surrounding area. Its lighthouse defies the Atlantic surges.

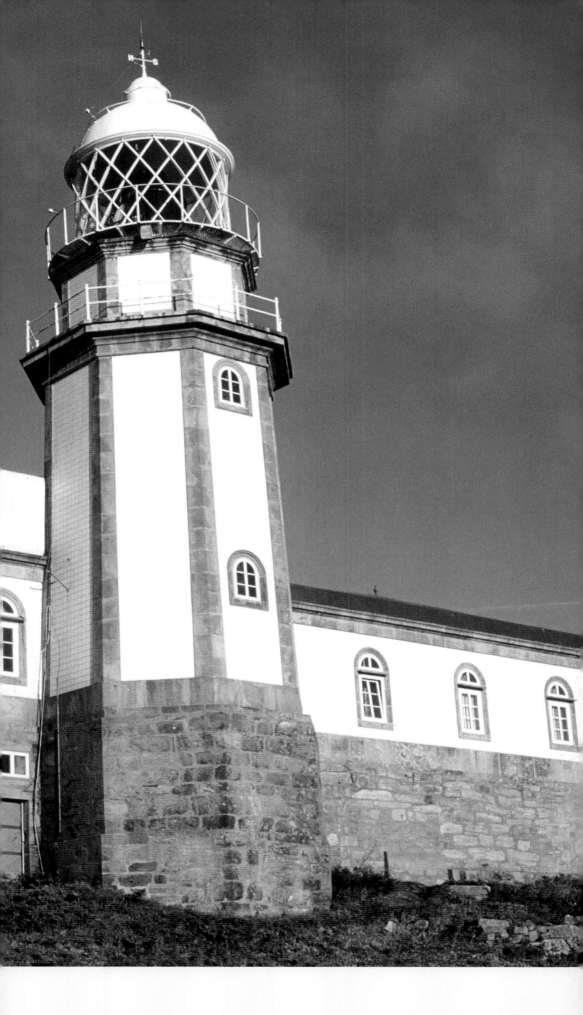

The octagonal stone tower, with its double balcony, eats into the U-shaped keepers' house. The stone base, window frames and ridges of the tower have been left exposed, giving the building an air of great distinction. It is built on the foundations of its predecessor (1865), which was deliberately demolished. Its elevation in relation to sea level reaches 127m and its range is 25 miles. This light, one of the last to be fuelled by pressurised petrol, crossed over to photovoltaic energy in 1990. Depending on the time of year, boat trips setting out from Sanxenxo-Portonovo enable visitors to get out to the island.

TOWER OF HERCULES
SPAIN | La Coruña | Galicia
Second century to 1791 | 49m | White flashes | Guided tour

The Roman emperor Trajan was in power during the building of what is now the oldest lighthouse in the world that is still active. La Coruña, a port in north-west Spain, was then known as Brigantium.

Legend has it that Hercules was the architect (in reality, it was Gaio Sevio Lupo) and that the site was the stage of a three-day battle between Hercules and the giant Geryon, who ended up having his three heads decapitated. To celebrate his victory, it is claimed that Hercules ordered a lighthouse to be built on the battle site. Others attribute the tower to King Breogán, founding father of Celtic Galicia; from its summit, his sons admired a very green land – Ireland. A ruined fortress in the Middle Ages, restored as a lighthouse in the seventeenth century, then damaged again, the tower was saved under Carlos IV. According to the designs of a naval engineer, Eustaquio Giannini, what remained of the Roman era was reinforced between 1788 and 1791 with a solid granite facing. The height of the tower was also increased by two octagonal floors, one of which housed the watch room. A spiral staircase leads to the summit from where the light carries for up to 23 miles. The walls are pierced by a number of rectangular openings decorated with cornices and bricked up to varying degrees. Between 1849 and 1854, the lighthouse played host to a keepers' school. Petitioners proposed that it be twinned with the Statue of Liberty, a former 'lighthouse', and the most famous seamark in the world.

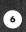

⑥ CHIPIONA
SPAIN | Andalusia

1867 | 63m | White flashes | Guided tour

This is the oldest lighthouse in Spain and is also one of the loftiest in the world. A staircase comprising 344 steps, created from fine wrought-iron work, leads up to its lantern. With a first-order landing light, its range is 28 miles from the Punta del Perro, just a few kilometres to the southwest of the mouth of the Guadalquivir, the river of Seville. The small town of Chipiona takes its name from an old lighthouse, which was mentioned in works by the Greek geographer Strabon. Kaipionos Pyrgos protected the reefs of Salmedina. This Monumentum Caepionis is also cited in the *Geography* (first century) by the Latin writer Pomponius Mela, originally from Spain.

The stately yellow and red tower is pierced by white windows surmounting a four-floor square base. It is a control centre, flanked by a two-floor keepers' house. The latter is equipped with a very fine patio, illuminated by a glass pyramid.

In the summer, visitors are welcome to the site on Tuesdays and Thursdays in groups of up to five people.

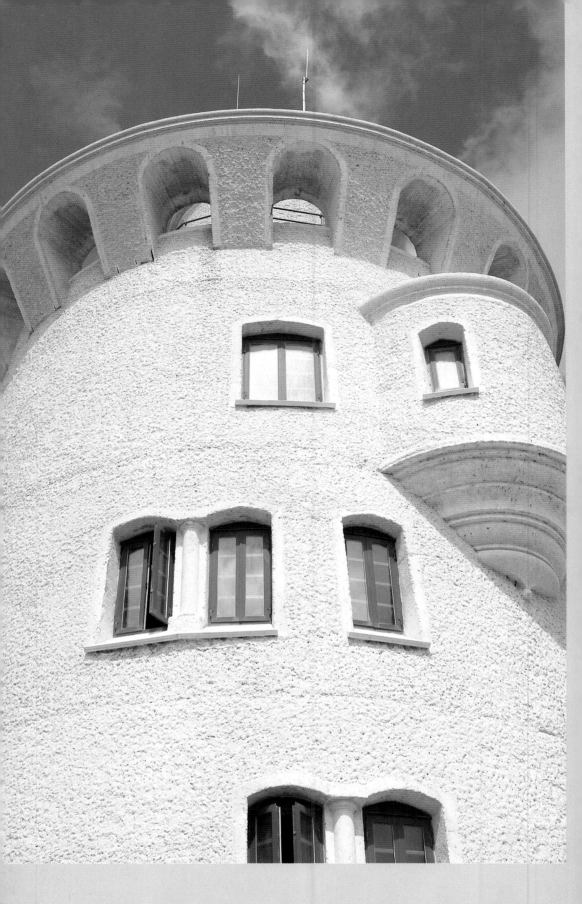

⑦ **PUERTO SHERRY**
SPAIN | Andalusia

1980s | Around 23m | Occulting red light | Site accessible

Puerto Sherry, a marina with nearly 800 berths and built at the end of the 1980s, is an extension of the port of Santa Maria at the mouth of the Río Guadalete, in the bay of Cadiz. Its port light stands at the end of a jetty protecting the nautical complex from the sea swell, which picks up some strong winds in this sector. The structure also serves as a lookout tower, where the Andalusian charm is guaranteed: the soft yellow of the rough coating, half turrets jutting out, numerous windows and an openwork balcony.

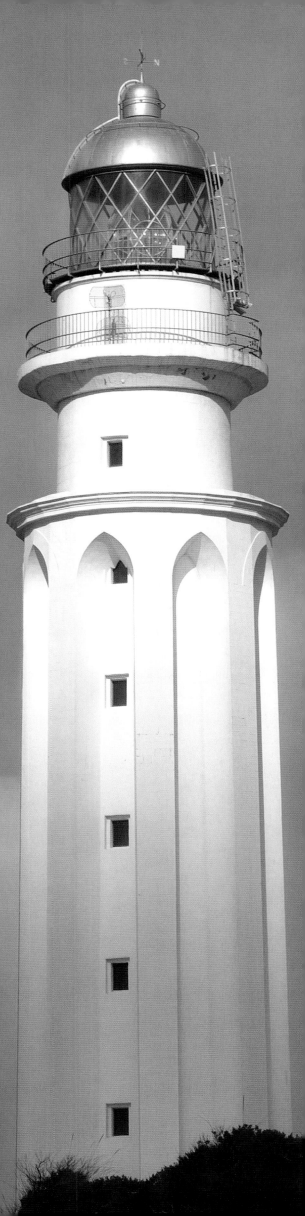

CAPE TRAFALGAR
SPAIN | Andalusia

1862 | 34m | White flashes | Site accessible

Cape Trafalgar is a celebrity in its own right. Off this 'western tip' – with its Arabic name of Taraf El-Gharb, which has evolved into Trafalgar – the French fleet (or Franco-Spanish at least) suffered severe humiliation in 1805. Napoleonic France plotted none other than the invasion of Great Britain here. Nelson, who lost his life in the battle on 21 October 1805, gave his enemies such a roasting that it guaranteed the English control of the seas until the First World War. The repercussions of this prompted the French to step up the surveillance of their own coasts, and therefore construct some lighthouses.

Here we see the elegant conical tower of Trafalgar, which is white with a slight hint of yellow and stands at the end of a strip of sand between Cadiz and Tarifa, to the north-west of Gibraltar. A corbelled structure with eight gothic buttresses was added in 1926, to help support the weight of a new lantern; this lighthouse is one of the most powerful in Spain.

This is where the Straits of Gibraltar officially begin.

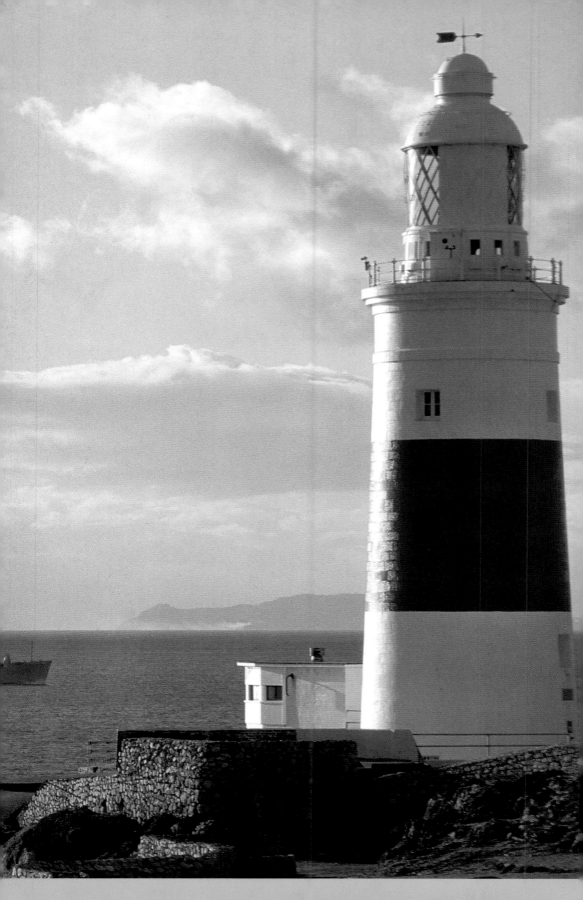

⑨ EUROPA POINT
GREAT BRITAIN | Gibraltar

1841 | 20m | White and red sectors + continuous red subsidiary light | Site accessible

Despite being of Arabic origin (Gibel Tariq, the Tariq mountain) and situated in Andalusia, Gibraltar (6km²) has been in British hands for the past three centuries. There is nothing surprising, then, about the fact that its lighthouse is a perfect example of English colonial architecture. Built by the Army Corps of Royal Engineers, it is managed by Trinity House. Each year, nearly 100 000 vessels pass in front of Europa Point.

This brickwork tower occupies the southernmost tip of the peninsula. It is both a landing light and a seamark for vessels using the famous straits, which link the Atlantic and the Mediterranean. In the 1950s, a second lens was installed beneath the main one, and its red light completes the other red sector of the first lens. The pair of them illuminate Pearl Rock, a dangerous group of rocks emerging at the western entrance to the bay. The development in the lens required the tower to be raised in height slightly. Electrified in 1956, the lighthouse was automated in 1994. Just beside the lighthouse is the foghorn shelter.

⑩ PUNTA DE TORROX
SPAIN | Andalusia
1864 | 23m | White flashes | Site accessible

In the nineteenth century, six lighthouses were built along the coast of Málaga (Costa del Sol). These were managed by the same engineer, Antonio Molina, with the exception of the lighthouse of Málaga. Torrox is the largest of them all. It dominates Torrox-Costa Bay and the mouth of the Río Torrox. Until 1950, no proper path crossed the dunes, thus cutting the lighthouse off from the little town of the same name, some 4km away. Supplying the lighthouse was done via mules carrying provisions on their backs, and the men placed in charge of the upkeep of the lighthouse were awarded an isolation bonus as a result!

This truncated tower made of large stones is mounted on a cylindrical base and has been painted white. Chipiona was coated in cement for a while and painted blue, however. Surrounded by a service building, the lighthouse rises up from the interior patio. To enable the addition of a second balcony, the lighthouse was raised in height in 1922. A technician assigned to ensure its smooth running still lives here.

11 CABO DE GATA
SPAIN | Andalusia
1863 | 19m | White and red sectors | Inaccessible

Cape Gata and its semi-arid, volcanic environment are the jewels of the grandiose National Park that bears its name – the largest parkland in the whole of the western Mediterranean. Indeed the latter protects a 30km strip of coast alternating between creeks, steep cliffs, parched dunes, salt marshes, maritime prairies and long beaches – like that of Fabriquilla pictured here, with its generous rollers. There are no longer any shipwrecks in the surrounding area of Almería. During the First World War, the lighthouse keepers were unfairly accused by the British of informing the Germans about the movements of their vessels, a vast number of which were sunk near the cape by submarines.

Based on a natural panoramic viewpoint, this lighthouse of classic Spanish craftsmanship sits imposingly on the ruins of a fort. It is made of stone with a double balcony, and is attached to the accommodation. The lighthouse was damaged during the Spanish Civil War, during an air raid in July 1937.

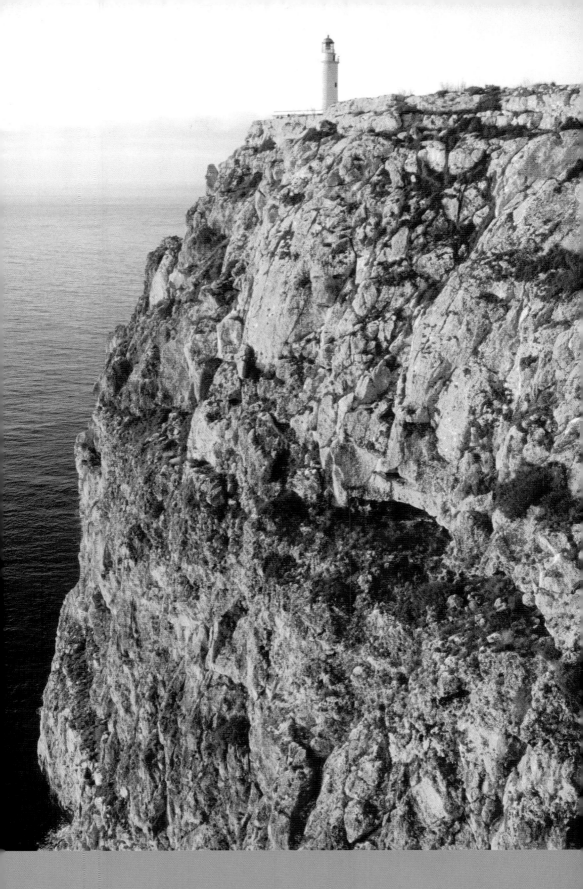

⑫ SA MOLA
SPAIN | Balearic Islands | Formentera
1861 | 22m | White flashes | Site accessible

There is no need to be a giant or a haughty sovereign of a vast landscape to be able to provide major assistance to navigation. This sentinel, whose light signal is visible for up to 23 miles, guides the cohorts of vessels passing to the south-south-east of the Balearic Islands.
Timidly crowning the 192m lunar plateau to the extreme east of Formentera, this is the only mood swing on the island, famed for the equanimity of its landscapes. The site, a reference for sailors since the dawn of navigation, has been adopted by a garrulous colony of Mediterranean puffins as well as a host of other seabirds. In 1998 one of its lighthouse keepers, Javier Pérez from Arévalo López, reported having seen a corpse pass below him one day, in its coffin...

CAPE CAVALLERIA
SPAIN | Balearic Islands | Minorca

1857 | 15m | White flashes | Site accessible

White from head to toe, this lighthouse is a perfect illustration of a common Spanish design: a modest or even squat tower, a lantern crowned with a hemispherical metal dome, and one or two balconies. Added to that there is an accommodation building with one or two floors closely linked to the tower, with the whole structure clinging to a rather steep cliff. Attention should also be drawn towards another feature, which is almost exclusively Iberian: in the prime of their youth, in the middle of the nineteenth century, the majority of the Spanish lighthouses were 'fed' with olive oil, a fuel widely available.

To the north of the island of Minorca, this extremely isolated lighthouse occupies a rocky spur (Cape Cavalleria), which vessels pass on their way between Gibraltar and France or Italy. Some 94m above sea level, the virulent south-westerly local wind, known as the *Vendaval*, is merciless in winter.

(14) EL FANGAR
SPAIN | Catalonia
1986 | 20m | White and red sectors | Site accessible

The first lighthouse here was built on stilts in 1864 and was demolished in 1972. It was then replaced for a few years by a cast iron beacon, prior to being superseded by this latest construction. Like the tower, the circular service room of the new lighthouse is made of reinforced concrete and its double balcony is enhanced by a red collar.

It is located to the north of the Èbre delta, at the edge of the sandy Fangar peninsula, which protects a lagoon and a natural port. The main wetland in Catalonia is also a national nature reserve.

Tarragona, further to the north, isn't very far away.

⑮ **PUNTA CALA NANS**
SPAIN | Catalonia | Cadaqués

1864 | 7m | White flashes | Site accessible

This modest lighthouse has a bird's eye view of the southern entrance to the bay and the natural port of Cadaqués, set back into the mountains. In 1982, the Lighthouse Commission wanted to destroy what was then almost a ruin, and replace it with a modern construction. However, they failed to take into account the protests of the local population, who managed to obtain permission for the upkeep and restoration of the old construction, in the name of preserving the heritage.

Prior to its automation, a position at this station was seemingly sought after, as it was perceived as a sinecure. Those of you who are familiar with Cadaqués, a splendid fishing village on the Costa Brava cherished by Salvador Dalí, and prized by so many other famous painters, wouldn't be at all surprised to learn of this.

16 CAPE CREUS
SPAIN | Catalonia

1853 | 11m | White flashes | Site accessible

Close to Cadaqués, the surrounding area of Cape Creus, which is also a nature reserve and often swept by the Tramontana or the Levante winds, is much feared by sailors. The second oldest lighthouse in Catalonia, located on Esquena Point, it marks the most eastern point of the Iberian Peninsula. The short, initially square, and then cylindrical, tower is centred on the roof of a spacious keepers' house. The lantern is entirely glazed right the way to the top of the dome.
In the 1960s, the station served as the setting for several adventure and pirate films, including one that inspired Orson Welles with his staging of a Jules Verne novel and its 'lighthouse at the end of the world'.
An information centre welcomes walkers.

PRAIA DA BARRA
PORTUGAL | Aveiro

1893 | 62m | White flashes | Site accessible

A fairly shallow coastal lagoon estuary, blocked off by a tombolo, the area is dotted with various navigation channels and small traditional coloured boats (*moliceiros*). This tower is a symbol of a Lusitanian Venice with its bold stripes, faded by the sun and the sea. This is the most slender lighthouse in the country. Like a lot of others, it came about because of repeated incidents at sea that became increasingly troublesome. The idea for this tower (1856) was a long time in the making and was not actually drawn up until 1879; it was the design of a self-taught man and outranked those of 11 engineers!

This light also marks the southern entrance to the ria leading to the port of Aveiro, around 47km upstream. The structure stands at Barra, on a narrow strip of sand, which gives it a ringside seat for Atlantic storms. It has a range of 23 miles.

To give it some originality, the tower, surrounded by accommodation, was equipped with a lift in 1958, which follows the central pillar of a spiral staircase. In 1947, a third-order Fresnel lens replaced the original first-order lens. The lighthouse was electrified in 1936 and linked to the national grid in 1950. It became automated in 1990.

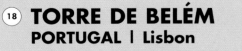

(18) TORRE DE BELÉM
PORTUGAL | Lisbon

Sixteenth century | 30m | Inactive | Visit

Built in the middle of the Tage between 1515 and 1521, the Belém tower is a masterpiece of Manueline architecture, named after King Manuel the First, who was inseparable from great Portuguese navigation. The silting up of the Tage was aggravated by a tsunami, which was generated by a massive earthquake in 1755. This resulted in the connection of the fortress to the north shore of the river. The tower was designed to honour Vasco de Gama, discoverer of the spice route, and to defend maritime access to Lisbon, of which Belém is a suburb. This marvellous four-floor Gothic construction, topped with a terrace, mixes maritime, natural and

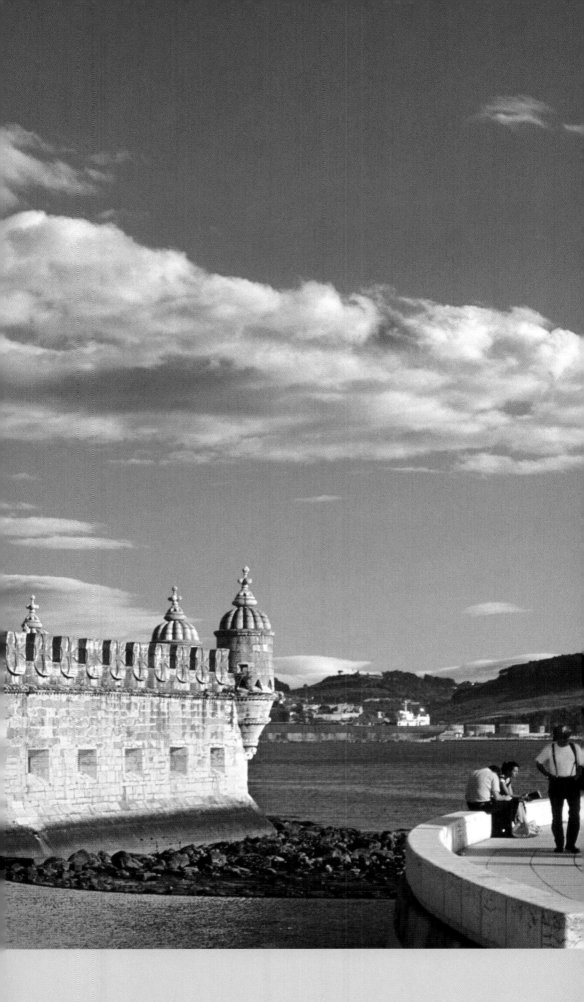

fantasy designs. It is finished off with some decorative Moorish elements, such as the domes of the watchtowers, and it is classed as a Unesco world Heritage site.

The stronghold was used as an arsenal, a prison, a customs post, a harbourmaster's office, as well as finally a lighthouse in the nineteenth century. Old postcards show the ultimate aid to navigation at the site: a metal framework tower, dismantled between 1930 and 1940.

⑲ LA LANTERNA
ITALY | Genoa
1543 | 77m | White flashes | Guided tour | Museum

La Lanterna of Genoa, an amphitheatre-shaped port on the Ligurian Riviera, is one of the oldest, still active lighthouses in the world. The first lighthouse was built on the site in 1128. A paternal uncle to Christopher Columbus, Antonio was appointed as guardian here in 1449. This structure, like the next, suffered accidental fires and varying degrees of damage on several occasions. These were caused by clashes between aristocratic families, the French or the inhabitants of Pisa.

However, it was the inhabitants of Genoa themselves who, in 1506, unwittingly knocked the top off their lighthouse with a hail of bullets destined for the French. According to a legend that has never been corroborated, the architect of the new tower was hurled into the void to remove any ideas he might have of offering his services to rivals from Pisa or Venice. Another legend promised five years and five months of misfortune to inhabitants in the event of the light being unexpectedly extinguished.

Originally, the lantern's framework was covered with sheets of copper and lead, fastened by over 600 nails. The brick tower is square from base to tip and is made up of two sections that are almost equal in height, marked by terraces pierced by holes for draining away the rain. The terrace on the first floor is accessible to the public, but the floor above cannot be visited. Some 117m above sea level, its range is 27 miles thanks to a first-order lens (1913). La Lanterna was electrified in 1936. Its restoration was completed in 2004 after nearly ten years' work.

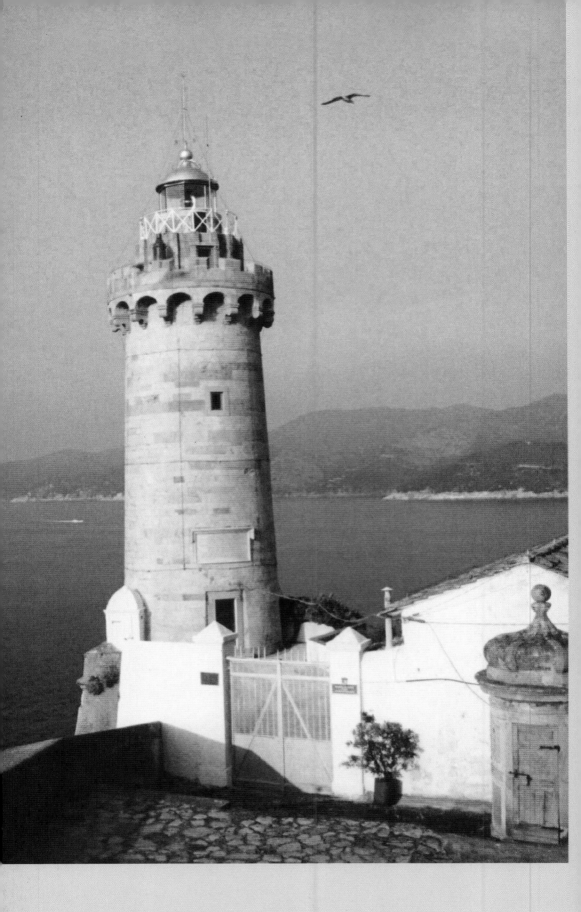

㉛ PORTOFERRAIO
ITALY | Isle of Elba

1862 | 25m | White flashes + additional fixed red light | Site accessible

Between Corsica and Italy, the Isle of Elba is the largest of the Tuscan archipelago. The pretty horseshoe-shaped port of Portoferraio houses its administrative centre. This landing light marks the western entrance to the bay, and its secondary red light warns boats to watch out for the shallows, which extend along Cape Bianco. The structure stands at the corner of a fortress (Forte Stella), built in the sixteenth century. Like other fortifications here, it was built on the initiative of a Medici, Cosimo I, to defend the island from pirates. This crenellated tower is close to the villa dei Mulini, Napoleon's residence during his exile; it too has views across Portoferraio Bay.

ISLAND OF MURANO
VENICE LAGOON

21

1912 | 35m | White light | Site accessible

The Venice lagoon measures around 15km wide and is separated from the Adriatic by a 50km line of sediment. It can be accessed via three channels: Porto di Lido, Porto Malamocco and Porto di Chioggia. To navigate around here involves using a network of natural and artificial channels. To the north of Venice, Island of Murano (renowned for its glass) is one of the largest of the 40 or so islands that are scattered about this stretch of water.

The stone lighthouse (which really *does* lean over and isn't an optical illusion!) is situated to the south-east of the island, at the entrance to the Grand Canal of Murano opposite the Canale delle Navi. A rear alignment light, it is marked by three horizontal black bands; the front light is 3km from here.

㉒ PORER
CROATIA

1833 | 31m | White flashes | Available for rent

A mile to the south-west of the Istrian peninsula, the islet of Porer is surrounded by violent currents and swept by strong westerly winds, hence its three landing stages. The lighthouse is set in the middle of a sterile, rocky slab measuring 80m in diameter and worked over by the sea. There is an abundant underwater life in the surrounding area, though.

Between Pula and Kotor (Montenegro) in the Adriatic stretches a line of sentinels, which groups together no less than 600 islands, a few of which are inhabited. The Porer lighthouse, visible

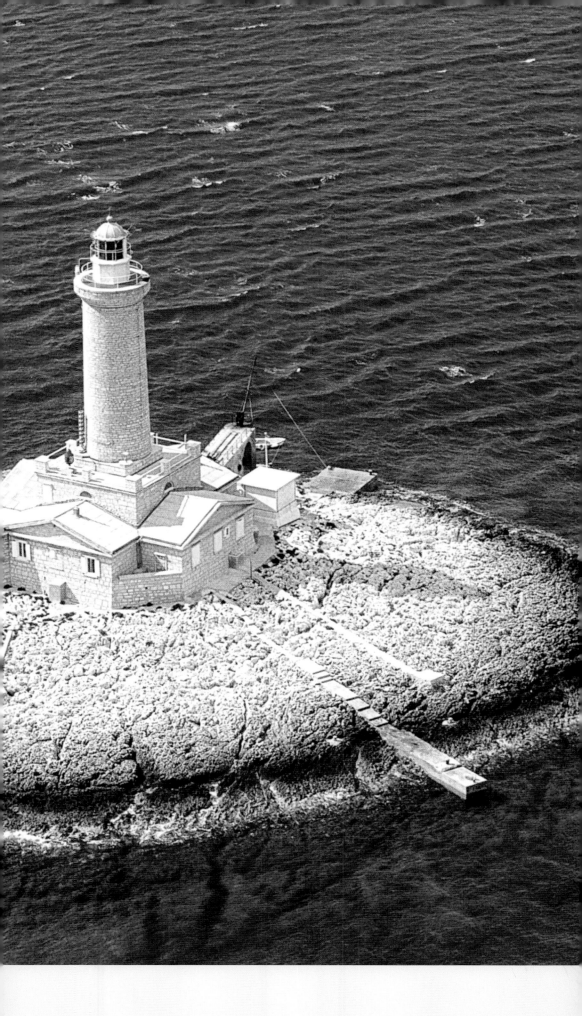

some 25 miles away, guides shipping towards the ports at the far end of the epicontinental sea (Koper, Trieste, Venice) and marks the entrance to Kvarner Bay for those bound for Rijeka.
The tower, including the lantern and the one-floor wing, are built of exposed stone and date from the time of the Austro-Hungarian Empire. Several lighthouses on islands or headlands are available for rent 'for those who are brave and courageous', according to Plovput, the national operator. It is the only means of visiting this particular lighthouse. Two flats accommodating four people have been fitted out and boats leave from Pula or Premantura.

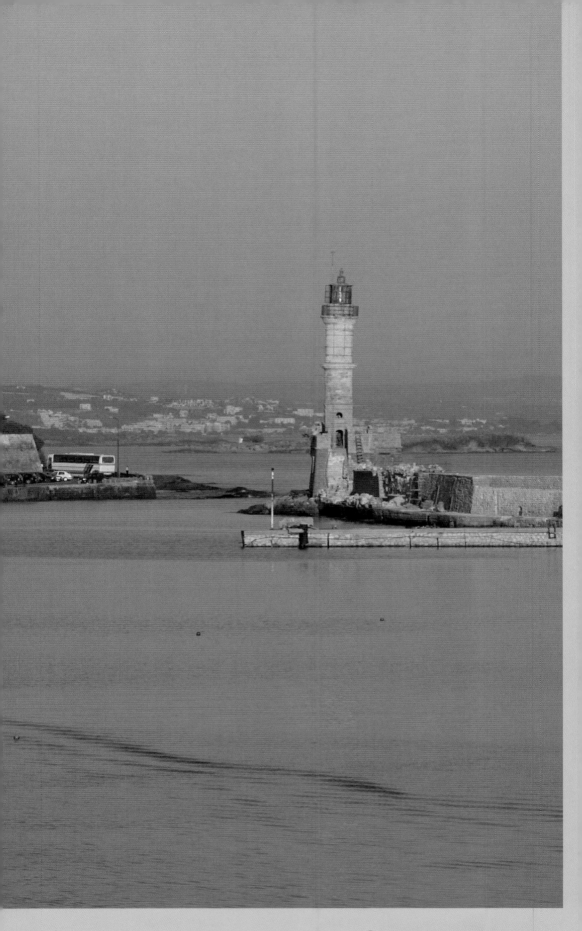

㉓ CHANIA & RETHYMNON ㉔
GREECE | Crete

Around 1821–41 | 18m | Inactive (decorative light) | Site accessible
Around 1864 | 9m | Inactive | Site accessible

The lighthouses in the charming 'Venetian' ports of Chania (above) and Rethymnon were restored or rebuilt in the nineteenth century, at the time of the Ottoman yoke. The structure in Chania has nevertheless retained its original base, which can be accessed from the breakwater by a flight of steps.

These two buildings sum up the tumultuous history of an island that the major maritime powers of the Mediterranean (including Genoa) fought over for a long time, against a backdrop of incessant revolts by the local population. Following the division of the Byzantine Empire by the Crusaders (1204), Crete was sold to the doge of Venice. Benefiting from its exceptional

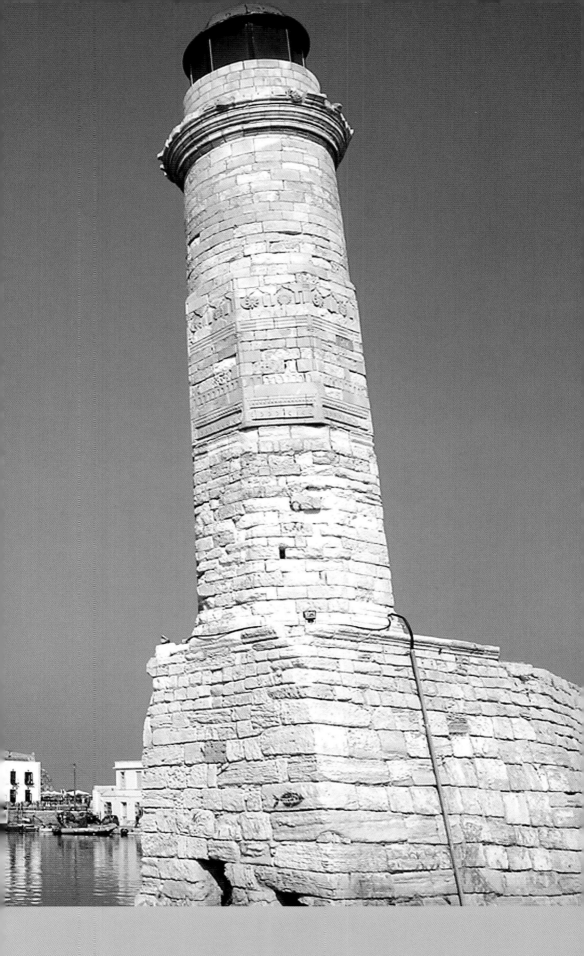

position, amid the insular arc linking the Peloponnese to Asia Minor, between the Libyan Sea and the Aegean Sea, the Venetians turned it into a naval, military and commercial base, which was impregnable for a considerable time. The fortified ports of Chania date back to this Venetian period – as does its first, rather differently inspired lighthouse – and that of Rethymnon.

It was only later, from 1645, that the Turks managed to commandeer the island and retain it in their fold until 1897. Deserting the old port of Chania and opting instead for a natural cove, a few kilometres away, the 'new' port was known as Souda.

AGIOI THEODOROI
GREECE | Ionian Sea

1828 | 8m | White flashes | Site accessible

The neoclassical lighthouse of Agioi or Aghios Theodoroi (Saint Theodore) is located in Lassi, on the Fanari peninsula. It marks the entrance to Argostoli Bay, the main town in Kefalonia, the largest of the seven Ionian Islands.

This building with its Greek peristyle image and Doric style colonnade is far from old, however. The initial tower was built on the initiative of the British governor, Charles James Napier, friend of the poet Byron, back in 1828. Severely damaged by an earthquake in 1953, it was replicated the following year, drawing on the original plans as its inspiration.

(26) PAPHOS
CYPRUS

1930s | Around 10m | Site accessible

Paphos is the legendary birthplace of Aphrodite, the goddess of love supposedly born from the sea spume. It is only a secondary port today, compared with Larnaca or Limassol. However, at the time of the Roman occupation, Paphos was the island's main town. The area bordering the lighthouse bears witness to some important antique vestiges, classified by Unesco, such as the Roman theatre coiled around the foot of it.

On the south-west coast, this round tower with its balcony and lantern signals a zone of reefs and shallows. Four other lighthouses are maintained by the Cyprus Ports Authority. The restoration and opening of this lighthouse are directed by the municipality, within the framework of a global project to enhance tourism at the archaeological site.

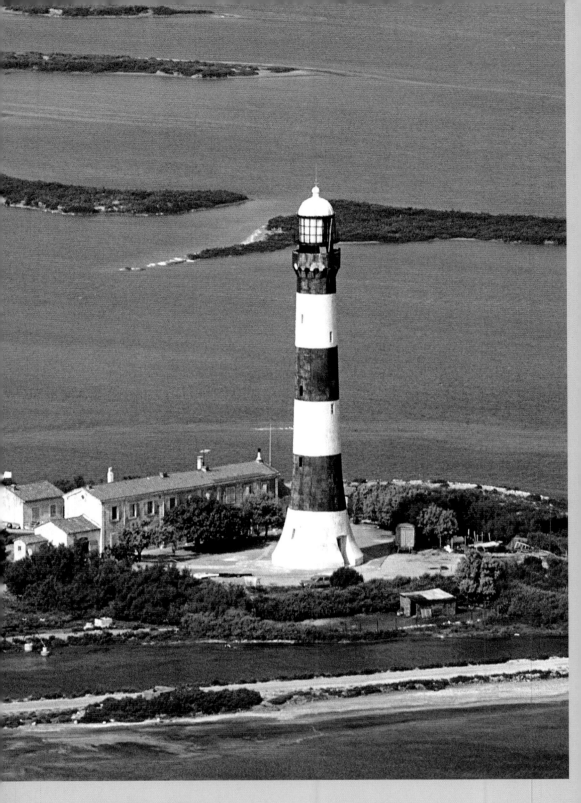

(27) FARAMAN
FRANCE | Camargue
1892 | 43m | White flashes | Site accessible

Here we enter the sumptuous Rhone delta. Faraman is located to the west of the Grand-Rhone, the most powerful of the two dyked arms of the sea, which intertwine the Camargue area. Where does the land begin and the water end? With its ponds, marshes, salt marshes, beaches, channels, islets, lagoons, various alluvial deposits, etc, it isn't easy to find a place to build a lighthouse amidst this unsettled terrain.

The year 1830 sounded the taking of possession: a 15m wooden tower was driven into the ground like a flag on sandy, silted soil. In 1840, this position was consolidated by a 36m cylindrical tower. However, the plot of land eroded, and was further pared down by the incoming tide. It ended up consuming the base of the lighthouse, which collapsed, but not without handing down its stone to its successor. The order was then given to move it back some 1200m. Springing up not far from Salin-de-Giraud, this lighthouse, black and white since 1934, is completed by russet-tiled accommodation and outbuildings.

Notice how the base flares out and how smooth the brickwork is; you can never do enough to discourage the sapping effect of the water. Its range is 27 miles. The lighthouse was automated in 1999. In the foreground lies the sea wall (1859) which includes sluice gates that regulate the exchanges of water.

(28) CORDOUAN
FRANCE | Gironde estuary
1611–1789 | 68m | White, red and green sectors | Guided tour

The 'lighthouse of kings and the king of lighthouses', the 'petit Versailles' is the oldest lighthouse in France. Situated 7km from the coast, this classic monument sits at the mouth of the Gironde, which drains into the Bay of Biscay. Upstream, Bordeaux and its wines have always been highly prized by the British and thus the lighthouse was built to protect transport from the Bordeaux area.

What you see before you is the fruit of a brilliant surgical operation: the upper tower was grafted onto the main structure in 1789, on the terracing of a baroque construction (1584–1611) designed by Louis de Foix. The whole structure (six floors) is surrounded by a circular bastion pierced by a postern, it too dating from the Revolution. All the flowery vocabulary of the *Grand Siècle* is expressed in the stonework. Inside, we notably find a chapel and some royal flats, which were never used. Such splendour was not down to chance. Cordouan's mission was to dazzle, to flaunt the royal power and, if need be, to deliver a message to the English: Aquitaine is French so there's no need to return. However, the fact remains that the first tower was built on the order of the Black Prince in the fourteenth century, when the region was in the hands of the English.

In 1823 Augustin Fresnel's first lens was successfully installed and tested here. The lighthouse is accessible from March to October by boat from Royan or Verdon, whereas the lighthouse on the Grave headland accommodates the Cordouan Lighthouse Museum & the Museum of Lighthouses and Beacons.

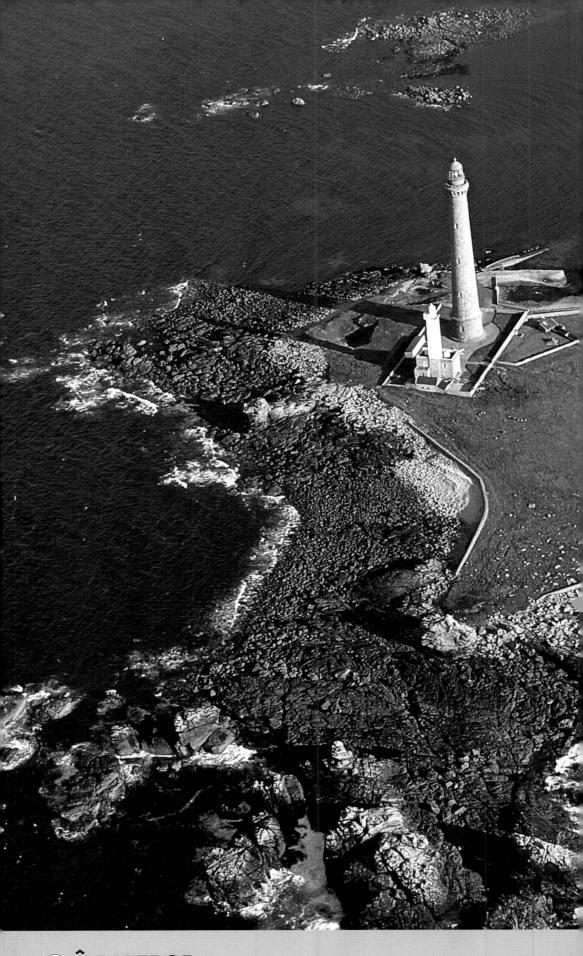

㉙ ÎLE VIERGE
FRANCE | Plouguerneau
1845 and 1902 | 82.5m | White flashes | Visit

There are two lighthouses on a patch of short grass eroded by the sea along this very jagged stretch of coast. To the north of Brest, the Lilia-Plouguerneau coastline lies within reach of the islet's foghorn, some 1.5km away. Eclipsed by its successor, the lighthouse, built in 1845, is perched on the accommodation and is larger than it seems at 33m. Its insufficient range (18 miles) at the opening to the Channel and its intense traffic determined the construction of a second tower, visible up to 27 miles away. It is the tallest lighthouse in Europe and was five years in the making.

In the lighthouse keeper's jargon, this is 'purgatory', an insular lighthouse where you can house

your family, midway between 'hell' (the offshore tower) and 'paradise' (the inshore structure). Its interior has a highly polished style: the walls of the stairwell are tiled with opalescent blue; this wall lining alone, designed to limit condensation, required 12 500 tiles!

Both constructions are made from large stone and quarried granite obtained on site. Their decoration (capping pieces, cantilevers, cornices, etc), as well as the staircase of the large lighthouse – 365 steps, plus 35 more up to the lantern – is made from local granite, specific to the harbour of Brest, that hardens as it dries out.

Visitors can reach île Vierge via a short trip in a launch.

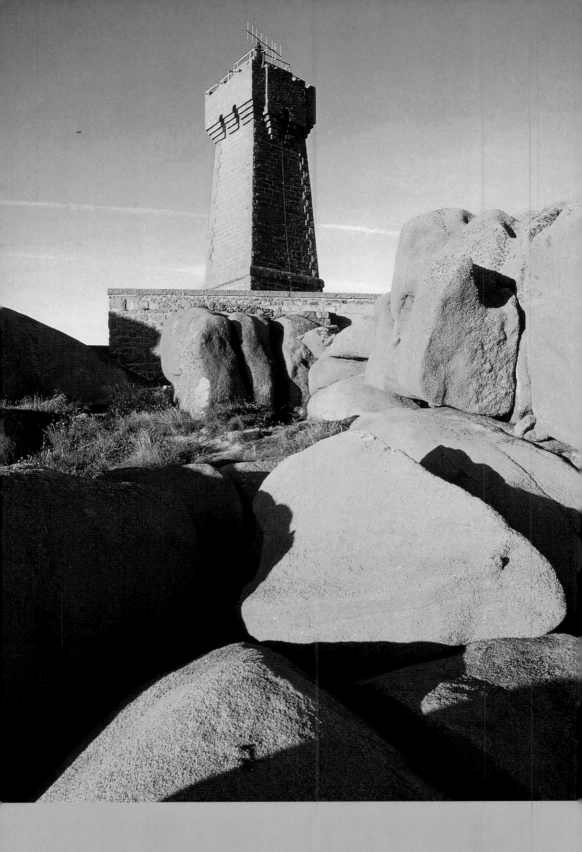

(30) MEN RUZ
FRANCE | Ploumanac'h

1948 | 15m | White and red sectors | Site accessible

Men (or Maen) Ruz means 'red stone'. The Breton language has the same perception of colours as the scientific language, which bears witness to red, carboniferous granite, not pink. Depending on the time of day and the light intensity, the colour of the rock in this area of northern France can range from red, to orange, to sandy grey. This lighthouse, surrounded by a chaos of rocks, was 'created' from the oxidised granite, which has given the tourist area along this stretch of coastline its name (Granit Rose or pink granite).

Truncated, this crenellated dungeon-like pyramid marks the access passage to the tidal dock of Ploumanac'h harbour, in Perros-Guirec. Designed by an architect from nearby Saint Malo, Henri Auffret, it replaced another tower (1860), which was destroyed by bombing in 1944.

With one coastline on the Channel and the other on the Atlantic, Brittany alone accommodates 150 French lighthouses. This concentration originates in its ragged shores, crafted by a strong tidal current that thwarts the Atlantic swell.

CALAIS
FRANCE
1848 | 51m | Visit | White flashes

Situated opposite Dover, this landing light dominates Calais, a tortured port in the Second World War. Although it was damaged, this lighthouse miraculously survived. Indeed, the destruction affected a number of historic lighthouses in the Cotentin region on the 'Pas de Calais' (Strait of Dover). This strait forms the northern tip of the English Channel. Its light, which carries 22 miles, was not re-established until 1948. It was superseded by a bastion from the former fortified town wall.

The octagonal tower is partially enclosed in the keepers' accommodation. In 1992, it was necessary to replace its brick facing with enamel, as it was crumbling away due to the dampness. It was reinforced by concrete hooping. The watch room, topped by a balcony, is painted black and the decorative elements are made from stone. The thickness of the walls tapers between the base and the summit, going from 1.90m to 1.15m. The plans for it were used to design the electric lighthouse at Port Said (p. 14). It too was electrified prematurely (1883), and it was automated in 1987, signalling the departure of its last keeper, a woman. A 'discovery room' looking at the maritime signalling techniques has been installed on the first floor.

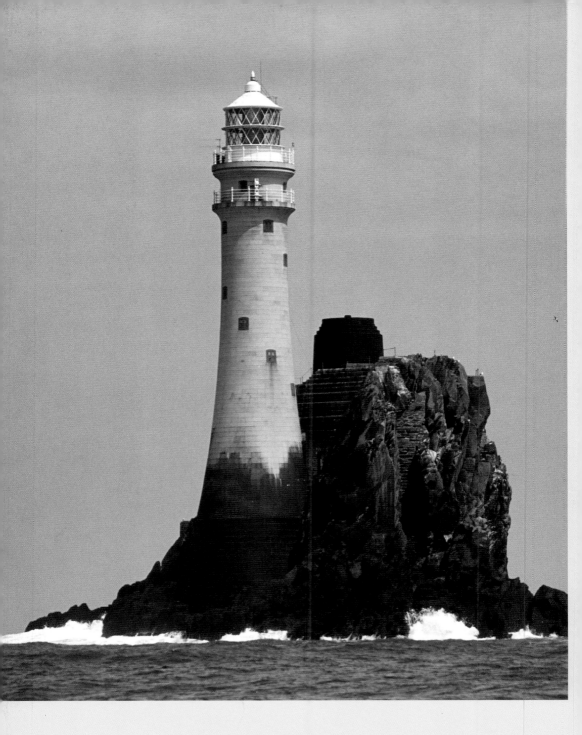

(32) FASTNET
IRELAND | County Cork
1904 | 54m | White flashes

Fastnet rock is famous around the world due to the majestic shape of its lighthouse and the hostility of its environment. Emigrants nicknamed it 'Tear Drop', because it was the final piece of Europe on the journey to America.

The decision to make the area safe around the sinister reef situated on the south-west tip of Ireland, some 4 miles off Cape Clear, was hastened by a shipwreck that brought about nearly 100 deaths.

The first lighthouse (and its adjoining house), the work of famous Irish constructor George Halpin senior, was opened in 1854 after six years' work. Very soon it was necessary to consolidate this cast iron tower, often swallowed up by the waves. Finally it was left to William Douglass, the final representative of an illustrious English dynasty of lighthouse builders, to design a new tower. This one involved the assembling of 2074 blocks of grey Scottish granite, carefully sized, and each weighing over 2 tonnes. It was assembled under extremely difficult conditions between 1899 and 1903. For a year the lantern from the previous lighthouse was used, the new one having been smashed by a storm – prior even to being installed.

With a range of 27 miles and electrified in 1969, the largest Irish lighthouse, with its very flared foot to consolidate the foundation and cushion the structure from the waves, was automated in 1989. The site was then equipped with a helipad. Fastnet is also the turning point for the biennial sailing race that has sported its name since 1925.

TARBERT

IRELAND | County Kerry

1834 | 22m | White + red sector

This harbour light was built to the north of Tarbert Island at the request of shippers and vessel owners, to assist commercial yachts frequenting the Shannon estuary and the port of Limerick. The Shannon is the longest river in Ireland (360km), and since 1905 this red light has illuminated a dangerous reef, Bowline Rock, to the west of the river mouth, and marks the course to safe moorings. The lighthouse is built on a rock and the keepers' accommodation has now gone. A small cast iron bridge, of a delicate design and measuring around 60m, has linked this limestone tower to the shore since the beginning of the 1840s.

(34) SKELLIG MICHAEL
IRELAND | County Kerry
1826 | 12m | White flashes

A gigantic mass of minerals, Skellig Michael stands 8 miles to the south-west of Kerry. In the sixth century, a Celtic monastery was built here. When informed that a lighthouse was going to be constructed, J. Butler of Waterville and his father, then owners of the premises, calculated a rent over a 986-year period proportional to the selling price of the puffin feather (abundant on the island). They received £780 as a full settlement.

Work began in 1921, with stone taken from the site. Two towers were illuminated to prevent any confusion with the Cape Clear light. The light at the top was to be extinguished when another 'island-cliff' lighthouse, Inishtearaght, was opened in 1870. The one lower down was refashioned and modernised in 1967 and two accommodation areas were built. The keeper in the lower tower was relieved of his duties in 1865, after thrashing his colleague at the top while under the influence of alcohol. Three children are buried on this wild rock. The keepers and their families continued to reside here until 1901 when they were re-housed (like those in Inishtearaght) in new accommodation on the more hospitable island of Valentia.

Clinging to the cliff 53m above the sea, this lighthouse was automated in 1987 and has a range of 27 miles. It is accessible via a path along a ledge and there is a helipad on the site.

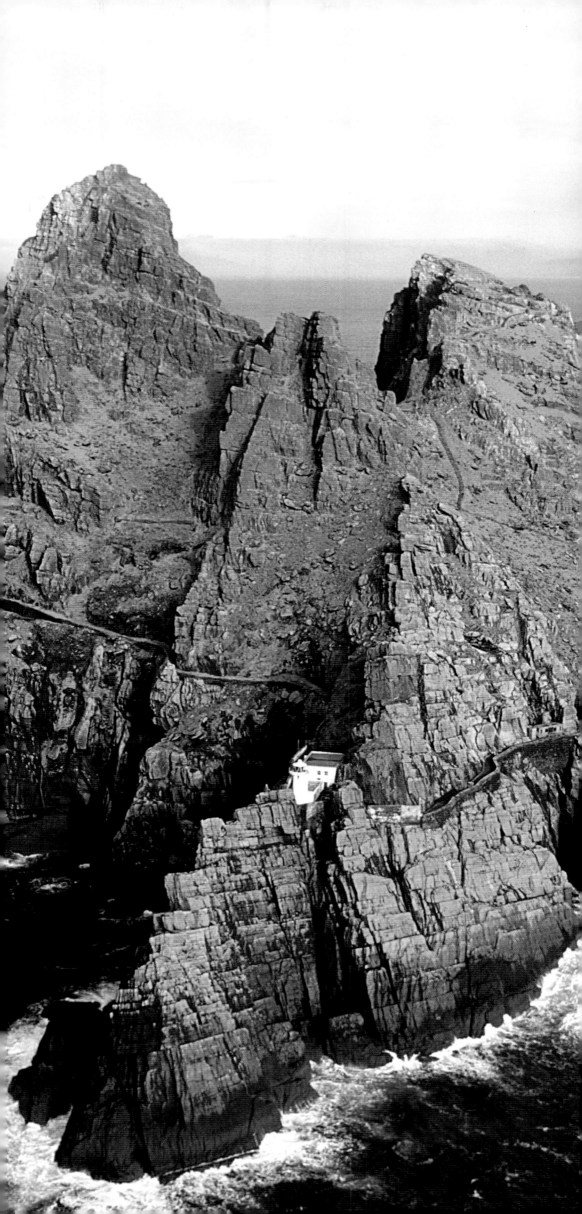

BASS ROCK
(35) UNITED KINGDOM | Scotland

1903 | 20m | White flashes

Bass Rock is an austere volcanic ridge rising to over 100m at the southern entrance to the Firth of Forth, an estuary of the River Forth that bathes Edinburgh and drains into the North Sea. A vast number of species of seabird live here, but it is, above all else, a gannet kingdom, with 30 000 to 40 000 pairs nesting here. Needless to say, it is the largest colony in Europe – if not the world. The French name for this pelagic bird, an excellent diver, derives from the island's name (Fou de Bassan). In France, the only nesting ground for gannets is on Sept-Îles, along the north coast of Brittany. In Scotland, cruises setting out from North Berwick, just a few kilometres away, take visitors to the island in the company of ornithologists.

Designed by D. Alan Stevenson – not to be confused with his uncle David A. Stevenson cited on the following page – the tower is located low down on a fold in the rock, 'just' 46m above the water. For the entire period that there was a keeper on the island – until 1988 – its lantern was illuminated with paraffin oil, which fuelled a burner equipped with an incandescent gas mantle. A natural phenomenon, the rock is traversed from end to end by a tunnel carved out by the sea.

RATTRAY HEAD
UNITED KINGDOM | Scotland | Peterhead
1895 | 34m | White flashes | Site accessible at low tide

For a long time there was just a small bell buoy, battling against the tide, to signal the dangers in this area of the North Sea to the north-east of Scotland, and this despite protests from shipping companies, and even Lloyd's. The reasons for this were a deep disagreement between the operators of British lighthouses, Trinity House, and the Scottish Northern Lighthouse.

This lighthouse stands at the edge of a beach fringed with dunes, midway between the port refuge of Peterhead and Fraserburgh. Its build was entrusted to David A. Stevenson. The two-section form is original: a whitened brick tower (14m) surmounts a granite cone (20m). The lower section, pierced by a door, was used to house, in addition to a water tank, the motors and compressors from the first ever first-order foghorn installed on a reef lighthouse. In the upper section, bedrooms, a living room, a kitchen and a lookout room were fitted out.

With a range of 24 miles, this lighthouse was automated in 1982. A bed and breakfast and a tearoom were opened in the keepers' accommodation on shore. One lens is on display in Aberdeen's maritime museum.

MUCKLE FLUGGA

UNITED KINGDOM | Scotland | Shetland

1858 | 20m | White flashes

How inoffensive Muckle Flugga seems in these calm conditions! The rugged Shetland archipel-ago stretches 160km to the north-east of the Scottish Highlands, and Muckle Flugga is the largest of this group of some 100 or so islands. It is also the furthest north of all the British islands and is the lookout for vessels going between northern Europe and America. The closest land is Greenland.

A light was hurriedly illuminated in 1854, after 26 days' work, to assist the Royal Navy during the Crimean War. The ocean methodically smashed it to pieces from the very first winter and the decision was made to build higher. Four years later, the current lighthouse was opened. Of

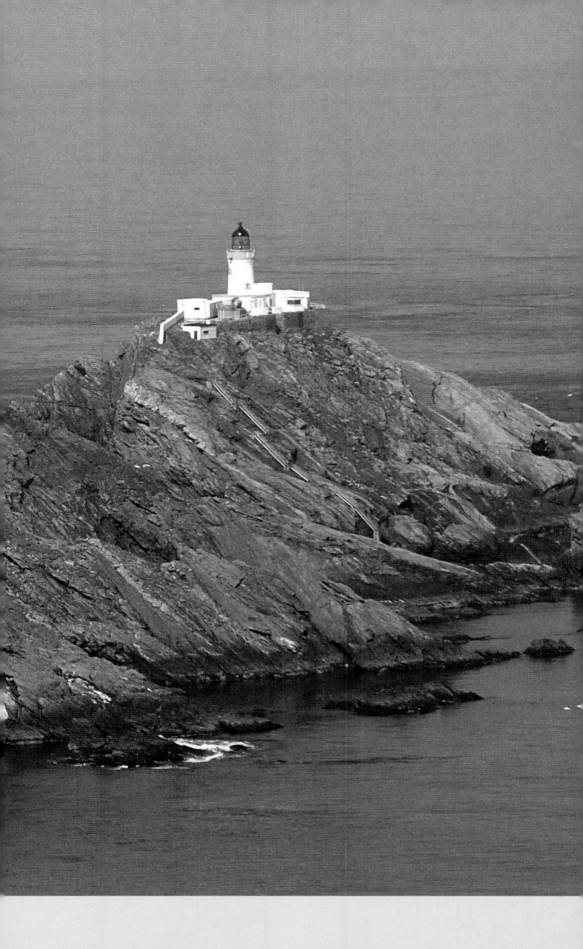

class c craftsmanship, it was created by two members of the Stevenson family, David and Thomas. The latter was the father to Robert Louis, author of *Treasure Island*, who as a young man visited this very place in 1869. This Scottish dynasty designed the majority of lighthouses in their native region on behalf of the Northern Lighthouse Board.

A month at sea, a month on shore: such was the watch system for the six keepers at the station, who worked in shifts in teams of three. Automated in 1995, this lighthouse has always been difficult to access by boat; today, the maintenance rotations are performed exclusively via helicopter. Its range is 22 miles.

STOER HEAD
UNITED KINGDOM | Scotland

1870 | 14m | White flashes | Site accessible | Night stay

Once again, David and Thomas Stevenson were the engineers of this little white and ochre lighthouse, capped with a black lantern and surrounded by a low white wall. Some 59m above sea level, the light of this short tower is visible 24 miles beyond the western tip of the Stoer peninsula. It guides the boats travelling along the Minch Strait, which separates the Inner and Outer Hebrides from the Highlands, to the north-west of Scotland, and also announces the start of what is a minefield of islands and reefs, which only narrow out at the Scilly Isles.

The lighthouse was automated in 1978 and the route here is a well-illuminated one. The first floor of the keepers' house is available for holiday lets all year round through the National Trust for Scotland.

RUA REIDH
UNITED KINGDOM | Scotland

1912 | 25m | White flashes | Accessible site | Night stay

From 1853, a Stevenson, David this time, offered to equip the site with a navigation aid, but without success. His son, David A., took up the project and saw it through, despite various differences of opinion with the Commissioners of Northern Lighthouse and Trinity House, and the financial reticence of the Board of Trade. Like other Scottish lighthouses, Rua Reidh is dressed in white and ochre, and capped by a black lantern. Situated to the north-west of the Highlands, it bears the name of an isolated headland that sticks out into the Minch Strait, between Stoer Head and the Isle of Skye, and marks the entrance to Loch Ewe. In 1944, two keepers participated in the rescue of sailors from a Liberty ship, pushed onto the coast by a violent storm. This lighthouse was automated in 1986. The whole of the keepers' house can be rented out privately if there are 20 or more visitors, otherwise hotel or bed and breakfast accommodation is available.

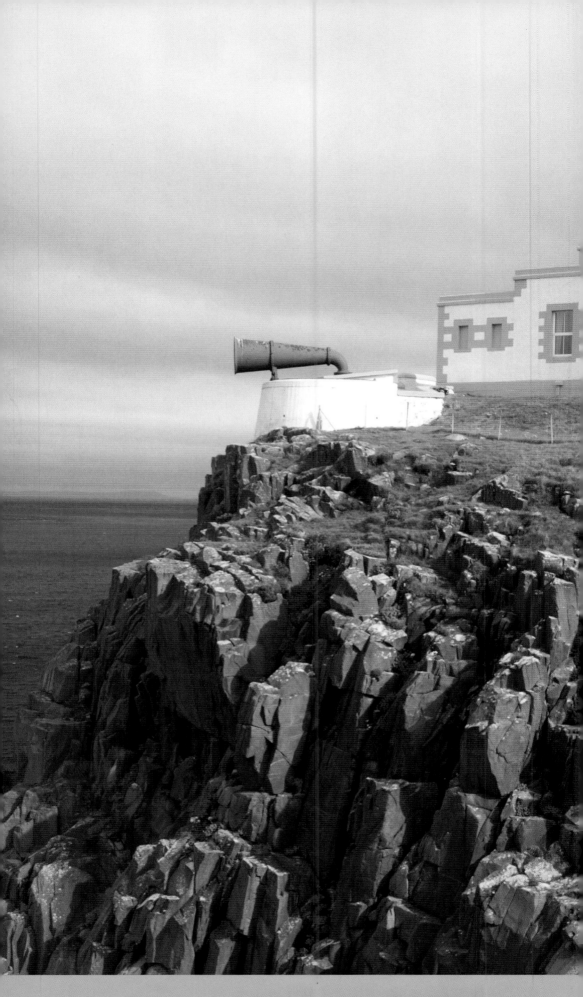

④⓪ NEIST POINT
UNITED KINGDOM | Scotland
1909 | 19m | White flashes | Site accessible

This lighthouse is located at the extreme south-west of the large Isle of Skye (Inner Hebrides) in the Minch Strait, which protects the Outer Hebrides barrier.
Perched on a rocky peninsula, 43m above sea level, its theoretical range is 16 miles. The former lens is exhibited in the Scottish Lighthouse Museum in Fraserburgh. Designed by brothers David A. and Charles Stevenson, this pretty white lighthouse is brightened up with the classic

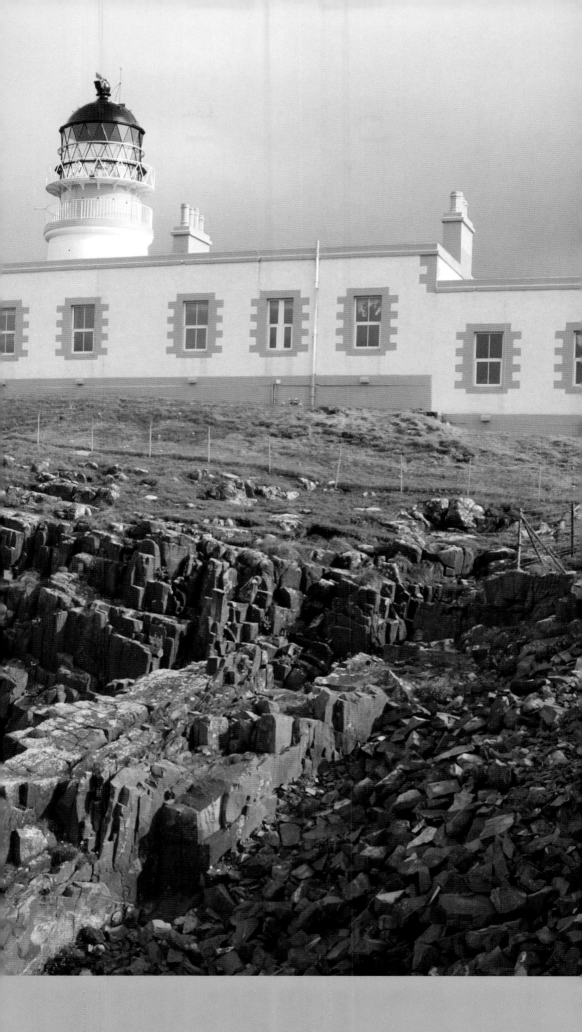

ochre (tower balcony, foundations, corner sections, chimneys, window surrounds, etc) and crowned by a black lantern. Since its automation in 1990, several constructions have been sold to a private agent. The keepers' accommodation was used as a holiday let for a while. The building is accessible via a path at the end of an easy, hour-long walk.

(41) LISMORE
UNITED KINGDOM | Scotland
1833 | 26m | White flashes | Site accessible

Scotland comprises 7000km of coastline and over 200 lighthouses. The reason for this is the extremely ragged coast, particularly in the Highlands, slashed with deep rias like fjords, veined with water courses and scattered with inland lakes. In the Inner Hebrides archipelago, this lighthouse is located on an islet (Eilean Musdile/Mansedale), an outpost to the south-west of the island of Lismore. It marks the entrance to the beautiful Loch Linnhe in the Firth of Lorn, which flows between Mull and Oban. This construction is owed to the most famous Stevenson of all, Robert. Automated in 1965, it has since been solar powered.

Its first main keeper was a descendant of Alexander Selkirk, the Scottish sailor who inspired Daniel Defoe to write the adventures of Robinson Crusoe. Four keepers were assigned here and relieved on a fortnightly basis: four weeks on the reef, followed by two on shore. Fishing has always been an activity highly prized by lighthouse keepers. Here, in 1940, there was a miraculous catch: two aviators were fished out of the water, saving their lives.

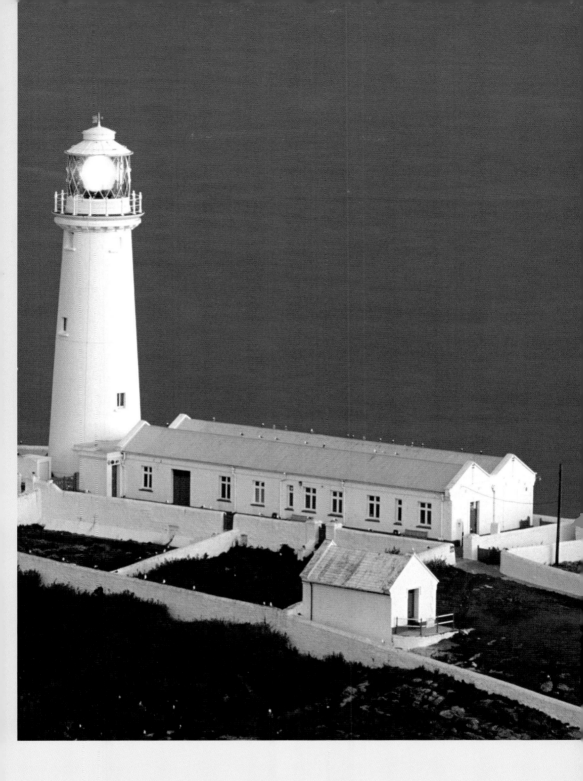

SOUTH STACK
UNITED KINGDOM | Wales | Anglesey

1809 | 28m | White flashes | Guided tour

Anglesey is a large island bathed by the Irish Sea. Môn, in Welsh (Mona to the Romans), was a spiritual Mecca for the ancient Celts. Holyhead is a mountainous outcrop to the west of this island, with the equally steep South Stack (Ynis Lawd) further west still.

It can be reached via a bridge, the third of its kind installed here since 1828, suspended over a 30m-wide channel with turbulent waters. This bridge can be accessed via 400 steps cut into the cliff. A health course on the way here, a 'Way of the Cross' on the way back! In October 1859, an appalling storm ravaged western Europe, driving a large number of vessels onto the coast. On the night of the 25th, the assistant keeper of South Stack wanted to meet up with his superior. While he was on the bridge, his head was hit by a rock that had come loose from the cliff; he died three weeks later.

This pristine lighthouse, electrified in 1938, was automated in 1984. It can be visited from April to September, as can its information centre.

(43) GODEVRY
UNITED KINGDOM | Cornwall | St Ives
1859 | 26m | White and red sectors | Site accessible

A handful of miles to the north of St Ives, often washed by big seas, the islet of Godevry is surrounded by some formidable rocks: the Stones. The latter were the cause of a number of tragedies which, in the first half of the nineteenth century, bore witness to the remarkable growth of Hayle, a nearby mining port. A liner and its 60 or so passengers foundered here in 1854, persuading Trinity House, an authority on the matter, to remedy the situation.
The octagonal stone tower is surrounded by a low wall to protect the keepers from the violent winds and the big waves. The red light illuminates the mass of hazards.

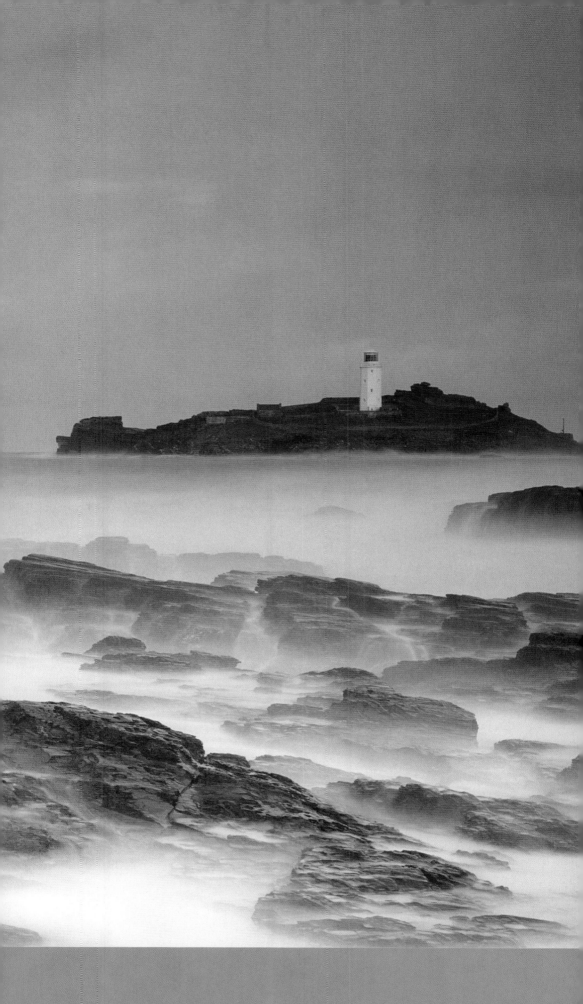

Godevry was one of the very first British lighthouses to be automated in 1939, the changeover of keepers being particularly perilous here. During Christmas 1925, one of the two keepers fell victim to pneumonia and was taken back to shore, which in itself was not without its share of difficulty. Alone, his colleague ensured the watch for eight days – and eight nights.

The keepers' house has since been demolished. Equipped with a helipad, the lighthouse was solarised in 1995. Godevry can be proud to have inspired the novelist Virginia Woolf in her major work – *To the Lighthouse* (1927).

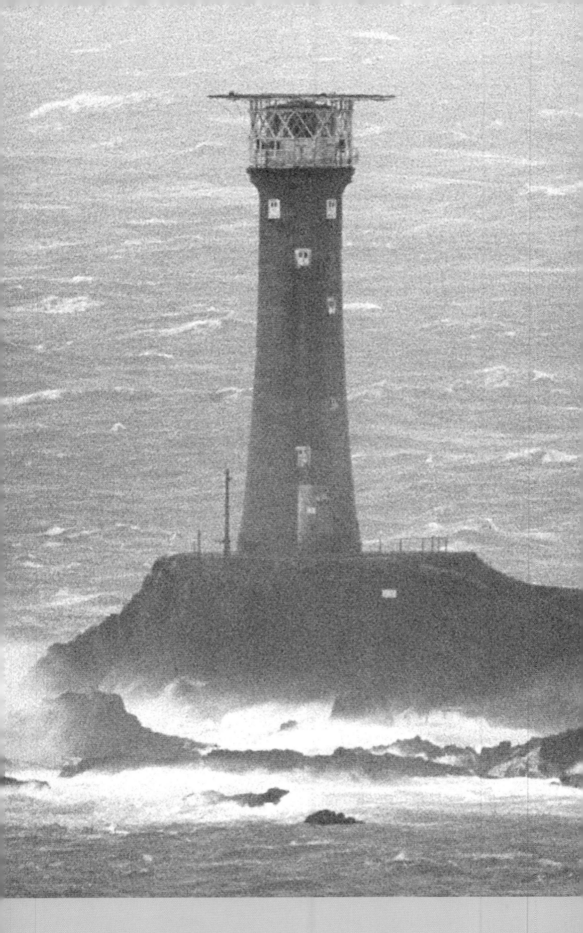

(44) LONGSHIPS II
UNITED KINGDOM | Cornwall

1875 | 35m | White and red sectors

Longships II belongs to the proud tradition of impressive British towers in the open water, of which Eddystone III (1759) was the prototype. It stands on the highest rocky islet there is at this site (12m), in a zone paved with reefs, a mile to the west of Land's End between Cornwall and the Scilly Isles. To say that it was exposed to the Atlantic onslaught and extremely violent winds is an understatement. The surrounding area ranks among the most dangerous in the world, and several major lighthouses mark out the zone.

A first small lighthouse was built on the islet on 1795 and it provided all the services you might expect, despite the difficult life for its keepers. The construction of the new lighthouse,

managed by one of the Douglass brothers (a large family of builders of English lighthouses for whom this was their first engineering work) was to take three years. For reasons of stability, this tower is built like a type of inner tube. You go from one floor to the other by means of ladders, which connect rooms whose diameter do not exceed 2.5m.

Electrified in 1967, it was also topped with a helipad in 1974, to which access is gained via a hatch This cylinder of granite bid its last keepers farewell in 1988. On shore, its red light marks a channel, which may be negotiated when the weather allows. Its lens shines day and night.

THE NEEDLES
UNITED KINGDOM | Isle of Wight

1859 | 31m | White, red and green sectors

The first light illuminated here in 1786 wasn't entirely satisfactory: mounted on a 144m cliff, it was frequently masked by mist and spray. The new lighthouse, designed by James Walker, was therefore lowered to correctly illuminate the western approach to the Solent. This passage in the English Channel measures 24km long and 6km wide and separates the Isle of Wight from the coast around Southampton and Portsmouth. The name Needles obviously designates the group of chalky rocks that have broken away from the high cliff over the years due to erosion. The cylindrical bicolour granite wall tapers from 1m thick at the bottom to 0.61m at the summit. At the base, a braking step absorbs some of the impact from the swell and dissuades the water from climbing the tower. Its foundations plunge down into the chalk, which was dug out to install a cellar and a storage area. Like other British reef lighthouses, a helipad (1987) crowns its lantern. Equipped with a foghorn, it has conserved its original Fresnel lens (second-order). A keeper and three assistants ensured it was in good working order until its automation in 1994.

⁴⁶ PEPPER POT
UNITED KINGDOM | Isle of Wight
Around 1328 | 10.67m | Inactive | Site accessible

This most unusual medieval light tower is one of the oldest lighthouses in the UK. Visible to the south of the island near St Catherine's Down, it is reminiscent of the time when monks and hermits lit fires in such structures to pray for the sailors' safe return. Though this stone octagon today evokes the image of a rocket, its nickname is 'Pepperpot'.

The fires were lit on the ground and the tower is pierced by eight openings, through which the light would have escaped – albeit often covered by the mist rising in Chale Bay. Despite this, monks kept vigil here, ensuring it functioned correctly and this probably lasted until the Reformation of the sixteenth century.

It was built alongside a (ruined) oratory, on the entreaty of the Pope and on pain of excommunication, funded by Walter de Godeton. Following the shipwreck of *Sainte Marie de Bayonne* in Chale Bay, 'squirrelling' from the surviving crew resulted in the Church gaining a fair proportion of the cargo of wine, the barrels consequently belonging to them! A less flowery version of events came about before the tower even existed; this ousted the Pope, changed the name of the boat, extended the list of guilty parties and modestly concluded with a pecuniary sanction.

BEACHY HEAD
UNITED KINGDOM | Eastbourne
1902 and 1832 | 43m and 14m | White flashes

The human silhouettes show the scale of this steep vertiginous cliff, and this chalk landscape is typical of the Sussex coastline. The two lighthouses, situated a few kilometres from the resort of Eastbourne, border the Straits of Dover and enable the English Channel and the North Sea to communicate.

The 90m Belle-Tout (not visible) dominates the scene. This granite veteran lacked effectiveness in relation to its height, particularly frequently enveloped in fog. Today it is a private residence. Hydraulic jacks, greased rails – in 1999, its owners 'slid' its 850 tonnes 17m backwards, while it was just 3m from the precipice! If they hadn't done so, given the speed of the erosion, its fall was inevitable. The cost of the rescue: £250 000.

The replacement was built right at the bottom of the drop, at a respectable distance (165m) from the cliff. The building site was drained and pumped thanks to a cofferdam, over a two-year period. A kind of breeches buoy with a basket was set up on the summit to ensure the transport of men, material and granite. The lighthouse's range is 25 miles and it was automated in 1983. You can clearly see the two lighthouses from the surrounding cliffs. When cruising, it is possible to round the headland and, during the high season, a boat charter company from Eastbourne runs trips. The brickwork construction of the new lighthouse was inspired by the original plans.

(48) WESTKAPELLE
NETHERLANDS | Zeeland

1470 | 52m | White flashes | Visit

A church or a lighthouse? This structure is both. It is a survivor of a certain type of fortified medieval church that have high towers with flat roofs, which are as much seamarks as lookouts in the North Sea. Goedereede houses a similar structure, also in Zeeland, to the south of the Netherlands.

Westkapelle is located to the west of an island reclaimed from the sea, known as Walcheren. Inhabitants still battle against a double threat today: silting up and flooding. Around 1458, the inhabitants moved their village back from the water and undertook to build a church/lookout tower.

The square brick tower with its staggered floors is decorated by small alcoves with broken arches. Equipped with a lantern in 1817, it lost its nave in a fire in 1831 and as a result any religious vocation. A total of 197 steps separate the ground from the rutilant 12m-high cast iron turret. In 1944, bombing wiped out the buildings all around it; damaged itself, it only became fully operational again in 1951. The third-order Fresnel lens was installed in 1906, a year prior to electrification. The range of this automated lighthouse in 1981 was 28 miles! Its alignment with the lighthouses of Noorderhoofd and Zoutelande marks the estuary of Westerschelde, the mouth of the western Escault, which has been a major axis of European trade since the Middle Ages.

MARKEN
NETHERLANDS | Holland

1839 | 15m | Occulting white light | Site accessible

Three identical lighthouses, the predecessor of this structure and the two De Ven lights, were built in 1700. One still remains to the north of Enkhuizen, and they were designed to help vessels cross the inland sea of Zuiderzee as far as Amsterdam. To counteract flooding, this sea was closed off and separated from the Waddenzee in 1932 via a 32km coastal road, flanked with locks. Partially dried out and separated with large polders, it was turned into a freshwater lake and renamed Ijseelmeer (Ijseel lake), after the name of the river that flows into it. To the west of this stretch of water (north-east of Amsterdam), the very 'touristy' village of Marken occupies an ancient island, equipped with a causeway that has linked it to the mainland since 1957. The brick tower is placed alongside a keepers' house and the whole establishment is nicknamed Het Paad, 'the Horse' of Marken. Its original lantern (1901) is exhibited in the port.

(50) LINDAU
GERMANY | Lake Constance
1856 | 33m | White flashes | Visit

Maritime coasts don't have the monopoly over lighthouses. Any navigable stretch of water of any importance justifies the installation of various navigational aids. This is the case for Lake Constance (the Bodensee) which is divided between Bavarian Germany, Switzerland and Austria.

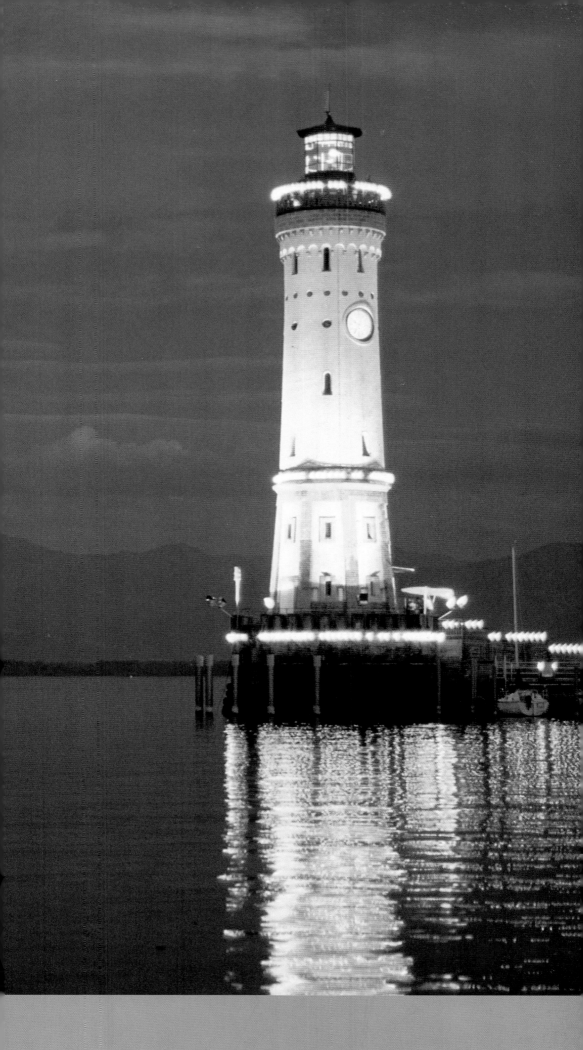

Equipped with a balcony and a lantern, this elegant stone lighthouse, the southernmost light in Germany, punctuates the western breakwater of Lindau, an insular town to the east of the lake. Built by the German railway, this port light, now the property of the Bodenseeschifffahrt shipping service, facilitates the movement of ferries and pleasure craft. It is equipped with a clock, and a statue of a lion (a symbol of Bavaria) stands opposite it.

ROTER SAND
GERMANY | North Sea

1885 | 28m | Inactive | Guided tour | Night stay

Although it is in the Weser estuary, Roter Sand and Alte Weser (1964) are close to the open sea. These are two lights from a squad of 15 lighthouses at sea that are in charge of the shipping, keeping the succession of vessels away from the sandbanks along the Außenweser.

In reality, the Roter Sand is not dissimilar to a 52.5m iceberg, with a vast proportion of the structure actually below the water. Its foundations consist of a steel caisson, driven into a sea bottom of red sand, from where its name is derived. It has a cast iron framework and the four floors are capped by two lanterns and a balcony all the way round. The small castle is fitted with watchtowers, which are in fact oriel windows, to get a better view of what's going on outside, but in complete safety. Two piles enable boats to moor here.

Its two lights were extinguished in 1986. Once the foundations were consolidated and the structure restored by the operating authority, a foundation was created which collected the necessary funds to guarantee its future: the Stiftung Leuchtturm Roter Sand. The lighthouse is now the property of the Niedersächsisches Wattenmeer National park. It is open to visitors on a daily basis, from May to September, on boats leaving from Bremerhaven. It is also doubtless the only sea lighthouse in the world where you can sleep, right at the summit, in one of nine bunks formerly belonging to the keepers.

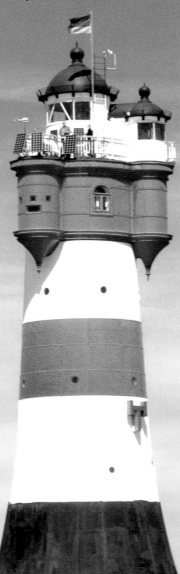

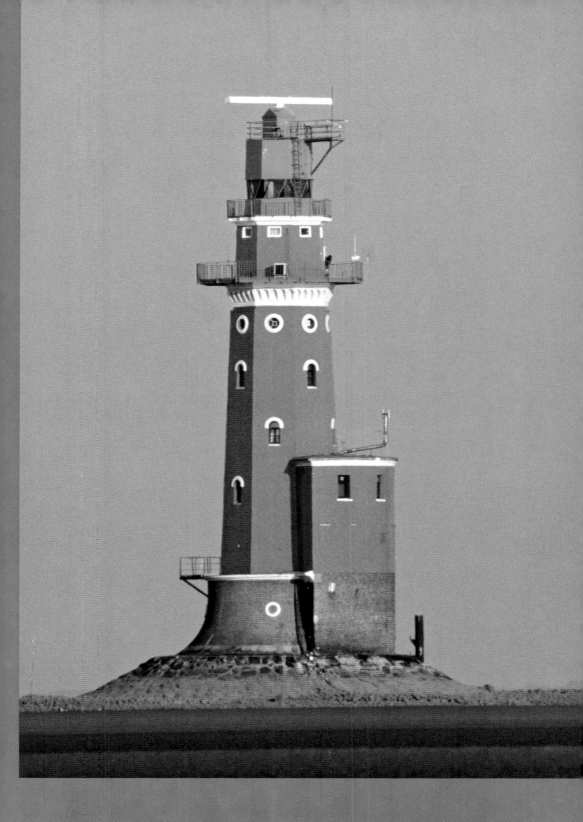

⑤² HOHE WEG
GERMANY | North Sea

1856 | 36m | Fixed light with white, red and green sectors | Site accessible

The estuaries of the Ems, the Jade, the Elbe and, above all, the Weser are peppered with sea lighthouses with often surprising morphologies. Their shapes are largely reminiscent of North Sea oil rigs, but here and there we encounter some rather original designs: Mellumplate, a caisson covered by a gigantic helipad, Robbennordsteert, a tall robot on legs, Alte Weser, a space vessel, Tegeler Plate, a periscope...
It is not Steven Spielberg who is credited with designing this particular structure, but Johann J. Van Ronzelen, an architect from the port of Bremerhaven. The tower is equipped with two balconies and capped by a green copper lantern supporting a radar antenna. Its metal coating is clad in brick and jazzed up with red and white paint. A jetty and signal station are adjoining. Hohe Weg, the 'high road', is designed to guide vessels in and out of the hazardous mouth of the Weser, 15 miles from Bremerhaven. Like Roter Sand, it is built on a sandbank, which is revealed at low tide. From 1783, a navigation aid has been installed here. The last keepers left in 1973.

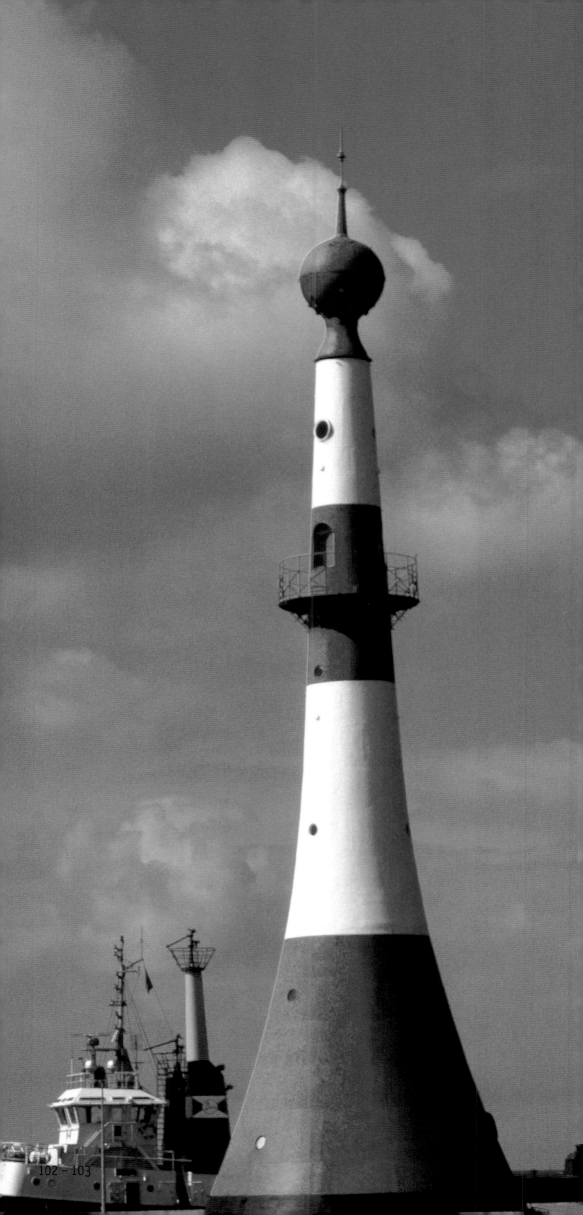

(53) MINARETT
GERMANY | Bremerhaven
1893 | 26m | White light | Site accessible

The design of this old cast iron seamark is contemporary to say the least. With a balcony mounted on the neck and a sphere at the summit, the structure is not dissimilar to a road traffic cone. In Bremerhaven, on the right bank of the Weser estuary, they prefer to call it the equivalent of 'Minaret'. Further forward this alignment light is placed at the southern entrance to Neuer Hafen (New Port). It guides boats manoeuvring around this narrowed section of the estuary; further back the other light is an elegant neo-Gothic lighthouse. The Loschen (1853), located near the port lock and the German Museum of Maritime Navigation, is partly afloat. In 1992, the Minarett was moved forward 56m so it would no longer be obscured by certain vessels.

Bremerhaven is twinned with Le Havre in France. This large estuary port (ten lighthouses!) was created *ex nihilo* in 1827 by Bremen and is nestled 60km upstream on the Weser to serve as its outer harbour. The former bridgehead for German emigration to the Americas, heavily bombed in 1944, gained a new lease of life thanks to maritime cultural tourism and the transformation in the fishing industry. Bremerhaven is the top German fishing port (calculated by disembarked tonnage).

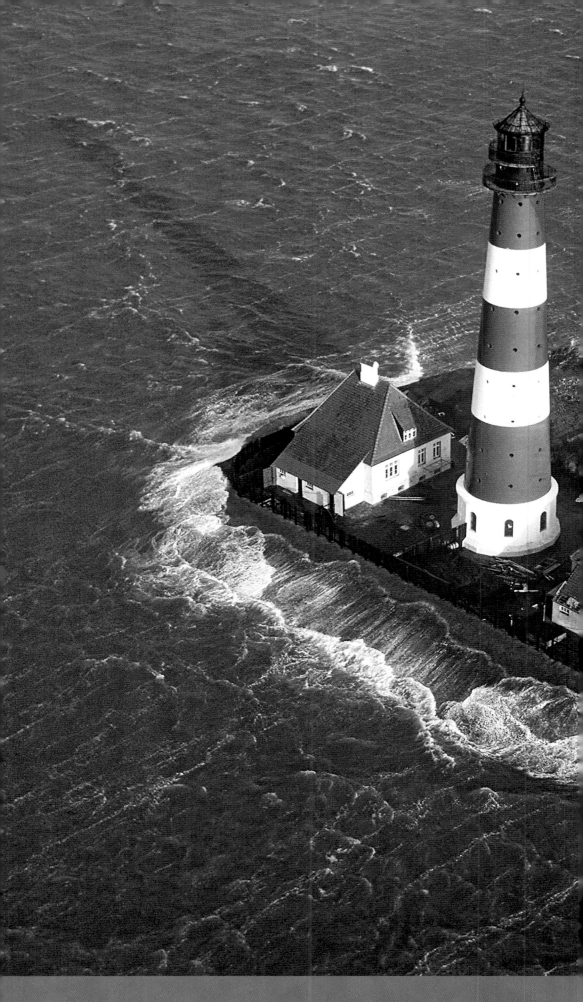

54 WESTERHEVERSAND
GERMANY | North Sea

1908 | 40m | Occulting white, green or red light | Summer visits

With its islets, dunes, salt marshes and mud flats, migrating birds and marine mammals quietly benefit from the preserved coastline of the Waddenzee, which borders the Frisian islands from the Netherlands to Denmark.

Westerheversand stands to the north-west of the Eiderstedt peninsula (Schleswig-Holstein), stretching along from the northern Frisian archipelago. Here, strong tidal currents constantly

shift the sands and even though an artificial talus protects the lighthouse from the sea, the surrounding ground can be totally flooded.

Hundreds of cast iron sheets were assembled to build the tower, which is decorated in very striking red and white stripes. Its foundations are buried in the sand and consolidated by 127 posts. The watchroom, the two balconies and the lantern are painted black.

Automated in 1978, this lighthouse is flanked by two stylish keepers' houses which are much in demand and well used: marriages are celebrated in one of them, while the other is used by the Waddenzee National Park.

TIMMENDORF
GERMANY | Baltic | Poel Island

1872 | 21m | White, red or green sectors |
Site accessible

The appeal of lighthouses for Anglo-Saxons is well documented, but the Germans are equally charmed by these structures. Historic buildings like this one, entirely restored in 1996–7, are protected by a federal law. This lighthouse occupies the sea front of the Timmendorf fishing port on Poel Island. The largest in Germany, this building is situated in the bay of Wismar.

The cylindrical brick tower with its lantern and balcony, capped by a red dome, rises above the centre of the two-floor main building. It was raised in height in 1931 from 17.4m to 21m: the upper third is still built from exposed house brick. Since then the lantern has been equipped with a third-order Fresnel lens. Still guiding vessels bound for the large port of Wismar, the lighthouse was automated in 1978.

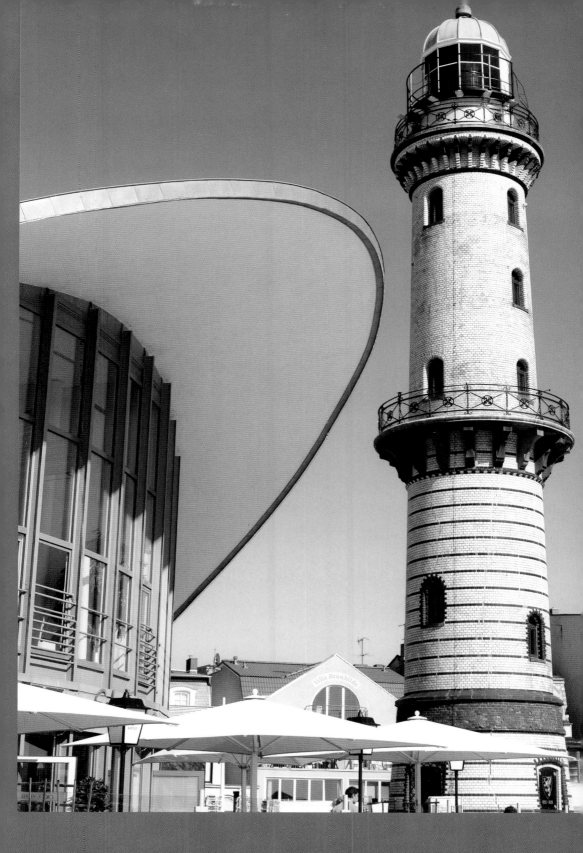

56 WARNEMÜNDE
GERMANY | Baltic

1898 | 31m | White flashes | Visit (May–September)

Warnemünde is the outer harbour of Rostock, a former Hanseatic trading post and now a modern industrial port complex of the Baltic (Ostsee), bordering the Warnow estuary. A plaque affixed to the lighthouse, dating from the time it was built, states that this is 'The last house before Denmark'. Two million passengers now embark each year on ferries bound for nearby Scandinavia.

Clad in light varnished or enamelled brick, this tower is decorated with a band of dark-coloured bricks on the lower section. The lantern is capped by a copper verdigris dome and the two balconies are some distance from each other. The original Fresnel lens (second-order) is still operational. The lighthouse was automated in 1998. Since the reunification of Germany, visits are made under the aegis of the Förderverein Leuchtturm Warnemünde, an association that ensures its preservation. A total of 135 granite steps lead up to the lantern.

CAPE ARKONA
GERMANY | Rügen Island | Baltic
1827 and 1902 | 21m and 35m | White flashes | Visit | Museum

The most ancient construction was built of red brick, the most recent of yellow brick. Of Prussian origin, the smallest structure is also the oldest; the other symbolises imperial Germany. Together they form the two central parts of the signalling device which, from the Darßer Ort to the Greifswalder Oie, warns of dangers in the Baltic. One stands behind the other and they look across to Scandinavia.

The duo is located on the island of Rügen, the largest of the German islands, on the end bordering the Pomeranian coastline. A bridge links it to the mainland, and the treacherous Cape Arkona is the island's northernmost point. Its twisting contours protect Stralsund, a former Hanseatic town and the final significant port before Poland.

The square tower comprises three floors pierced by nine rectangular openings on each side, which are partly filled in. It ceased all activity once its replacement was opened. The latter has responded to the demands of the growing traffic since 1902. An elegant structure, it has a double balcony and is mounted on an octagonal granite base; from this pedestal, its light carries for 22 miles. For many years, until 1992 specifically, it was painted with black and white bands prior to going 'au naturel'!

Both buildings are classed as historic monuments and open to the public. The former lighthouse and a keepers' house are also the home of a maritime history museum. Marriages are also celebrated here.

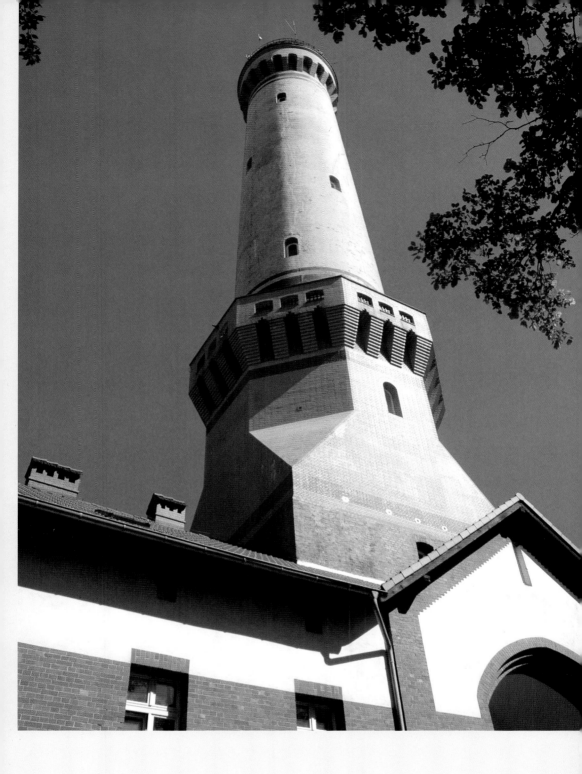

⁵⁸ SWINOUJSCIE
POLAND | Baltic

1857 | 68m | Occulting white light + additional red light | Visit | Museum

On the German–Polish border, the Oder flows into the Baltic, without dawdling in Szczecin Bay. It is an old Hanseatic town and the second largest port in Poland, together with Swinoujscie in the outer harbour. The Swina, at the opening of which this lighthouse stands, is one of three arms of the Oder estuary. Lighthouses prior to 1945 are of German construction, as the essential part of the coast remained under Prussian control after Poland was first carved up by its neighbours (1772).

The Swinoujscie lighthouse (Swinemünde for Germans) had a narrow escape. In 1945, its destruction was ordered by the Wehrmacht. However, the German keeper wasn't able to reconcile himself to lighting the match. This brick tower with its double balcony is the tallest in the world. It is square, then octagonal, and finally cylindrical, but it wasn't always like that. At the turn of the twentieth century, its facing was crumbling away under the spray: it was stripped and then covered with a façade of small bricks coloured either ochre or red and the thickness of a half-brick.

Renovated for the year 2000, the building was opened to the public, as was a museum dedicated to lighthouse and maritime rescue, housed in the keepers' accommodation. Poland takes great care of its historical lighthouses, which bear witness to an increasing number of visitors.

(59) **RUBJERG KNUDE**
DENMARK | Jutland

1900 | 23m (in former times) | Site accessible

Blavandshuk, Lyngvig, Lodbjerg, Skagen I and II, the Danish lighthouses have a theatrical air about them. Rubjerg Knude has all the 'unreality' of a backdrop in a video game.

It was once a 60m cliff, with a lighthouse on top and everything that goes with it. With the help of the wind, the sand used it as a framework for raising a dune, which today stands 90m high! Its whirling motion has left a crater around the lighthouse, which is almost a burrow. With a beauty that is both enchanting and dramatic, it is on the way to becoming completely choked up by the sand – and some of the outbuildings have already been swallowed up. Blinded, the tower has been declared unfit for service and was transformed into a museum and cafeteria in 1968; these facilities also had to be closed in 2002. The museum has been moved a few kilometres from here as the dune, as ogre-like as Pyla in Arcachon, moves forward a metre a year. This site is situated near Lønstrup, to the north-west of Jutland, a peninsula that harbours the brackish inland sea of the North Baltic.

⟨60⟩ STORA SVANGEN
SWEDEN | Bohuslän

From Gothenburg to Norway, Sweden unravels itself in peninsulas and islands along the Strait of Skagerrak, a major maritime passage, which enables communication between the North Sea and the Baltic. The coastal hamlets that have sprung up here all owe something to the comings and goings of the herring in the surrounding area. This strip of the coast is known as the Bohuslän.

Svangen is a totally desolate, arid islet, rounded off by the last great Ice Age. The dangers of this west coast were signalled by scores of often modest lighthouses, like this one, associated with a pretty keepers' house.

In 2003 the Swedish lighthouse company introduced an 'international lighthouse day' and by 2006 it had enabled 62 lighthouses to open their doors to over 5000 visitors. An idea worth trying elsewhere...

SYLTE FYR
NORWAY

6m | White, red and green sectors | Site accessible

In Norway too, the glaciers have forged the shape of the land, sculpting very abrupt fjords and chiselling out sumptuous lakes. One of the caves along this coastline has been flooded by the Norwegian Sea, and the Syltefjord (also referred to as Nordfjord on some maps) is situated on the south-west coast, between Bergen (in the south) and Ålesund, two famous fishing ports. On the surface of the water, the lighthouse at Sylte, a former fishing village, shows off its stylish wooden weatherboarding in what is a fabulous setting. The Norwegian version of the Canadian Pepper Pot! This use of wood is rather logical since it is an abundant resource here. Norway maintains a rich variety of some 150 lighthouses, over 40 of which are open to the public.

ÖNDVERDARNES, ÓSHÓLAR AND SAUDANES
ICELAND
Sites accessible

In the confines of the icy Arctic Ocean and the polar circle, Iceland is a volcanic island composed primarily of basalt, whose coastal profile is occasionally altered by eruptions. The west and, above all, the north are gashed by fjords. Here, whether it is round, square or oblong, the important thing is that the lighthouse stands out well in a landscape of dogs and wolves, covered in snow and bathed in mist or storms. This is where the warm sunset shades of yellow and red stem from. Similarly this is also why there is an armada of concrete sheds and metal turrets capped with disproportionate-sized lanterns in vibrant colours.

62 Öndverdarnes (1973) is located at the end of the Snaefells peninsula (where the volcano gives access to the centre of the earth – re-read Jules Verne if you have any doubts). At 5m high and slightly 'myopic', it emits a white flash just 11m above sea level.

63 The light of Óshólar (1937) reaches 30m despite being just 6.4m high. It just goes to show that, perched on the highest shoulders there are, you can see as far as 15 miles. This flashing light dispenses a white or red light according to the direction from the southern bank of the Ísafjördur, near Bolungarvík.

64 Saudanes (1934), near Siglufjördur, is a former Mecca for the herring salting. The oldest of the group, mounted onto a keepers' house, this structure measures 10.5m. It too has a white and red light with a focal plane of 37m and a light range of 16 miles.

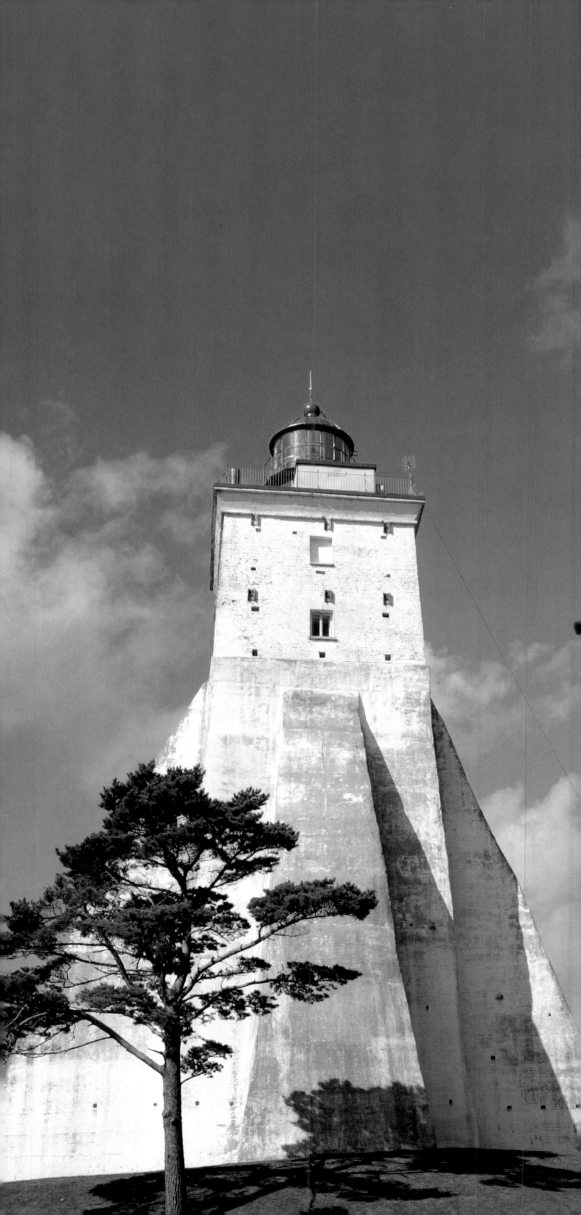

 65

KÖPU

ESTONIA | Hiiumaa Island

1531 | 36m | White flashes | Visit

This massive lighthouse has reigned for nearly 500 years over Hiiumaa Island, the Khiouma of the French, which others refer to as Dagö or Dagerort. Estonia and its islands are highly strategic at the entrance to the gulf of Finland, and indeed they endured various occupations up to the dismantling of the USSR. This very small maritime state has no less than 61 lighthouses.

The Köpu peninsula juts out into the Baltic Sea. Its lighthouse was created in line with the wishes of Hanse, a merchant association of northern Europe, to reduce the number of shipwrecks and to block piracy.

The hill that it crowns improves its focal plane (102m) and its range (26 miles) – but it did take 26 years to build. The square, limestone tower is supported by four enormous buttresses. These correspond with the former height of the tower, raised and equipped with a lantern in around 1845, and ending in a terrace. The oldest of the Baltic lighthouses, it is also the third oldest structure of this kind in the world. It nearly succumbed in the 1980s to a coating of oil-based paint: preventing the stone from breathing, this would have brought about an efflorescence of mould.

KABOTAZHNAYA
RUSSIA | Baltic

Date unknown | 29m | Glistening red light | Site accessible

This alignment lighthouse guides the access of vessels to the military port of Kronstadt, founded on the order of Peter the Great at the start of the eighteenth century on the island of Kotline, at the bottom of Finland Bay. Measuring 10km long and around 3km wide, Kotline seals off and defends the maritime entry to St Petersburg, set 20 miles back. In these highly strategic surroundings, the islands, some of them artificial, are bristling with forts.

The lighthouse was built on a quay (the Petrovskaya Pristan), at the edge of one of the two canals linking the three ports of Kronstadt and traversing the town. The steel framework of this square and slightly truncated tower is equipped with a lantern and balcony and clad in wood. As regards the alignment, it is painted red, save for the vertical black line in its centre.

(67) ROSTRALE COLUMN
RUSSIA | St Petersburg

1811 | 32m | Inactive | Site accessible

There are in fact two of these columns, Doric and crimson, installed on the tip of Vasilievski Island, near a Greek-style naval museum. The Neva, which has its delta here, becomes intertwined with the island prior to disappearing into Finland Bay.

These twin stone columns are said to be 'rostral', as they're decorated by the copper prows of ships. Designed by the French architect Thomas de Thomon, it imitates the Roman usage of such buildings as monuments to celebrate a naval victory, exposing the cutwaters of sunken enemy ships. In olden days their lights illuminated the route of vessels like big gaslights at this point of ramification of the Neva. Their flame is rekindled for special occasions. The official logo of St Petersburg incorporates the outline of a column.

SELENGA
RUSSIA | Lake Baïkal

Siberia is of course part of Asia and not Europe. This inadmissible 'infringement of geography' is only justified for ease of reading.

Try to imagine a stretch of freshwater measuring 636km long. It does exist. Lake Baïkal is the oldest and deepest lake in the world (1637m), and has been registered as a Unesco heritage site since 1996.

Between 300 and 400 water courses flow into it! The Selenga River, the equivalent of the Loire, is the largest of these. Its magnificent delta branches 150km from Oulan-Oude. It is here that you can find this makeshift, but pretty, pyramid-shaped lighthouse with its wooden lathes crowned by a small lantern. Lake Baïkal has the feel of a real inland sea and, as a result, there are many navigation aids here.

ASIA

LÉANDER TOWER
TURKEY | Istanbul
Twelfth to nineteenth centuries | Inactive | Restaurant

It is rather tricky to date this lighthouse with its indecisive style. A defensive tower was mounted on this reef, at the entrance to the Bosphorus from 1110, under the reign of Manuel Comnène. The current building (1719), victim of an earthquake and some fires, has been revised on various occasions.

This multi-service establishment (prison, lighthouse, lazaretto, toll gate, a platform from which you can fire a cannon to celebrate the arrival of a new sultan, etc) has become famous since its appearance alongside James Bond in the film *The World Is Not Enough.*

Its name came about from a hero of Greek mythology, Léander. He swam each night to his mistress Hero, who, enclosed in this tower, guided him with a lantern; one night, the storm snuffed out the lantern and Léander drowned. However, the Turks who named this lighthouse the Kiz Kulesi (tower of the young woman) have another version of events: the young lady was locked up in the tower by her father, the king, to save her from a snakebite. The reptile slipped into a basket of grapes sent to her by her lover and the beautiful girl passed away; a merciless fate. Another story doing the rounds is a mixture involving a girl, treasure and a messenger. Restored after 1992 and equipped with a decorative light, this lighthouse has been transformed into a restaurant-cafeteria. Boat trips set out from Ortaköy and Salacak Üsküdar. From the lighthouse's terrace, you can see the Sea of Marmara, Seraglio Point and the Bosphorus.

② AHYRKAPI
TURKEY | Istanbul
1857 | 29m | White flashes

Between Europe and Asia, 37 navigation aids mark out the approaches to Istanbul; 19 concern the Bosphorus, the motorway between the Sea of Marmara and the Black Sea. On the west bank of the straight, this lighthouse guides vessels coming from the Sea of Marmara.

An initial light signal was established in 1755, following the shipwreck one stormy night of a vessel laden with merchandise bound for Egypt. The story spread like wildfire: Osman III and his Grand Vizir came to assist in the rescue, and the sultan ordered the area to be illuminated.

This lighthouse is of French construction. At the end of the Crimean War (1854–5), two marine officers, Marius Michel and Camille Colas, obtained concessions for the Ottoman lighthouses: in exchange for the construction of buildings, their company was entitled to collect the lighthouse rights throughout the empire and share it with the Ottoman government. A lucrative contract, which was only denounced in 1935 by Atatürk; the majority of the 400 or so lighthouses in Turkey were built in this way.

This conical tower is the second tallest in Turkey. A keeper remains here and the light is turned on at 1730 and turned off at 0630 hours. Until 1994, its keepers were always from the Link, a dynasty whose longevity in this post is incomparable.

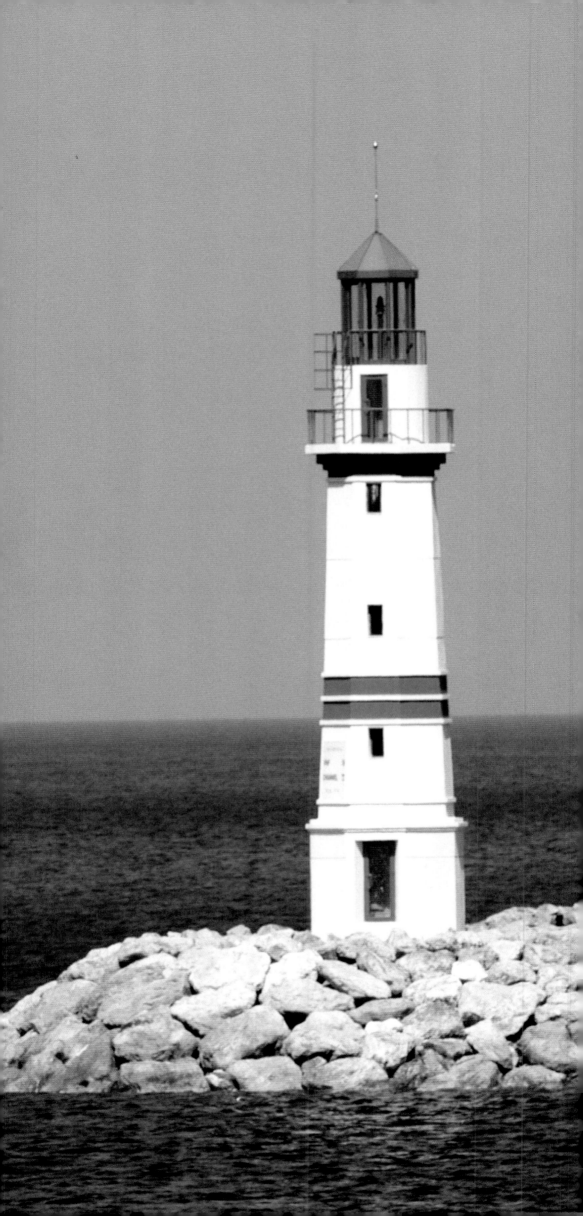

TURGUTREIS
TURKEY

2003 | 17m | Red light | Site accessible

This young and photogenic hexagonal port light forms the end of the breakwater protecting Turgutreis marina, to the west of the Bodrum peninsula, a fashionable resort on the Aegean Sea. Its half brother (green marking) occupies the head of an inland, perpendicular jetty. They were created at the same time as the marina, in the shelter of the Meltemi wind, which especially likes to blow in the summer between the Aegean coast and the Dodecanese islands, such as Kos, picking up a choppy sea.

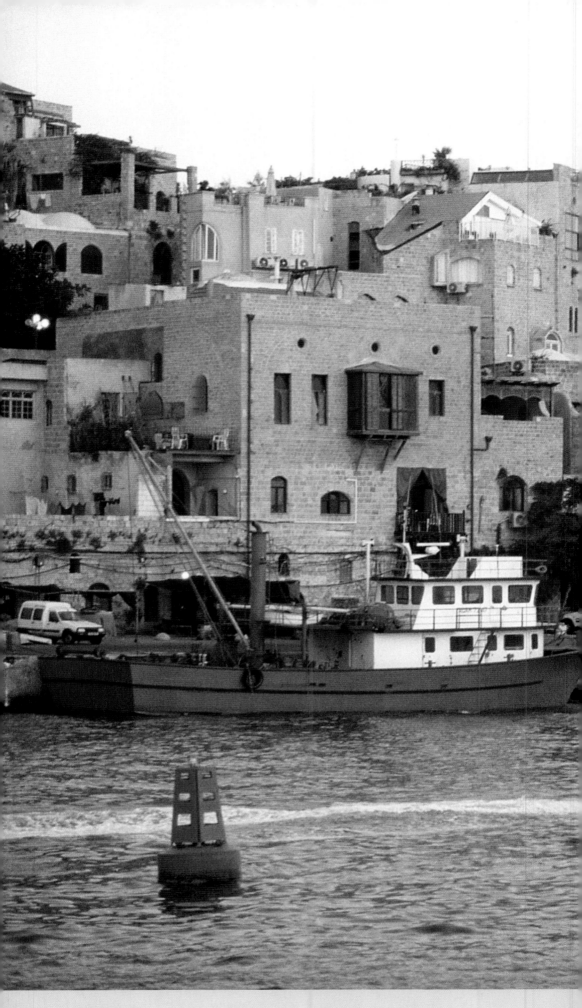

(4) JAFFA
ISRAEL

Jaffa, an old port city, has been attached to Tel Aviv since 1948 and is adjacent to it. Today it is just a fishing port and a marina as its neighbour has robbed it of its commercial traffic.
This circular concrete tower, reinforced by buttresses, emerges from a pile of constructions tumbling down towards the Mediterranean. It seems to have been restored fairly recently and, although logic would suggest dating it from the British mandate over Palestine (1920–48),

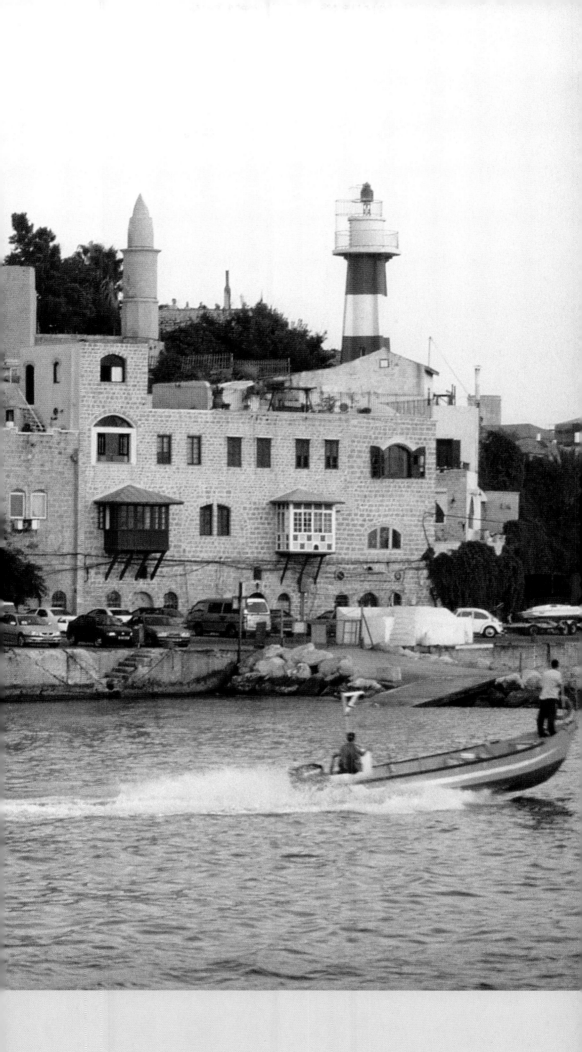

its parentage is attributed to a French company. However, it is possible that the latter was in fact built after an earlier light, in around 1865 or 1875.

At the northern entrance to the port, a chaos of rocks is revealed on the surface. According to Greek legend, having deemed that its beauty exceeded that of the marine divinities (the Nereids), Andromeda was attached to one of them and handed over to a marine monster sent by Poseidon; fortunately, Perseus set her free.

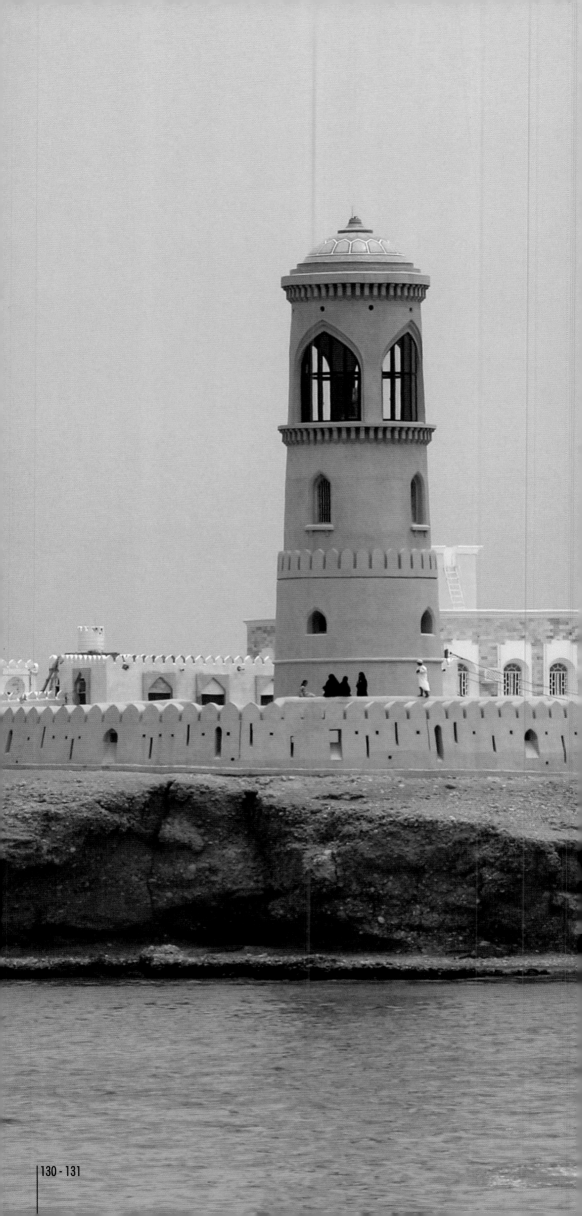

⑤ SOUR
OMAN

10–11m | White flashes | Site accessible

The sultanate of Oman, a waterside resident in the Strait of Hormuz, seals off the south-east corner of the Arabic peninsula, between the Red Sea, the Persian Gulf and the Gulf of Oman. It has been a very long time since this region was a nerve centre for trade via the sea. Oman was a maritime empire until the opening of the Suez Canal, which was to unleash European competition. Then it was amber, ivory, arms, incense, horses, slaves, silks and spices; today it is petrol.

Sour, at the entrance to the Gulf of Oman, was familiar to Marco Polo. The port evokes the golden age of Arabic exchanges with eastern Africa (Madagascar and Zanzibar where the sultanate was to transport everything, including its capital, in 1856), the Indian subcontinent and China. Pushed by monsoon winds, the dhows of the followers of Sinbad the Sailor – said to originate from Sour, the epicentre of naval construction – explored the Indian Ocean from here. The area revived tales by Henry de Monfreid toc.

Its citadel lighthouse demonstrates an architectonic decoration worthy of a *Thousand and One Nights*. On a rocky spur, two lookout towers (not visible), from or inspired by a Portuguese fort, complement each other.

⑥ FORT AGUADA
INDIA | Goa

1864 | 13m | Inactive | Site accessible

Vegetation has taken over this Portuguese tower, which is unusual in that the beginning of a spiral staircase links the balcony and the lantern. It was only retired from service in 1976. The building was set up in opposition to another Lusitanian fort (1612), built to protect Goa and prevent access to the Mandovi River estuary by the Dutch as much as the pirates. Its name, which can be roughly translated as 'water', is so called because it is fed by several sources and equipped with tanks, which supplied vessels stopping over in Goa. Part of the building is now a prison.

On the west coast, bathed by the Sea of Oman, Goa is the former capital of the Portuguese Indies. The Portuguese ungraciously made it their last trading post in 1961. Some years later the beaches of Goa saw some strange invaders flock to their shores in the shape of hoards of hippies, who were as hirsute as they were pacifist.

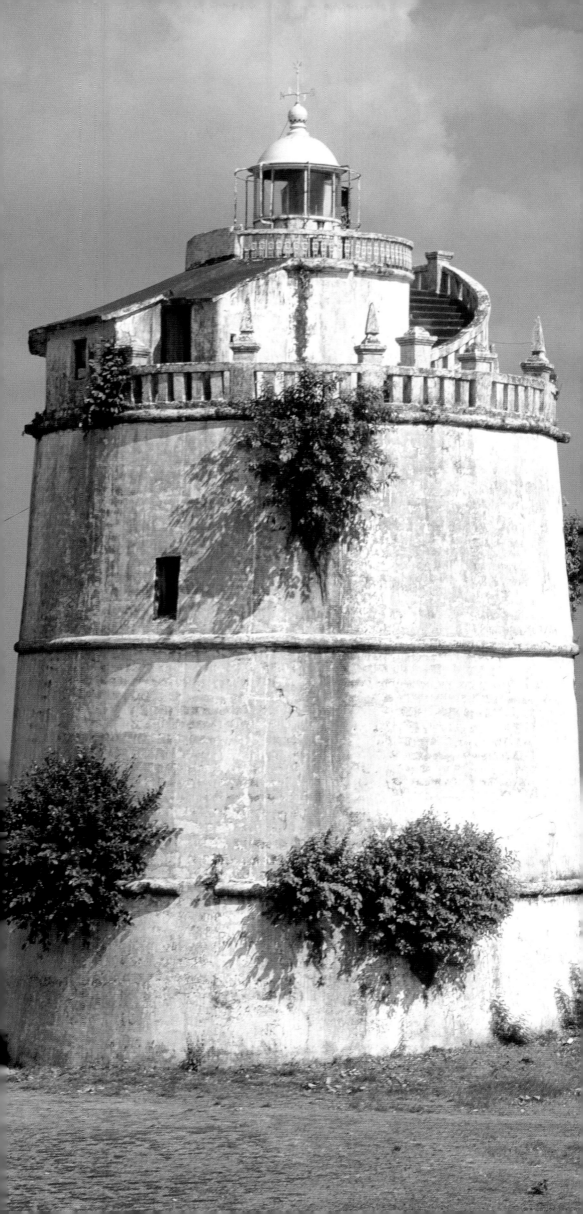

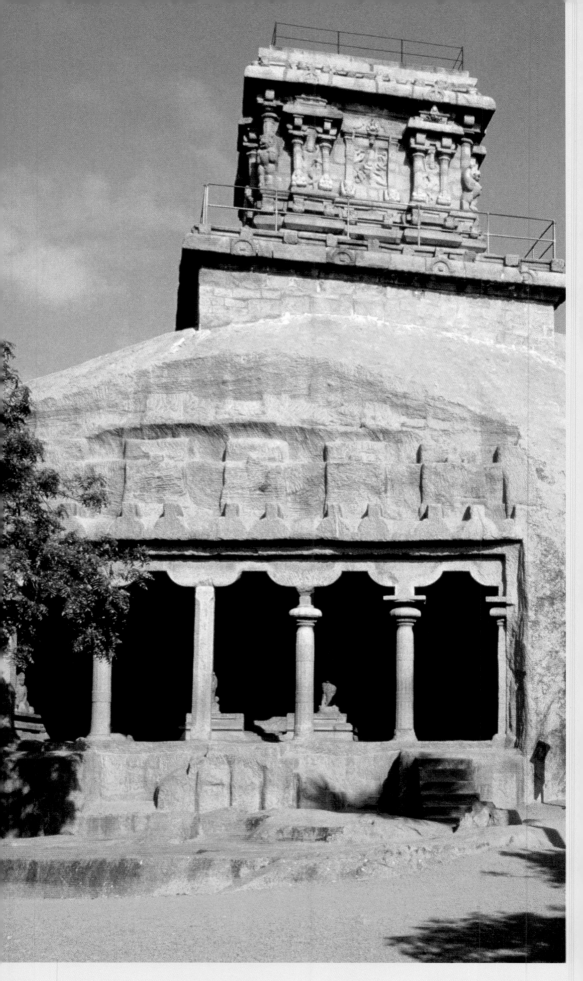

MAMALLAPURAM
INDIA

1900 | 26m | White flashes | Guided tour

Mamallapuram or Mahabalipuram is known for its granite monoliths, sculpted from low landforms (seventh to eighth centuries) and excavated to serve as temples under the reign of the Pallava dynasty. Very early on in history, the Indians burnt stakes at the summit of the most imposing sanctuary, Olakkaneeswara (above) or 'God with the flashing eyes', to guide the boats into port. The English mounted a lantern here in 1887. The structure, which retained its balcony, only functioned for three years before the new lighthouse was opened, just in front of the temple.

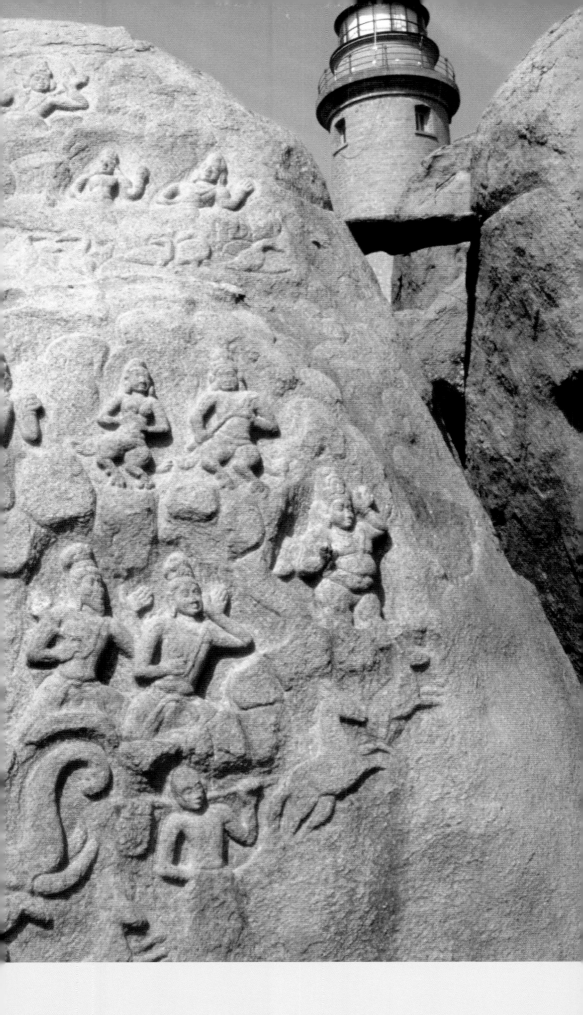

This stone tower, electrified in 1994, slipped into a fault in the rock formation, and the embellished fresco 'The descent of the Ganges' occurs on two rocks (27m by 9m) and pictures the river and its inhabitants from its source in the Himalayas. The site was registered as part of Unesco world heritage in 1984. In a region really put to the test by the tsunami of 2004, the structure only suffered minor damage.

The old port of Mamallapuram is situated 60km to the south of Madras.

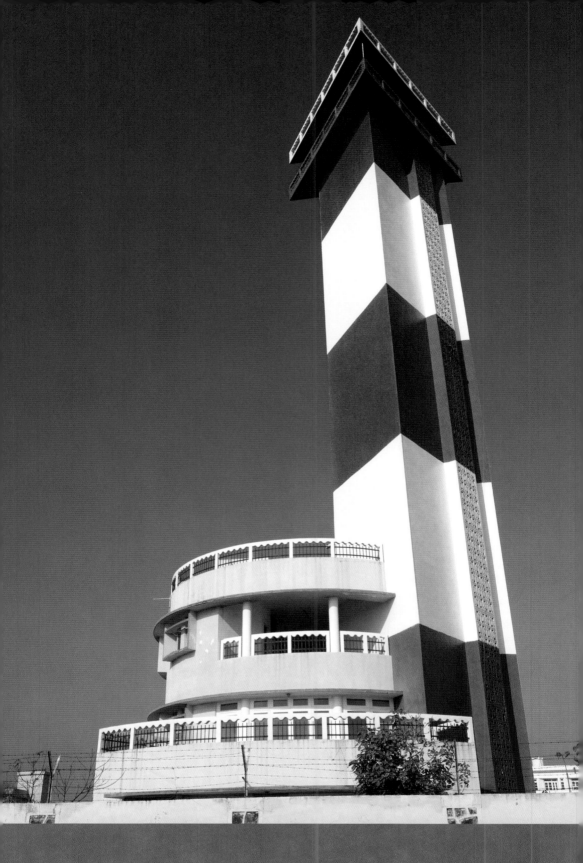

⑨ MARINA BEACH
INDIA | Chennai
1977 | 46m | White flashes |
Site accessible

Madras was renamed Chennai in 1996. To the south-west of the Bay of Bengal, the megalopolis of southern India reigns over the Coromandel coast, which was fought over so bitterly in times gone by between France, England and Holland, increasing the number of trading posts here. Madras, under British influence and the French enclave of Pondichéry, further to the south, were the main ports.
From 1796, the officers' mess at Fort George was capped with a light. One tower was heightened in 1844, then a lantern was mounted on the Haute-Cour in 1894. This lighthouse, the most recent addition to Chennai, punctuates one of the longest urban beaches in the world: Marina Beach stretches for 13km! On the coastal side the lighthouse forms a red and white triangle of concrete with two balconies. It is equipped with a lift and there is a three-floor rotunda to house the harbourmaster's office.
Since the 1960s and 1970s, India's economic fervour has been accompanied by the construction of scores of new lighthouses. In contrast, the most modern lighthouse in France dates from 1978. It is located at Fos-sur-Mer (Saint Gervais).

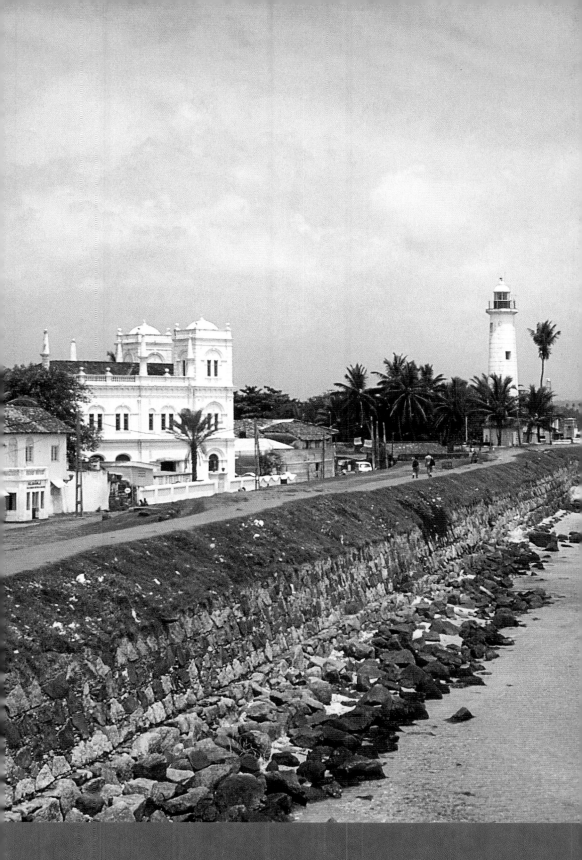

 # GALLE FORT
SRI LANKA

1939 | 26m | White flashes | Site accessible

Galle, to the extreme south-west of the island, is the oldest port in the former Ceylon and was also the largest until it was superseded by Colombo. On the spice route, well known for its Arab merchants, the strategic appeal of the island whetted many appetites. As a result, Galle was alternately Portuguese (1587), then Dutch (1640) and finally British (1796) until independence in 1947.

Galle Fort is the product of this 'colonial alluviation', each nation adding its influence to the construction. The site, registered as Unesco heritage, stretches over 36 hectares. Besides the lighthouse, it encompasses two museums (including a maritime one), a clock tower, some churches and mosques, as well as hundreds of dwellings.

The lighthouse stands at a corner of the fort on a bastion, not far from a cathedral-like mosque. Two rows of vertical embossing decorate the ridges of the hexagonal base of this conical cast iron tower. Its main tower section is ringed and the lantern embellished by a rutilant collar at balcony level. This building replaces another (1848), ravaged by a fire in 1934. It overlooks the access channel to the port.

During the 2004 tsunami, the Galle fortifications prevented far worse damage to the city.

CORREGIDOR II
PHILIPPINES

1950 | 14.5m | White flashes | Visit

The Philippines form a swarm of over 7000 islands. The south-east Asian archipelago passed through the hands of the Spanish, the Americans and the Japanese prior to gaining independence in 1946. The current lighthouse is too young (1950) to have experienced these historic events. It is nevertheless a product of them and it seems to provide an architectural synthesis. The Spanish and Japanese have largely contributed to its recent restoration and, since this photo, the lighthouse has been raised in height, as well as gaining a new lantern and a second balcony.

Corregidor is an ideal islet for keeping watch over Manila Bay. The first Spanish establishment (1836), revamped and improved at the end of the nineteenth century, didn't escape the terrible fighting that brought it into conflict during the Pacific War with the Americans; the structure had to be knocked down and replaced by one of a similar design.

The octagonal tower is centred on the fanned roof of the keepers' accommodation, which assumes the shape of a 12-sided rotunda. The whole structure is made of reclaimed stone from the previous lighthouse. The walls of the tower are pierced by four cross-shaped windows, which are illuminated at night. The height above sea level is exceptional: 193m.

 GUIA
MACAO

1865 | 15m | Site accessible

Macao comprises two islands and a peninsula in the South China Sea, populated by over 500 000 inhabitants. In 1999, China regained its sovereignty over a region that was a slave to the Portuguese from the middle of the sixteenth century and one that asserted itself as the hub of trade between China and Japan. In the nineteenth century, the growth of Hong Kong cast a shadow over this estuary port, beset by chronic silting up which curbed the intensive dredging of its channels. Since 1849, this cradle of international trade has been a free port.
The oldest lighthouse in Southern China, this building was almost lost. Seriously damaged by a typhoon in 1874, the lighthouse wasn't opened again until 1910, after being electrified. Perched on the highest hill in Macao, Guia, it forms part of a fort whose construction was started in 1622 amidst fears of a Dutch attack. Adjoining a Baroque chapel, the tower tapers, going from a diameter of 7m to 5m. A balcony has been added to it along with an observation platform surmounted by a lantern, access to which is gained via a spiral staircase. Yellow stone volutes frame the door, and these, like the windows, are embellished by graceful pediments. Its light is visible for up to 16 miles.
Macao has adopted the geographical co-ordinates of the position of its lighthouse: 113° 32' East, 21° 11' North.

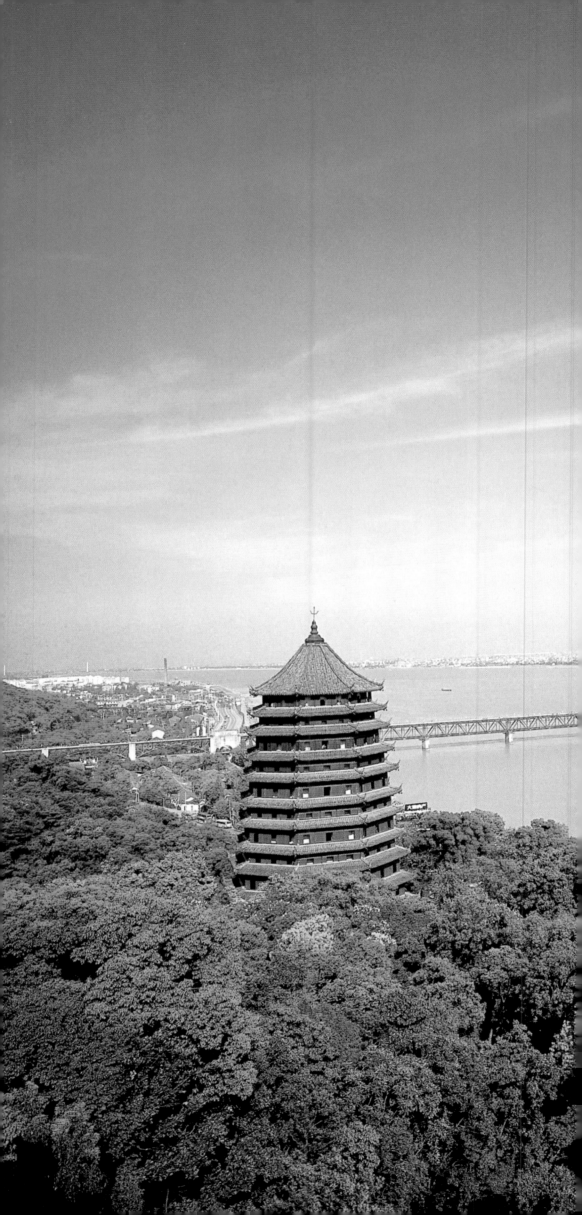

LIUHE TA
CHINA | Hangzhou

Around 1152 | 60m | Inactive | Visit

Since at least the year 970, a pagoda-lighthouse has dominated the River Qiantang, which flows into the deep Hangzhou Bay. It was designed to appease the tidal wave, a great disrupter of navigation, thanks to the balance of six Buddhist harmonies (Liuhe Ta) from which its name is derived: the earth, the skies and the four cardinal points. Oral tradition has had the time to embellish some fine stories, attributing it to an architect king or dragon, or to a young man, Liuhe, who bitterly struggled with the God of the Tides for the life of his father, a fisherman. The general outline of the building, rebuilt or renovated on several occasions, dates from the seventh century. The corbelled construction of its 13 wood and brick floors are wonderful, but six cornices are false and there are actually only seven floors inside the structure. To the south-west of Shanghai, Hangzhou, at the heart of the 'silk country', was the capital of the southern Song dynasty (1127–1276), which created a large economic, political and cultural centre. The tower tells of their refinement.

Other pagoda-lighthouses remain, such as those of Mahota (Shanghai) and Jingxin (Wenzhou).

XIAMEN
CHINA

This structure is located in Xiamen, opposite Taiwan. A sampan, a couple of bold coloured port lights and some large buildings in the background are symbolic of the contrasting images of a wakened China. Some 250 000 inhabitants in 1985, 700 000 in 2001, 2 million just a moment ago... Xiamen port has prospered since it opened up to international trade in the 1980s.

A port dealing in tea, silk and porcelain of course, from the time where the Europeans referred to it as Amoy, this region was particularly renowned as the nerve centre of the opium trade, and it was one of the first ports forcibly handed over to western appetites by the Nankin Treaty (1842). Today, Xiamen attracts entrepreneurs and buccaneers from world finance. Once a year a vast International Investment and Business Show is held here.

ENOSHIMA
JAPAN

2003 | 60m | White flashes | Visit

France has 3200km of coastline, while Japan has a staggering nine times more (28 000km), which is positively studded with lighthouses. Contrasting with numerous structures that are severely lacking in architectural artistry, there are some splendid modernist structures springing up, like the maritime tower in Yokohama or the Enoshima lighthouse. From the top of the latter you can see way out into Sagami Bay, across Mount Fuji and to the south-east of the conurbation of Tokyo. Strewn with very popular Buddhist and Shintoist temples, the small island of Enoshima is attached to the mainland by a small 600m footbridge.

This tubular steel 'corset' sits imposingly in the centre of a beautiful botanical garden created in 1880 by an Irish trader, Samuel Cocking. In 2003 it replaced a rather graceful lighthouse that dated from the beginning of the twentieth century. Like its predecessor, this one is decorated with an external staircase and at night it has rather fancy illuminations.

OCEANIA

① CAPE LEEUWIN
AUSTRALIA | Augusta

1896 | 39m | White flashes | Guided tour

Leeuwin is the most discrete of three legendary capes, which mark the boundaries of a circumnavigation of the globe. This lighthouse stands to the south-west of Western Australia near Augusta. Here, at the junction between the Indian and Southern Oceans, waves engage in a merciless battle. Solemn in appearance, and one of the largest lighthouses in Australia, this structure referees the fascinating spectacle and keeps boats, which can spot its light up to 26 miles away, away from the coast.

Built to satisfy the safety needs of shipping related to the local wood industry, this seven-floor limestone tower was designed by William Douglass, designer of the Fastnet lighthouse (p. 74) in Ireland. It still retains its original English lens apparatus (Chance Brothers). Until electrification in 1982, it was fuelled by kerosene burners and manoeuvred manually by means of a clock mechanism.

The site is managed by an association, Augusta and Margaret River Tourism. Its conversion into a museum with tourist accommodation in the keepers' houses (not visible) is planned. Though calcified by the hard water, a hydraulic wooden wheel still remains; the remnants of a clever system of water conveyance created by the lighthouse builders, which served the keepers well. A reception centre and various commercial facilities have been created, and Cape Leeuwin is a privileged area from which to observe whales from June to August.

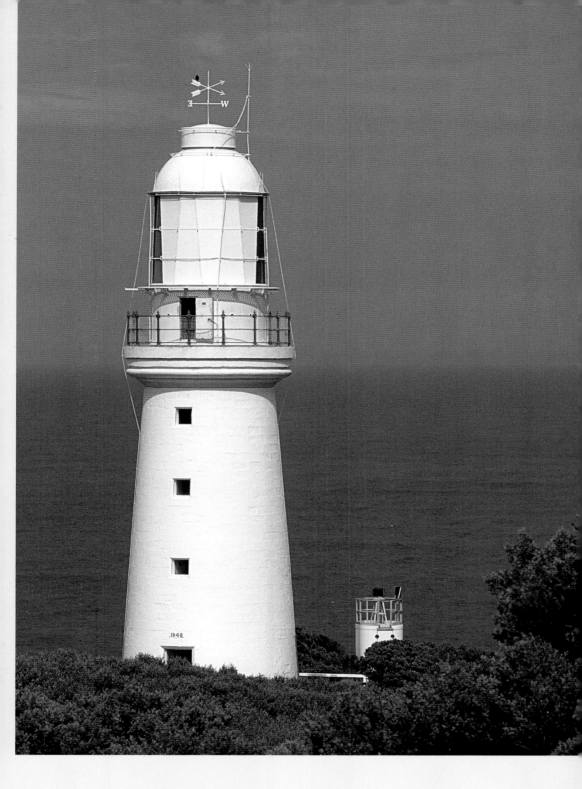

(2) CAPE OTWAY
AUSTRALIA | Victoria

1848 | 20m | Inactive | Guided tour | Night stay

Cape Otway lighthouse, to the south-west of Australia, is the second oldest light on the mainland. Doubtless the sight of it comforted emigrants as, after a long, tough voyage via the Cape of Good Hope, it would have announced Melbourne and its sheltered port. There was still the Bass Strait to negotiate however, which separates the immense island from Tasmania.

This particular lighthouse, erected on a 100m cliff, and that of Cape Wickham (1861, King Island, Tasmania) are the sentinels to the western entrance of this arm of sea where the Indian and Pacific Oceans confront one another in a gap measuring just 84km. A shipwreck naturally led to the commissioning of its construction and several other buildings, including that of Cape Wickham which is still active. The disaster occurred in 1845, on the reefs of King Island, carrying 370 emigrants away in the waves, as well as the crew. Ten years earlier, over 200 prisoners and their children also perished here.

The keepers and their families had to live with the isolation and the biennial supply for a considerable time; a road suitable for motor vehicles was only laid in 1937. The light was extinguished in 1994 and was replaced by a solar powered lantern. Various local sandstone service buildings still remain, such as the main keepers' house (1857), now available for overnight rental. The auxiliaries' house (1858) has also been preserved. The telegraph station (1859), justified by the increase in maritime traffic, is a reminder that the first underwater cable in Australia was installed here between Otway and Launceston (Tasmania).

③ LOW HEAD POINT
AUSTRALIA | Tasmania
1833 | 19m | White flashes + fixed red light | Site accessible

This structure stands on the north coast of Tasmania. To accelerate the development of Launceston, in 1805 a port at the far end of the estuary, a piloting and a signal station were built here, followed by a lighthouse at the mouth of the River Tamar in 1833. Van Diemen's Land, as this island is referred to, was a penitentiary colony, and convicts were consequently invited to break the stones for it and then build the tower. Once the light was illuminated, two convicts were in charge of assisting the keeper, though they were tied up at night. You can imagine that the flaws in this plan were numerous and that the lighthouse was badly maintained. Sure enough, in 1888 its state of disrepair motivated its demolition.

The same year, a more solid, conical tower, built with two layers of bricks, rose up out of the earth. It has been decorated with a red circle since 1926 and this detail is repeated at the edge of its base. Since 1898, a secondary light illuminates the Hebe reefs, whose name is derived from a vessel that broke up here in 1808. The structure was electrified in 1940.

Today, buildings from different periods still remain, like that of the pilot station, which is predated only by a structure in Sydney. One of these buildings has been turned into a maritime museum, and four small houses can be rented out for the night. From the ancient generator shelter emerges a foghorn, which was in operation from 1929 to 1973; every Sunday at noon the horn is sounded by way of demonstration.

④ CAPE BYRON
AUSTRALIA | New South Wales
1901 | 22m | White flashes + fixed red light | Guided tour | Night stay

Australia, the largest island on the globe, is the size of a continent and 14 times bigger than France. In general, its coast is not terribly ragged and is of a modest altitude. With its Great Dividing Range leaving only a narrow strip of coast down Australia's south-east corner, New South Wales is distinctive.

Some 170km south of Brisbane facing the Tasman Sea, Cape Byron is the most eastern tip of the country. Its name pays homage to the English sailor John Byron, grandfather to the poet. This lighthouse houses the most powerful light in Australia. It was designed by Charles Harding in the ornamental colonial style of his master, James Barnet, a native of Scotland. This celebrated colonial architect from New South Wales designed a number of lighthouses. The tower and the keepers' accommodation, which resemble a Victorian castle, are made from cement casts manufactured on site.

Positioned 118m above sea level, its main light carries some 27 miles while its secondary red light illuminates the reefs. The first-order dioptric lens, rotating in its tank of mercury, is original. A rarity in Australia, this lens was manufactured in France (Henri Lepaute). The process of generating short flashes, while revolutionary, was in full development.

Two auxiliary keepers' houses can be rented out for the night here.

⑤ WAIPAPA
NEW ZEALAND
1884 | 13m | White flashes | Site accessible

To the east of Australia, two islands – one to the north referred to as 'smoky' in reference to the volcanic fumaroles, and one to the south known as 'Jade' – form the bulk of New Zealand. Here we have South Island. At its southernmost point, this stylish coastal light marks the southeast entrance to the Foveaux Strait, which separates it from Steward Island. It was opened three years after the worst sea disaster New Zealand had ever known. A total of 131 passengers and crew members from the steamship *Tararua*, appointed to work on the regular Otago-Melbourne line, lost their lives here; half the bodies were buried in this area, near Invercargill. Hexagonal in shape and of Victorian inspiration, it is one of the last two wooden lighthouses built in the nineteenth century. Its contemporary, visible in Kaipara (1884, North Island), was taken out of operation in 1957. That of Akaora (1880, South Island) belongs to the same type; it was taken out of service in 1980 and moved to the sea front to make it easier to visit. Those wooden structures that have resisted the storms are rare.

In days gone by, Waipapa had three houses for the keepers and their families. Automated in 1976, the lighthouse was converted to the use of solar energy in 1988. It is worth a mention here that New Zealand was probably the first country to have officially appointed a woman (Mary Jane Bennett) to a keepers' position in 1858, in what was also the country's first lighthouse, Pencarrow (Wellington).

CASTLE POINT
NEW ZEALAND

1913 | 23m | White flashes |
Site accessible

The New Zealand coast is often high and irregular and has a host of isolated and inaccessible lighthouses. However, this isn't the case here, where the structure was built close to a small town, to the south-east of North Island. The school and various convenience stores give this station, nicknamed 'Holiday Light', a coveted position. In 1922, the main keeper fell from the top of the tower while installing the telephone; his ghost was reluctant to leave the premises for several years.

The lighthouse stands on a rocky spur, 65km to the east of Masterton. Its light has a range of 19 miles, guiding the vessels coming from America or the Panama Canal and directing them towards Wellington. Its truncated cast iron framework was the last one to be prefabricated in Great Britain. Its electrification was performed in two stages: initially through the installation of a diesel generator (1954), then the connection to the general grid (1961). It hasn't housed a keeper since 1988.

⑦ KILAUEA
USA | Hawaii

1913 | 16m | Inactive | Site accessible

This archipelago in the centre of the North Pacific, annexed in 1898, is home to the most modern lighthouse in the North American States (1959). Built on the northernmost populated island (Kauai) and inactive since 1976, this reinforced concrete lighthouse marks the Hawaii landings on the route to the Orient. Its promontory, yielded for a symbolic sum by a sugar company, was hard to access. The supplying of the site was by a flotilla of craft unloaded with a derrick (a simple crane). Its second-order Fresnel lens (still in place today) was delivered with some tricky assembly instructions written in French. On the day of its opening ceremony, the local population was invited to a banquet on the site and to fish for shark: in the guise of bait, a cow's carcass was deposited at sea!

This lighthouse is celebrated for saving the lives of two aviators in 1927, who were attempting the first trans-Pacific flight by the American army. Maitland and Hegenberger had a broken radio and were low on fuel, lost in the Pacific vastness; however, they were fortunate enough to spot its light just as day began to dawn.

The Kilauea Point National Wildlife Refuge, in the boundaries of which this reinforced concrete lighthouse is located, raised funds through the sale of personalised bricks, in order to finance its restoration. Three keepers' houses also remain.

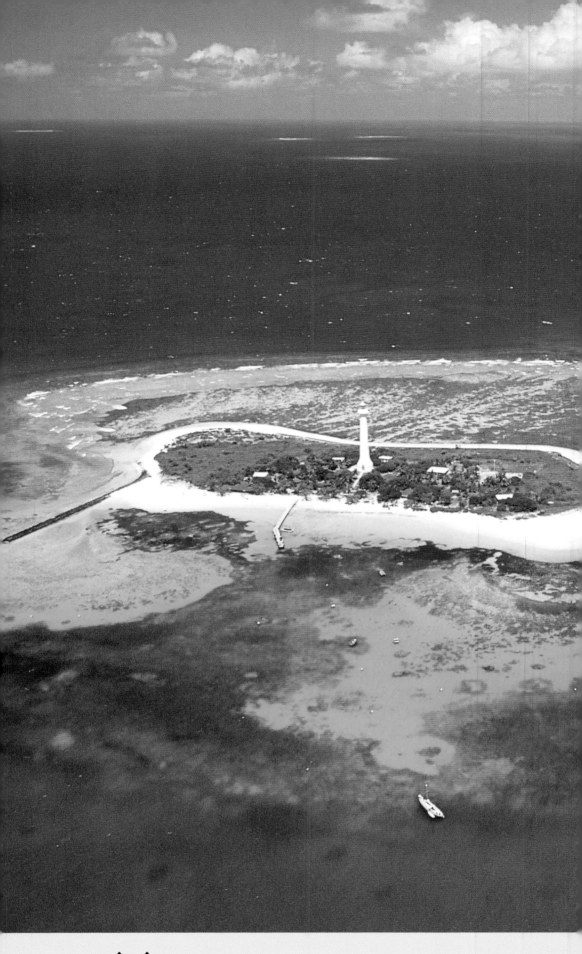

⑧ AMÉDÉE ISLAND
FRANCE | New Caledonia

1865 | 55m | White flashes | Guided tour

Discovered and named by Cook, French-owned New Caledonia is surrounded by coral reefs. The fantastic mining resources of this island (nickel especially), which formerly housed a penitentiary colony, have generated intense maritime traffic since the nineteenth century. The Amédée lighthouse makes the entrance to the Boulari Pass secure, and this pass provides access to Nouméa harbour some 13 miles away.

For practical reasons, it was decided to prefabricate it in France. According to designs by Léonce Reynaud, Director of Lighthouses and a prolific designer, the Rigolet enterprise (Paris) manufactured the jigsaw of cast iron plates in the space of four months. The lighthouse was

assembled close to the workshops, its rigidity tested, and then dismantled. Some 1200 boxes of separate pieces were embarked at Le Havre, bound for the Antipodes. The small-sized plates were re-bolted to the inside of an independent internal framework, which was also made of metal. Ten months later there was light!

It is one of two or three of the largest metal lighthouses in the world. A total of 247 steps form a delicate staircase, it too made of metal, which leads to a terrace capped with a lantern. Equipped with a first-order lens, and electrified in 1985, it was operated with wind energy until 1994 before switching to photovoltaic energy. Its range exceeds 24 miles. This lighthouse served as a model to its counterpart in the French Roches-Douvres, which was destroyed by the Germans in 1944.

⑨ VENUS POINT
FRANCE | Tahiti | Polynesia
1868 | 33m | White flashes | Site accessible

Between Australia and America, French Polynesia ('numerous islands' in Greek) groups together five archipelagos, with 130 islands and atolls in the South Pacific. Tahiti is the largest strip of land in the Society Islands.

The Venus lighthouse is located to the north of Tahiti Nui, otherwise known as the great figure of eight, which is the shape this member of the Windward Islands traces. This construction was designed by Thomas Stevenson, one of the lighthouse builders from the famous Scottish line; his son, Robert Louis, author of *Treasure Island*, was able to admire it at leisure from the bridge of the schooner *Casco* during his stay in Tahiti in 1888.

This square tower was extended by 7m in 1963. The corner sections in exposed stone, the stylish lookout room and the terrace supported by elegant cantilevers all add to its charm. It would seem that beach rock was used for its construction, a sedimentary rock formed from the debris of shells and coral, and fragments of basalt; the whole thing was joined together by limestone cement. This rock is abundant in French Polynesia.

Point Venus, which is an extension of Matavai Bay and trimmed with black sand, bore witness to the arrival of Wallis, Bougainville and Cook one after the other – the latter observing the passage of the planet Venus in front of the sun here on 3 June 1769.

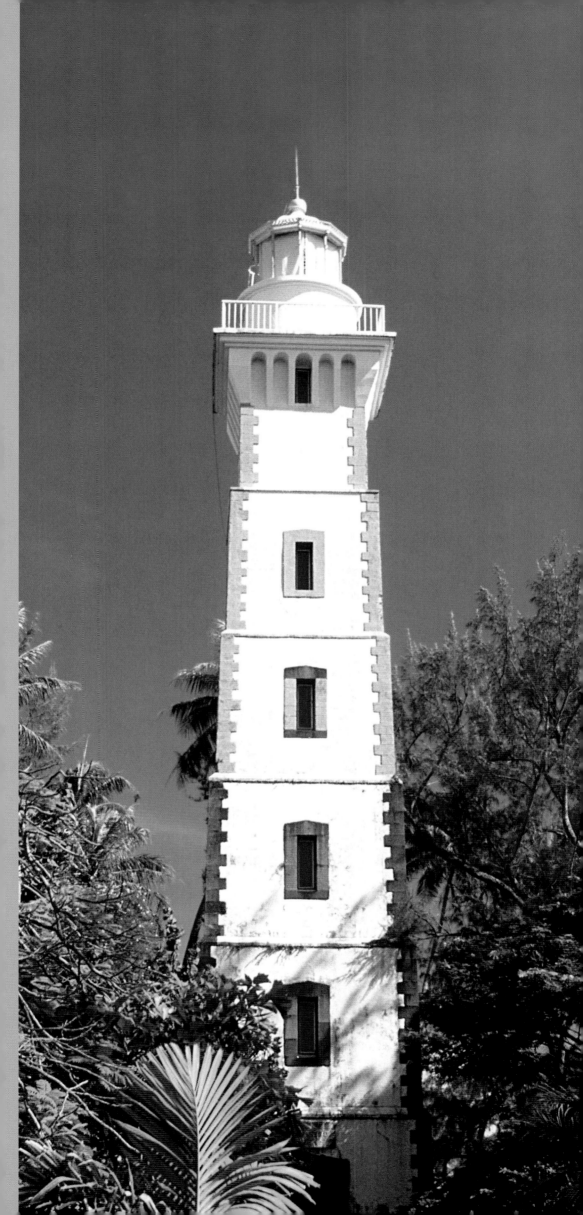

NORTH AMERICA

BROCKTON POINT

CANADA | British Columbia | Vancouver

1915 | 10m | Sparkling white light in the red sector | Site accessible

Contrary to its eponymous island, the harbour town of Vancouver, at the south-east entrance to the Strait of Georgia, is on the mainland. A first light was installed here in 1890 to help with manoeuvres to access the coal port and signal to vessels leaving the First Narrows channel. Its light designates a reef.

The lighthouse is mounted on an arch to enable pedestrians to pass beneath it. Indeed, it is one of the attractions of Stanley Park, the green lung of the local metropolis, which itself has existed since 1886. A coastal road goes right around the park and there is a walk that passes two lighthouses: Brockton Point, at the eastern tip of the park, and its alter ego port, Prospect Point, around 2.5km away.

The legendary North-West passage being (almost) a reality, you may get into the Atlantic to visit Canadian friends in the west from here, without passing via the Panama Canal or the Horn. Wrap up warm though!

(2) FISGARD
CANADA | British Columbia | Victoria
1860 | 14m | White and red sectors | Visit | Museum

So-called British Columbia comprises 2000km of coast watched over by some 40 or so lighthouses, which are often isolated and inaccessible. Measuring 450km long and 80km wide, the mountainous Vancouver Island is no exception. To the south, Victoria is the capital of the island and the province.

This mass of granite and brick making up the tower and adjoining accommodation was erected by the English. Its first keeper, a Welsh man, was contracted 'not to get intoxicated and to always behave appropriately'. For a while, salmon oil, supplied at a low price by the Indians, was totally satisfactory as a fuel.

Fisgard lighthouse is perched on an islet linked to the mainland by a raised causeway, 14km from the town centre. It marks the Royal Roads anchorage and the access to the port of Victoria as well as the western entrance to the port of Esquimalt. It dominates the Strait of Juan de Fuca, which separates Vancouver Island from the American state of Washington. The oldest lighthouse on the west coast, Fisgard was automated in 1929. In the accommodation, a museum recalls the lives of the lighthouse keepers.

③ POINTE AU PÈRE
CANADA | Quebec
1909 | 33m | Inactive since 1975 | Visit | Museum

With its eight pyramid-shaped flying buttresses, this concrete tower looks ready to set off on an intergalactic mission! Its outline is reminiscent of the lighthouse at Estevan Point (Vancouver Island), designed the same year.

This is the third lighthouse to be constructed in this position, close to Rimouski, on the south bank of the Bas-Saint-Laurent. Established in 1859, this station became an important centre for aiding navigation as it was equipped with a pilot station, a quarantine office and a Marconi telegraph tower. In 1914, it bore witness to the largest maritime tragedy to hit Canada: the shipwreck of the liner *Empress of Ireland* claimed over 1000 lives. Its lighting apparatus was upgraded on several occasions until the 1960s, and was finally switched to a framework tower in 1975; this too has been reformed since then.

Today, this structure is still one of the tallest in the country. The keepers' house has been transformed into a sea museum. The tower can be visited (from June to mid-October) and has a breathtaking view, provided that you can tackle the 128 steps that lead to it. Fortunately, the restaurant installed in the former engineer's house cooks up some hearty dishes – including croissant with prawns and seafood chowder.

④ LA MARTRE
CANADA | Quebec
1906 | 19m | White flashes | Visit | Museum

Located in North Gaspésie, overlooking the southern bank of the St Lawrence River estuary, this octagonal wooden pyramid forms the support for an unusual circular cast iron lantern. Canadians usually prefer their lanterns to be more angular.

However, what immediately draws your eye to it is its beautiful red livery, which also decorates the keepers' accommodation. Imagination did not govern the selection of such a conspicuous colour. It would have been hard to choose a better shade for a landscape

gripped by ice or buried under the snow for a minimum of five months a year. The St Lawrence is virtually an inland sea, but the first lighthouse built here in 1876 was totally white.

This establishment is the only non-automated one in Quebec. The rotation of the lens is still powered by the original clockwork mechanism made from cables and weights.

A lighthouse museum has been opened in the keepers' accommodation and the tower is open from June to September.

(5) # CAP DES ROSIERS
CANADA | Quebec

1858 | 34m | Occulting white light | Guided tour

27m, 34m, 37m? The height of this tower varies according to the source. With or without the heel lift, it is the largest lighthouse in Canada. Eastbound, following route 132, the road is fringed by lighthouses. The bitumen ribbon highlights the coast of Gaspésie, a peninsula that fashions the mouth of the St Lawrence. The Cap des Rosiers and its village come under the jurisdiction of the Forillon National Park. Written on the map as 'Cap Rozier' back in 1632, the French explorer Samuel Champlain was attracted by its abundance of wild rosebushes.

The umpteenth shipwreck – that of *Carrick* – was to set in motion the construction of a lighthouse. This vessel, laden with 180 Irish emigrants chased away from their homes by the Great Famine, was wrecked in 1847, the victim of a storm and the lack of light. The 48 survivors started up a line of ancestry here.

When the lighthouse was opened, it was fuelled with seal oil, but the signal emitted by this particular light was the most powerful in the country thanks to its lens being imported from Paris. A cannon acted as a foghorn. The tower is made from limestone and decorated with whitewashed brick. The austerity of the climate means that it is only open from mid-June to mid-September.

⑥ CARLETON
CANADA | Quebec
1984 | 8m | Red flashes | Site accessible

A modest construction, this light on the Tracadigache Point (South Gaspésie) is no less representative of the Canadian style. This design, perfectly adapted to the local resources and the irregular coastline, has been reproduced a considerable number of times, in Nova Scotia and elsewhere. In addition, the structure is mobile so it can be moved when the environment changes (erosion, silting up, etc).

The 'Pepperpot', as it is sometimes called, is a small, white, directional pyramid, which is octagonal in shape and made of wood. It is crowned by a red lantern and a balcony, not dissimilar to the national emblem.

The Carleton light plays the role of a lateral beacon in the Baie des Chaleurs (Heat Bay), so named because it is covered in mist when the air temperature is far greater than that of the sea. This building is the third built on the site.

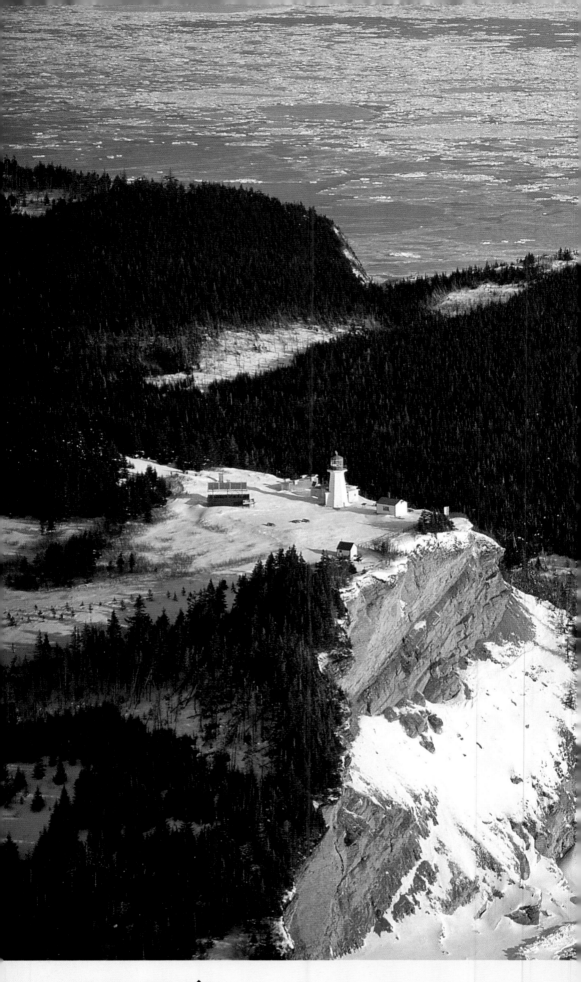

⑦ CAP GASPÉ
CANADA | Quebec

1950 | 12.8m | White flashes | Site accessible

With a wall of cliffs and a fearsome coastal current often thwarted by a violent Easterly wind, this is the ice shelf in winter. At the intersection of the St Lawrence and the Atlantic, Cap Gaspé forms an impressive divide in these waters. Moving around, developing both in terms of thickness and hardness as well as binding together, the ice is a hindrance to navigation. The icebreakers of the Canadian Coastguard battle to open the channel and retain access to the river. In the Gulf of St Lawrence, the route is maintained up to twice a day.

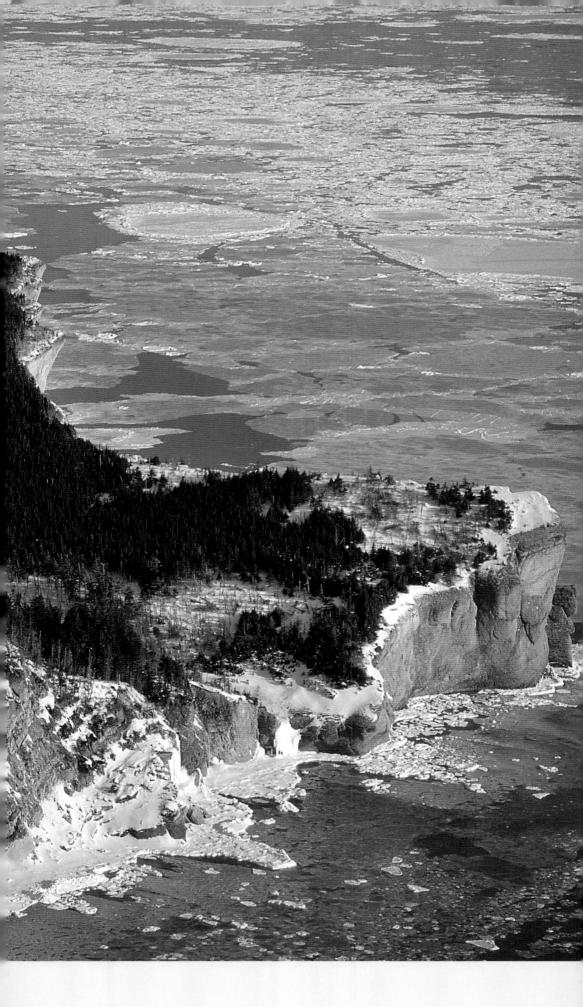

An initial light was illuminated here in 1873 to ensure the safety of the comings and goings of the fishermen in the Bay of Grand Banks. It burnt down. There was a second (1892), which was higher than the first and made of concrete. The current focal plane reaches 107m! A clearing was cut into a resinous massif, to the north-east of Gaspé Bay, where Jacques Cartier disembarked in 1534. The forest path that led him here traverses the Forillon Park woodland for several kilometres. However, this is preferable to the twisting hiking track, given that both itineraries end with an ascent.

PEGGY'S COVE
CANADA | Nova Scotia

1915 | 13m | Fixed green light | Visit

Enjoying three very ragged oceanic coasts (Atlantic, Pacific and Arctic) and bordering four of the five Great American Lakes (Huron, Superior, Ontario and Erie) as well as a host of stretches of water (including Lake Winnipeg) and navigable routes (such as the St Lawrence), Canada maintains a considerable number of lighthouses, in the order of over 500 stations. Numerous protection associations get the public familiar with them and keen to discover more.

The granite foundation of this classic-design lighthouse, keeper of the entrance to St Margaret's Bay, is not dissimilar to that of Breton lighthouses. The name Peggy's Cove stems from the local legend that tells of a Margaret being the sole survivor of a shipwreck and thereafter a pioneer. This concrete structure made the other wooden structure (1868) inactive and it was ultimately blown down by a hurricane in 1954, together with its keepers' house.

A post office, highly prized by philatelists, occupies the ground floor of this lighthouse and receives the most visitors of all the lights in Canada.

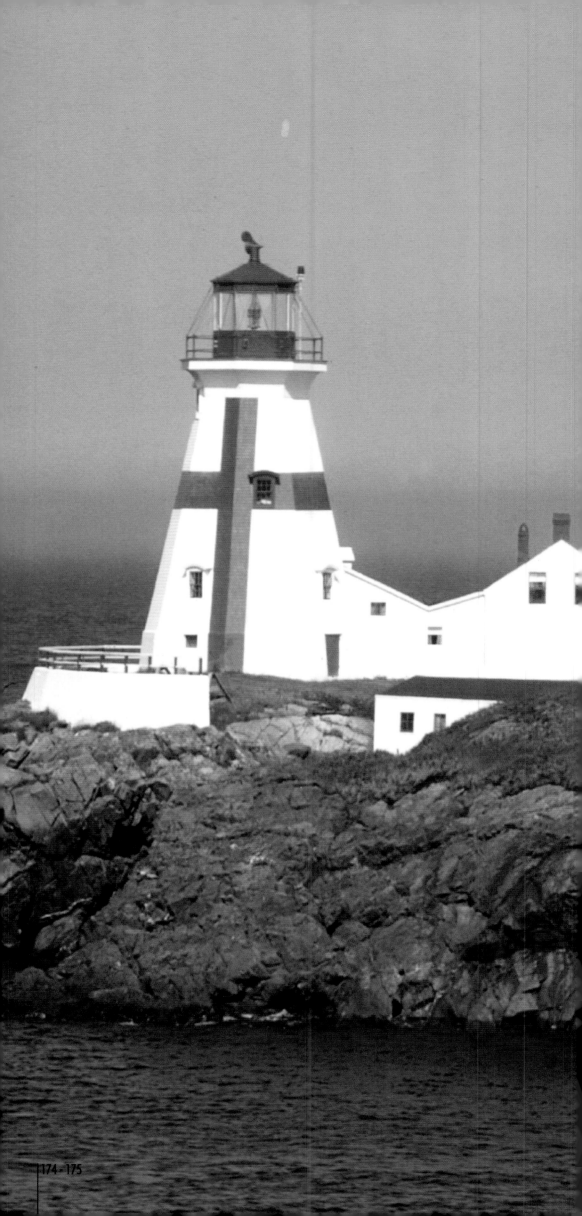

⑨ HEAD HARBOUR

CANADA | New Brunswick | Island of Campobello

1829 | 16m | Red fixed light | Site accessible

New Brunswick looks out across the Gulf of St Lawrence on the one side and the Bay of Fundy and its crazy tides on the other. You can see this arm of the sea emptying like a bathtub before your very eyes, from a height of between 10m and 16m. A terrifying tidal range then, mixed with pea-souper fogs! The south of the province borders Maine (United States) and smuggling was naturally rife here over the various eras, such as during Prohibition.

You immediately notice the daymark on the old wooden lighthouse, which is octagonal of course. This St George's cross symbolises the British protection over what was initially French territory, from which the Acadians were expelled in 1755. When this light was illuminated again, New Brunswick had not yet joined the Canadian federation (1867).

The tower, whose cast iron lantern dates from 1887, is linked to the main building via a covered walkway to protect the keepers during the storms. Its outbuildings consist most notably of a foghorn shelter (1915) and a boatshed (1947). The whole construction sits on a rocky islet, East Quoddy Head (the other name for the lighthouse), the end of which borders the tourist island of Campobello, a sentinel guarding the indentation of the Bay of Fundy: the Bay of Passamaquody.

A local association supports this station, which was automated in 1986. Access to Campobello is gained via the Lubec Bridge (United States) or the ferry (Canada), from where you can continue on foot at low tide only.

⑩ PEMAQUID POINT
USA | Maine | New Harbor

1835 | 12m | White flashes | Visit | Museum

Lashed, hammered and polished by glaciation, then vigorously swept by the Atlantic Ocean, the rocky escarpment of Pemaquid is very 'scenic', as they say in these parts. It is located fairly close to New Harbor, at the end of a headland, which separates Johns Bay from that of Muscongus. The first tower built in 1827 did not last long and it was rumoured that the mortar was mixed with seawater. Whatever the reason, it quickly crumbled away and had to be replaced by this structure. Its aim was to chaperone the development of the fishing industry (soon that of lobster) and the transport of wood from a highly wooded state. The tower is made from loose

stone and the accommodation, dating from 1857, has been transformed into a wooden fishing museum. The lantern has retained its fourth-order Fresnel lens (1856). In the foreground you can see the oil tank (1896). Higher up you have the pyramid-shaped bell tower warning of fog, as well as the shelter for the steam engine: both of these were rebuilt in 1992, after they were demolished in a storm. This lighthouse was the first to be automated (1934) in Maine.

An association, the New England Lighthouse Lovers, repainted the tower and intends to revamp the porous masonry. Another organisation, Friends of Pemaquid Lighthouse, opens the tower to visitors on certain days during the high season. Cruises are organised at sunset.

(11) PORTLAND HEAD
USA | Maine

1791 | 24m | White flashes | Site accessible | Museum

It is said that George Washington, future first president of the United States, personally hired the two masons, who were to build this tower in 1787, in the name of the colonial government. Made from loose stone taken from the site, rather than the rocky Cape Elizabeth, the light illuminates the southern entrance to Portland. The illustrious Longfellow, a native of the area, dedicated a poem to it in 1849: 'A new Prometheus, chained upon the rock...'

This veteran of the Union witnessed some strange things. In 1864, while the American Civil War was raging, the shipwreck of a boat of immigrants, and the desire to help vessels to spot its light more rapidly and avoid attacks, led to the improvement of the lens and the extension of the tower section by nearly 6m. It lost its top in 1883 and was then raised in height again the following year so as to put an end to complaints!

The tower is connected by service buildings to the Victorian keepers' house (1891). This maisonette accommodation was occupied by the main keeper, his assistant and their families until 1989. The ground floor was transformed into a museum. A garage, the foghorn shelter (rebuilt in 1973) and that of the oil tank, complete the installations. The whole base was modified slightly in 2005 thanks to revenue from the shop, the museum and the telescopes. Boat trips set out from Portland.

⑫ CAPE NEDDICK
USA | Maine | York

1879 | 12.5m | Red light

Cape Neddick is representative of a certain rather typically American style of architecture: a tower adjoining or immediately next to a traditional, often affluent-looking house; in this particular case, the two elements have been joined together since 1911 by a covered walkway. The tower consists of two layers of brick, covered outside by steel. The Victorian keepers' house is divided into six rooms, across two floors. It takes the shape of a cross, positioned in such a way that the tips of the roof indicate the four cardinal points.

This lighthouse is situated on a bare islet (otherwise known as Nubble), just a stone's throw

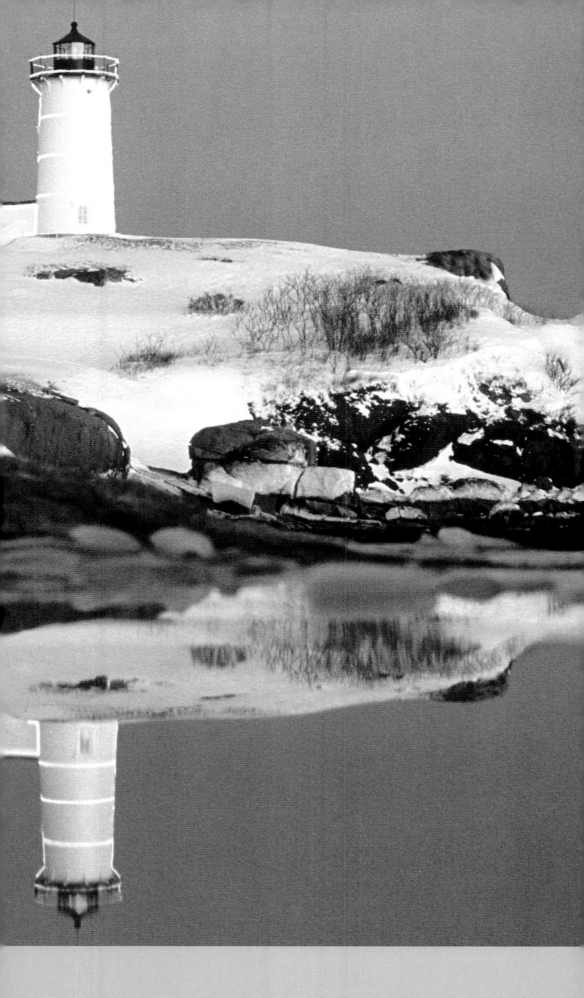

from Cape Neddick, close to the northern entrance to the port and the River York. Its last keeper left in 1987. The site is comprehensive: in the foreground, the small red brick house (1902) has successfully provided shelter for the oil tank and then the generator; to the left, there is a workshop-shed. The remaining buildings comprise the breeches buoy and its wooden basket (not visible), which enables the keepers to receive their supplies, as well as a boat shelter.

This lighthouse, with its own association, is owned by the town of York.

(13) BOSTON HARBOR
USA | Massachusetts

1783 | 27m | White flashes |
Guided tour

This building is the oldest of the American lighthouses. The birthplace of the War of Independence, Boston is the emblematic port of New England, the former British colonial jewel and the historic capital of the United States. It is not surprising, then, that the Boston traders obtained a lighthouse in 1716. The chosen isle, Little Brewster, was ideal for guiding the approach to Boston via its large harbour, Massachusetts Bay, peppered with islands of all sizes.

This first tower was financed by the lighthouse rights, received on the cargo of merchant ships entering and leaving port, in conformity with British tradition: a penny for every tonne. The first Union foghorn was installed here in 1719: a cannon. This remained in position until 1851, and is still visible.

During the American Revolution in 1776 and the evacuation of Boston, the English blew up the lighthouse. When peace returned it was reconstructed along the same design. Made of stone and decorated with bricks, it was surrounded by iron rings in 1809 to prevent it cracking any further, and then raised in height by 4m in 1859. Various annexes have survived. Though the station has been automated, a Coastguard acts as a guardian angel; a way of paying homage to this fine ancestor, the last guarded lighthouse in the USA. You can access it with your own boat or make the most of the local excursions.

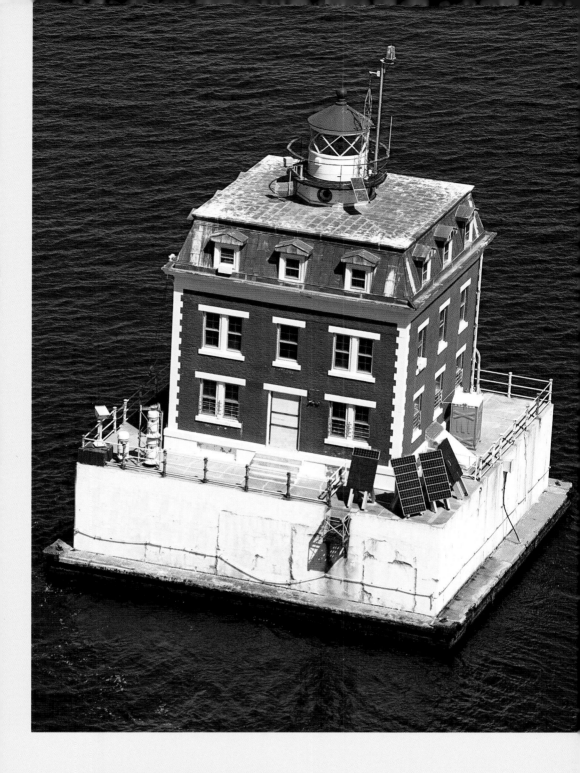

(14) NEW LONDON LEDGE
USA | Connecticut
1909 | 18m | Flashing white and red light | Guided tour

This has general fenestration, a mansard roof, cornices, pediments, corner sections, etc, but what is this fine, large, red brick house, typical of the second French Empire, doing here at the entrance to Long Island Sound? A local entrepreneur was quite simply requested not to spoil the rich residences of the nearby coast.

The 'insular houses' of this sound (Penfield Reef, Stratford Shoal, etc) top the swathe of reefs, hidden by the flow of water and highly feared in times gone by. The port of New London, to which this structure indicates the way, is situated at the junction of the Thames River and Long Island Sound, with New York to the west.

Its wooden and metal caisson was towed to the site. Filled with stone and flooded with concrete, it was sunk to a depth of 8.5m and protected with a riprap. The top of the pontoon contains water tanks and cellars.

The keepers worked here for three weeks in a row, then they spent six days on shore. The storm of 21 September 1938 was particularly memorable, with the waves reaching the second floor according to a report from one keeper. The ghost of New London Edge is called Ernie. Indifferent to the automation in 1987, this former keeper has haunted the place of his suicide since his wife left him for the captain of the Rock Island ferry.

Boat trips setting out from Avery Point are associated with the New London Ledge Lighthouse Foundation, which is working to restore the structure.

RONDOUT CREEK
USA | New York (State)

1915 | 15m | White flashes | Guided tour

Hudson doesn't stint on the insular 'house lights' either, or the mansard roof. Surely this is a sign that the Napoléon III style was the height of fashion, as vouched for by the Hudson-Athens or Esopus Meadows lighthouses. Readers shouldn't need reminding that the Hudson River feeds the large nautical stage that is, after all, New York.

Notably, a network of canals connect this artery to Lakes Erie and Ontario, not to mention the Pennsylvanian coal reserves. The benefits of this location are enjoyed by Kingston, a port along the large river, along with its tributary, Rondout Creek, midway between New York and Albany. In 1807, Robert Fulton used this 200km waterway to demonstrate the commercial validity of the steamship, a destroyer of the sloops and schooners of the Hudson and elsewhere.

The years 1837, 1867 and 1915 saw the successive construction of three different lighthouses, the first being made of wood. At the start of the 1860s, the female keeper was surprised to see the bowsprit of a schooner protrude into her dining room! Nevertheless, she didn't leave her position at the lighthouse until 1907, 50 years after having been appointed here, following the death of her husband. This misfortune was to lead to the creation of a new lighthouse made of stone.

The Hudson River Maritime Museum launch in Kingston deposits visitors at the lighthouse. Otherwise, a local boat company kills two birds with one stone by continuing on as far as the elegant Esopus Meadows.

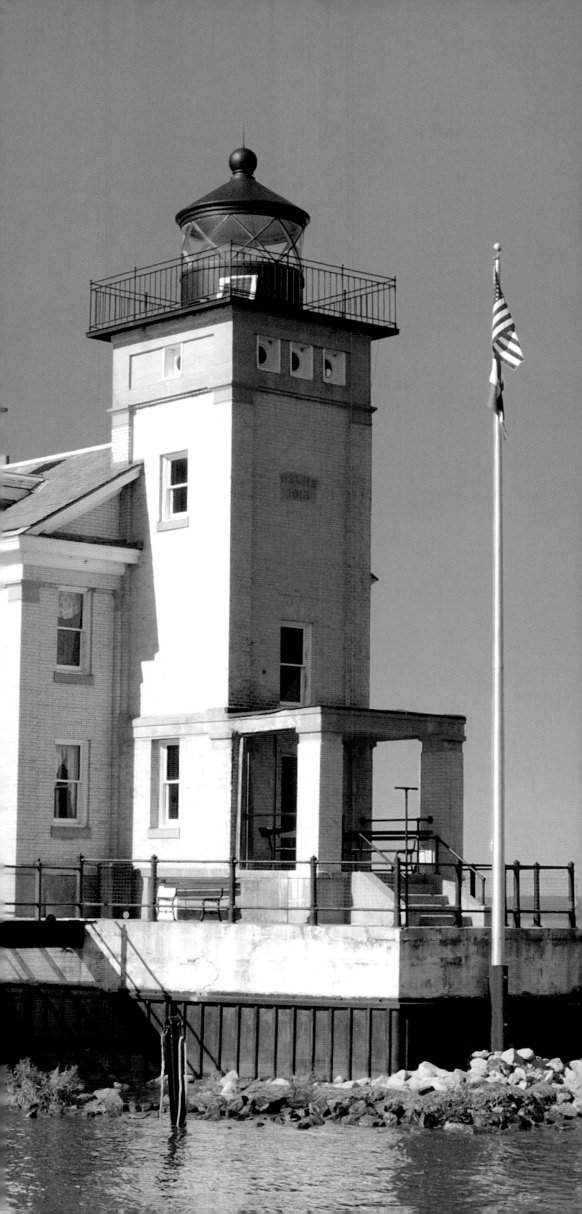

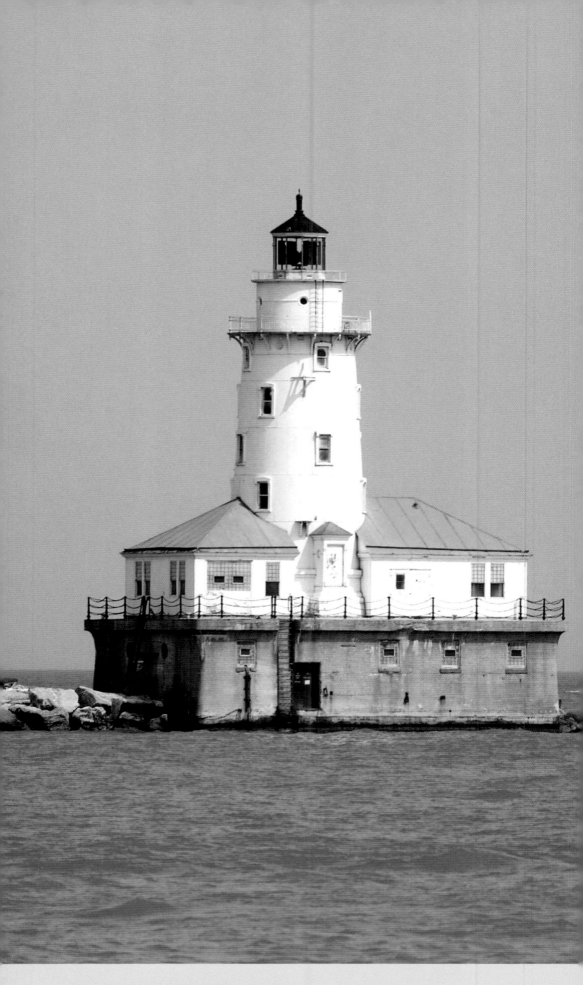

⑯ CHICAGO HARBOR
USA | Illinois

1893 | 14.5m | Red flashes

With its back to the rows of skyscrapers filling the Chicago skyline and stretching in a crescent to the far end of Lake Michigan, this lighthouse is located at the end of the port breakwater. The cast iron tower is lined with bricks, and as soon as it was designed it was decided to add a few accommodation areas so as to save money on a real residence. However, it has not always been here. In 1919, it was moved from the entrance to the Chicago River. It was then flanked by two buildings: one for the foghorn, the other for a boat. The third-order Fresnel lens

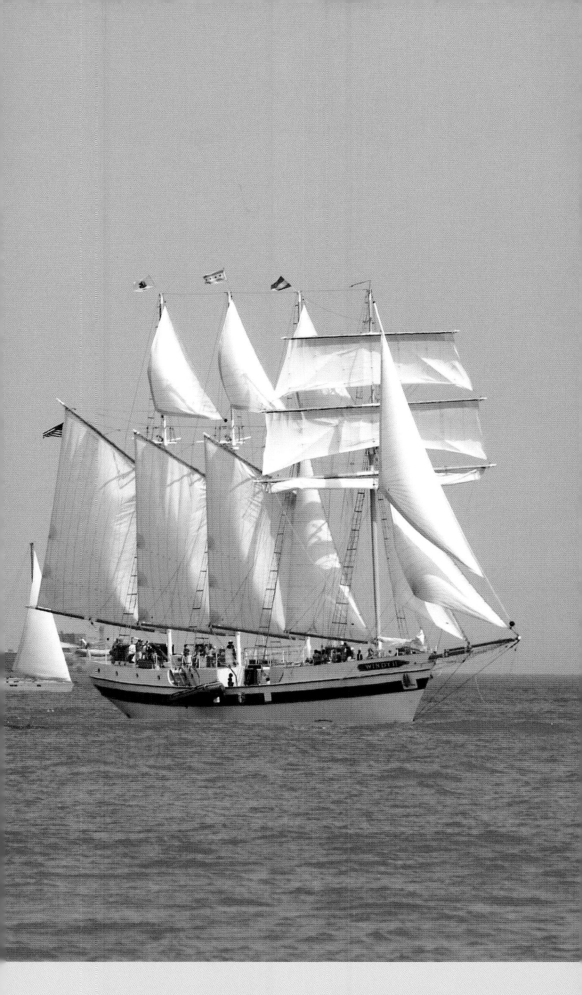

was exhibited at the Universal Exhibition in Chicago (1893), which was celebrating the 400th anniversary of the discovery of America. It was destined for New Point Loma (pp. 200-201), but was 'retained' by Chicago, where it continues to shine today.

This lighthouse and the schooner entering the outer harbour would have witnessed some fine things during prohibition in 1919, when Al Capone reigned in the field of organised crime. However, it is the grain and cattle trade that made the port prosperous. The Illinois–Michigan canal (1848) links the Great Lakes to the Mississippi via Chicago. Today Illinois is surrounded by some great farming states and Chicago is the outlet for cereals from the Great Plains. As regards the abattoirs, they have been popularised by the 'films noirs' and you need look no further than this for the headquarters of McDonalds!

The lighthouse cannot be visited, but boat excursions get close to it.

(17) KEWAUNEE PIERHEAD
USA | Wisconsin
1931 | 13m | Fixed white light

Reddened by the setting sun, the lighthouse at the mouth of the River Kewaunee is illuminated in a landscape that is broken by a midnight blue tide. On the same bank as Chicago and Milwaukee, but further to the north, the riverside village of Kewaunee is a resident of Lake Michigan, level with Green Bay.

A rumour of gold, albeit short-lived, attracted a fleet of immigrants here in around 1836, thus populating the area. For a long time, the exploitation and the transporting of construction wood up the river were the manna of Wisconsin, which had one bank on Lake Michigan and another on Lake Superior. Kewaunee benefited from this golden opportunity. Two piers were built in 1891 and the southernmost structure immediately received two alignment lights. These have sadly gone today, as has its catwalk, a traditional raised access gangway. It was replaced by a sheet steel tower onto which the fifth-order Fresnel lens of its predecessor was transferred. It was driven into the roof of the former foghorn shelter (1909). Its twin, 'Big Red', stands in Holland (Michigan).

LITTLE SABLE POINT
USA | Michigan | Mears

1874 | 32.5m | White flashes | Guided tour

No American state has as many lighthouses as Michigan. Flanked by three lakes (Erie, Huron, Michigan), it comprises a massive 2600km of coastline (the whole of France has 3200km). The eastern bank of Lake Michigan is remarkable through its profusion of dunes.

The wooden foundation pilings, and a stone base, firmly anchor this brick tower into the sand. There is a fairly small tidal range here but it is not insignificant, which is slightly perturbing for a lighthouse so close to the water. Its lantern is equipped with an original third-order Fresnel lens. Unfortunately, its service buildings were razed to the ground in 1955. The tower was sandblasted in 1977 to get rid of the white paint covering this seamark.

Somewhat unusually, this very isolated lighthouse cost $6000 less than the intended $35 000. It was reclaimed by the wood merchants and sawmills, mindful of making the comings and goings of the schooners safe. It wasn't until 1902 that a path, midway between a footpath and a track, finally enabled supplies to be transported via the land. The Sable Point Lighthouse Keepers Association opens up this lighthouse in Silver Lake State Park in summer.

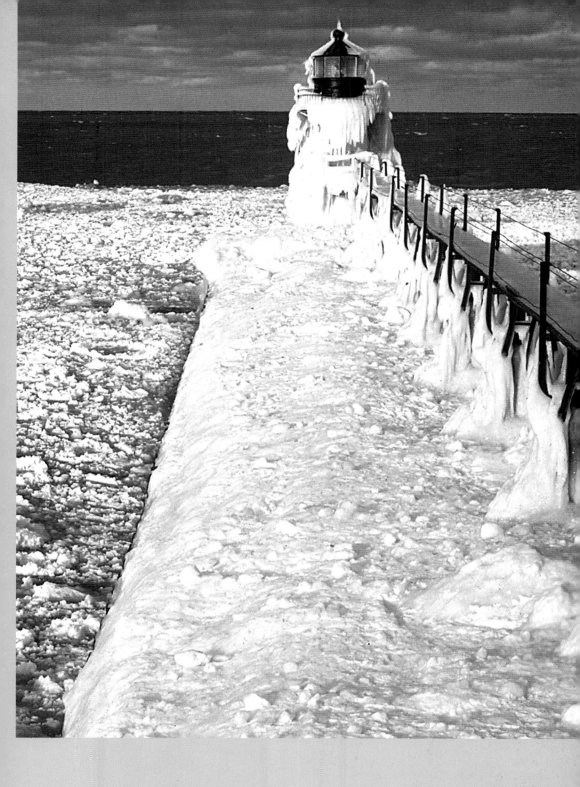

(19) ST JOSEPH NORTH PIER (OUTER)
USA | Michigan

1906 | 9m | White light | Site accessible

At the height of a reasonably cold winter, half of Lake Michigan freezes over. Ice floes are particularly prone to forming a compact mass here in the south. A lot of these metal footbridges, traditional on jetty lights in the Great Lakes, have sadly disappeared, along with their illuminations. Being an inland sea, Lake Michigan bears the brunt of some stormy gales. Washed by the waves, the pier becomes dangerous so it's better to use the higher catwalk.

Two alignment lighthouses share the pier at the entrance to the St Joseph River, not far from Benton Harbor: the photographer had his back to the so-called inner light for this shot. Built a year apart (1906 and 1907), they have little in common. The lighthouse pictured is white and conical shaped with a black balcony and lantern. It is made of cast iron and equipped with a foghorn. The other tower is octagonal and made from sheet steel, and is centred on the roof of the former foghorn shelter.

These lights and their predecessors might not have existed if St Joseph and its surrounding area hadn't successfully launched a fishing culture in the middle of the nineteenth century. As it was, the fruits of this labour were transported to Chicago and Detroit by water and rail.

(20) ASSATEAGUE
USA | Virginia
1867 | 43m | White flashes | Guided tour

Assateague is a very strange island. First of all, it is connected to the mainland by two road bridges: one in Maryland, the other in Virginia, the two states having an equal share in the land. Second, and most importantly, this slender barrier stretches across 59km. Although it only resists a tombolo of sand in the Atlantic, it has to cleverly sweep over Chincoteague Bay. On the strength of this, the Assateague lighthouse was built on the leeward coast to watch over the boats travelling along the channel between the island of Assateague and that of Chincoteague, dominating the brackish marshland, which is criss-crossed by herds of wild ponies. Assateague is a paradisaical nature reserve (Chincoteague National Wildlife Refuge).

Its predecessor, built in 1833, was said to lack vigour. The current lighthouse was built just between the end of the American Civil War (1865) and the return of Virginia to the Union (1870). The brick tower is surrounded by other constructions, which are also the property of the US Fish and Wildlife Service. It was only awarded its stripes in 1963–5. The auxiliary keepers' house (1910) still remains, as does the oil tank (1891). The Chincoteague Natural History Association has taken the lighthouse under its wing and it can be visited from Easter to Thanksgiving.

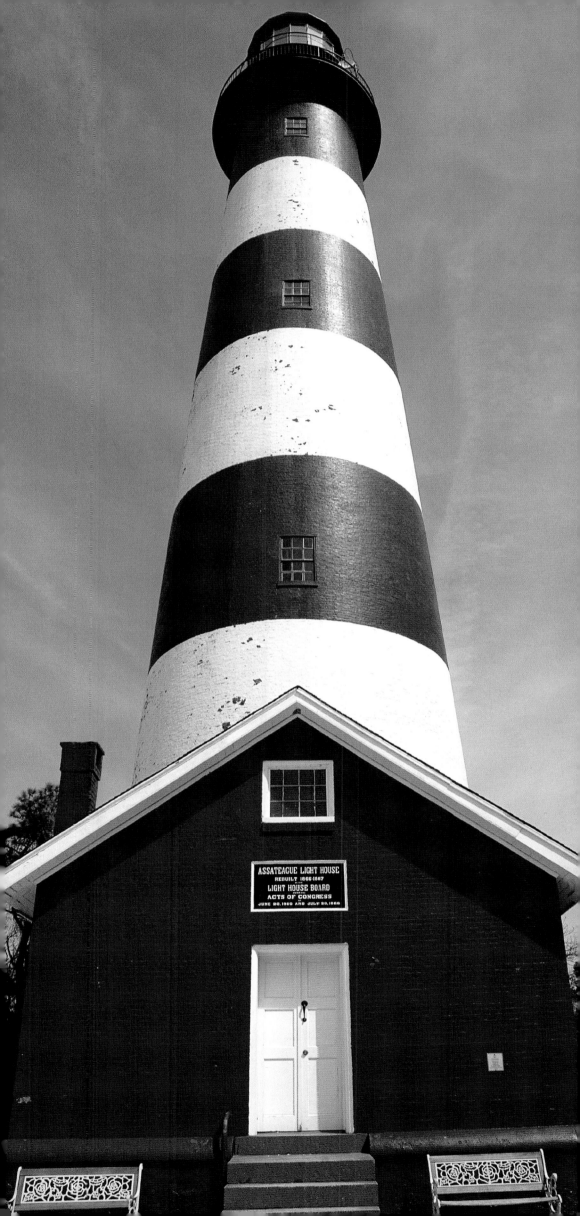

ASSATEAGUE LIGHT HOUSE
REBUILT 1866-1867
BY THE
LIGHT HOUSE BOARD
UNDER THE
ACTS OF CONGRESS
OF
JUNE 20, 1860 AND JULY 20, 1866

SANDY POINT
USA | Maryland | Annapolis
1883 | 11m | White flashes

Some 290km long and about 30km wide, Chesapeake Bay is well protected with a deeply ragged coastline, providing the country with its largest estuary. Flooded, the former valley has around 50 wide and highly ramified water courses pumping through it. Approximately 10 000 ocean-going vessels pass through it each year, bound for Baltimore or Hampton Roads.
Around 30 lighthouses compensate for the capriciousness of the landform, which is unevenly divided between Maryland and Virginia. An architectural delight, this caisson-based lighthouse was designed in the local manner. Sandy Point is located on the west coast, in the area sur-rounding Annapolis. The different parts of the caisson were assembled on site, on a platform;

this sub-basement was then filled with concrete and submerged. It serves as a pedestal for the octagonal brick, Victorian-style house. The third floor has a mansard roof, pierced with protruding dormer windows, like the lighthouses of Baltimore and Point no Point. Inside the caisson there is a cellar. On the first floor there is a kitchen and sitting room with a corner fireplace. The second floor comprises three rooms, and then there is a spacious lookout room under the gable, topped off with the lantern.

Solar powered and equipped with a foghorn, this lighthouse was sold by auction on the internet in 2006. Price: $250 000 all in, including the rug periodically sullied by the Coastguards, who ensure the building's upkeep. You can get close to it by tripper boat, leaving from Annapolis.

㉒ THOMAS POINT SHOAL
USA | Maryland | Annapolis
1875 | 15m | White flashes + 2 red sectors

It would be hard to find a more stylish, traditional design than the lighthouse at Chesapeake Bay. Americans call it the 'cottage screwpile', the 'cottage' being supported by pilings at the base. There are only four remaining in the bay and half a dozen in the Potomac River. Still in good condition, Thomas Point Shoal is the last in its original place. It hasn't been decommissioned, unlike Drum Point, which now houses Solomon's Calvert Marine Museum; Hooper Strait, headquarters of the Cheasapeake Bay Maritime Museum at St Michaels; and Seven-Foot Knoll Lighthouse, which was physically relocated to the Baltimore Maritime Museum.

Buttressed on its seven legs at the northern entrance of South River, it stands downstream of Sandy Point. The building has most to fear from tropical storms and ice. Until its riprap was inserted, various processes (icebreakers, bundles of cast iron beams, etc) were tested after the ice weakened it in 1877. Such was the pressure on it that the lens was damaged and had to be replaced.

In 1972 public opinion dictated that a preservation order be obtained. Classed as a National Historic Landmark, this hexagonal cottage with its prominent dormer windows, surrounded by railings with elegant balusters, shares this title with eight other similar structures. Inside, it has two bedrooms, a sitting room, a kitchen, etc, and is equipped with a foghorn as well as being a weather station.

A partner to County's Maritime Museum and the United States Lighthouse Society, the structure is owned by the town of Annapolis. Tripper boats have to content themselves with getting fairly close to the lighthouse, but it should soon be opening to the public, with excursions setting out from the museum.

(23) CAPE HATTERAS
USA | North Carolina | Buxton

1870 | 61m | White flashes | Guided tour | Museum

The first lighthouse (1803) had to endure the American Civil War. In 1861, the Confederates even carried away its lens during their retreat. In the end the structure was blown up with dynamite and rebuilt further to the north. A gnawing malaise threatened it for a long time: erosion. This problem was so disturbing that in 1936, two years after its electrification, the tower was abandoned for a framework one and then sold to the National Park Service.

In 1950, away from any danger, the lighthouse was opened again. Alas, with the sea having set to work to undermine the structure again, the decision was made to move it. In 1999, Cape Hatteras and its outbuildings, two wooden keepers' houses dating back to 1854 and 1871, were shifted 800m back from the coast. The whole operation took 23 days, involved 22 experts, and cost 12 million dollars. The tallest lighthouse in the United States couldn't be moved without precautions, especially when built from brick, so it now sits on a granite base.

Cape Hatteras light is one of five prestigious sentinels of the Outbanks, a long line of sandy isles standing in single file off the coast of North Carolina. It is a flat coastline with shallow waters, violent currents and capricious sandbanks, which extend along Cape Hatteras. The victims of the pressure from the Gulf Stream in this area amount to hundreds, as this is where the powerful current diverts towards Europe after travelling the length of the American coastline.

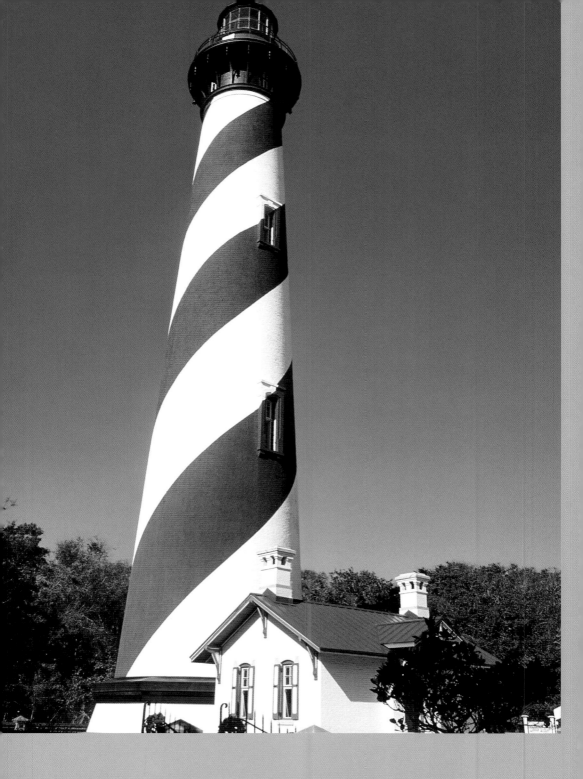

⟨24⟩ ST AUGUSTINE
USA | Florida | Anastasia Island
1874 | 50m | Continuous white light + flashes | Visit | Museum

To the north-east of Florida, there is a lighthouse with the same distinctive shape as Cape Hatteras and it looks as if it has come straight out of a Meccano construction set! The tower is made of brick and the Victorian keepers' house (not visible) is made of wood.

To the south of Jacksonville, Anastasia Island stretches in front of St Augustine, which is reckoned to be the oldest town in the United States. Closely connecting land and water, its geography is constantly changing, so much so that the lighthouse has become considerably distanced from the coast, without affecting its range (19 miles). The island is the site of the first lighthouse in Florida, a Spanish watchtower (1683), illuminated in 1824. Its lens was apparently buried during the Civil War. However, it was the erosion that got the better of it in the end. Pushed over by a storm, it toppled into the sea in 1880, just six years after a new tower had prudently been built some 800m further west.

Thousands of dangers lie in wait for a lighthouse. In 1986, a rascal equipped with a rifle decided to fire shots at its lantern, damaging the original first-order Fresnel lens; the glass was bulletproof from then on. In 2001, a power cut damaged the electrical and computer systems. Another, caused by Hurricane Frances in 2004, transformed the Head of Operations at the museum into a lighthouse keeper for several consecutive nights.

㉕ ALLIGATOR REEF
USA | Florida | Islamorada
1873 | 41m | White flashes+2 red sectors | Site accessible (boat)

The Florida Keys designate an arc of islets to the south of Florida. Fringed by coral reefs, making access to the marinas tricky, these islands are joined together by a 250km road on pilings. Right at the end of this you have Key West. After being formed in the Gulf of Mexico, the Gulf Stream gives these lower coasts with their shallow waters a warm lick.

Alligator Reef marks the first third of the Florida Keys, to the south of Islamorada. This and other metal framework lighthouses in Florida (Sand Key, Sombrero Key, Carysfort Reef, etc) and Louisiana used to be everywhere in the nineteenth century, but were virtually wiped out in Europe; the Walde light (Calais, 1859) is a parent to this structure. An American vessel, the *Alligator*, was ripped open on the reef here in 1821, bequeathing its name to the lighthouse as a result.

These Meccanos on stilts are suited to the shifting sea bottom where neither the sea nor the hurricanes can get a hold on them. A particularly memorable example of this was a hurricane in 1935, which got its revenge by wreaking havoc on the first-order Fresnel lens. This lighthouse was converted to solar power in 1997 and comprises an octagonal pyramid of forged iron. The bones of this building, a central column closing off a staircase and eight stakes propped up to stabilise the framework, rests on nine foundation pilings. The latter were driven 3m into the coral by means of a type of pneumatic hammer. Nestling in the middle of the platform is the keepers' house!

(26) NEW POINT LOMA
USA | California | San Diego
1891 | 21m | White flashes

A group of palm trees attempt to provide shade for the New Point Loma lighthouse, which marks the entrance to the port of San Diego and its crescent-shaped bay. It replaced Old Point Loma (1855), which was only in operation for 34 years. Its overly high light was veiled by the mist, or even by simple low cloud cover. The former can be visited, unlike this one, which is inhabited by the Coastguards.

A spiral staircase fills the central column leading up to the black lookout room. In the foreground lies one of two identical keepers' houses. The construction is naturally equipped with a foghorn, though it proved difficult to work correctly. The first Fresnel lens ordered was so

accomplished that manufacturer Henry Lepaute exhibited it in exhibitions from Paris to Chicago, which ended up appropriating it. Following on from that, the replacement lens proved to be too voluminous. The third, initially assigned to a Florida lighthouse, was just right and once it had been restored it was exhibited at Old Point Loma. The black-out ordered during the last war on the Pacific coast was to affect this lighthouse and others. The lamp was extinguished, all the windows blacked out, and the various buildings camouflaged in olive green paint.

From Cabrillo National Monument, which houses Old Point Loma, there is a panoramic view extending across the lighthouse, San Diego Bay and Mexico.

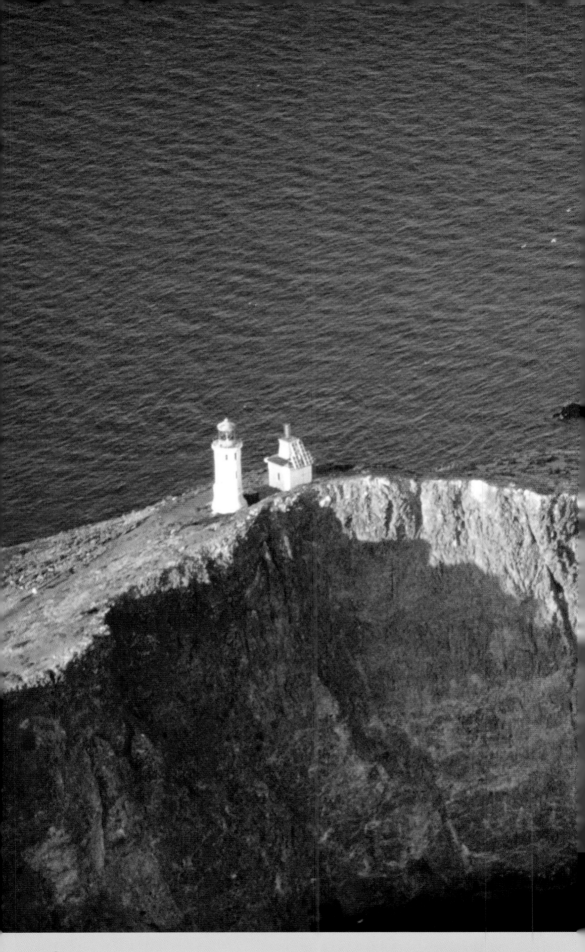

㉗ ANACAPA ISLAND
USA | California
1932 | 17m | White flashes | Site accessible

It is not so much the lighthouse but the site that stirs up curiosity. There are three volcanic Anacapa islands: East, Middle and West, which are steep and studded with submerged rocks. The construction occupies the eastern extremity of the smallest of these, East Island, which extends out to a mineral arch. Its light marks the eastern entrance to the Santa Barbara channel, which is narrow, highly affected by currents and often shrouded in mist; its foghorn, just in front of the tower, thunders constantly.

Until 1932, two routes were open to the captains of the San Francisco shipping lines: the long option consisted of rounding a sprawling group of islands (Channel Islands), to which the

Anacapa archipelago belongs; the short-cut, which entered the strait, involved ships groping their way along in the darkness or mist at times. The latter generally found favour, but there were a number of shipwrecks along this route. The first lighthouse structure, built in 1912, proved insufficient so a complete station was built (not without its share of difficulty), on the entreaties of the pilots and officers from the American marines.

The old third-order Fresnel lens is visible in the centre of the visitors' reception area, as well as two Hispanic keepers' houses and the water tank shelter – the island lacking a spring. Boats leave from Ventura bound for this sanctuary, an integral part of the nature park, which is rich in flora and fauna as well as having a human element: Miss 'Arlington Springs', ancestor to the North Americans (16 000 years old), comes from this area.

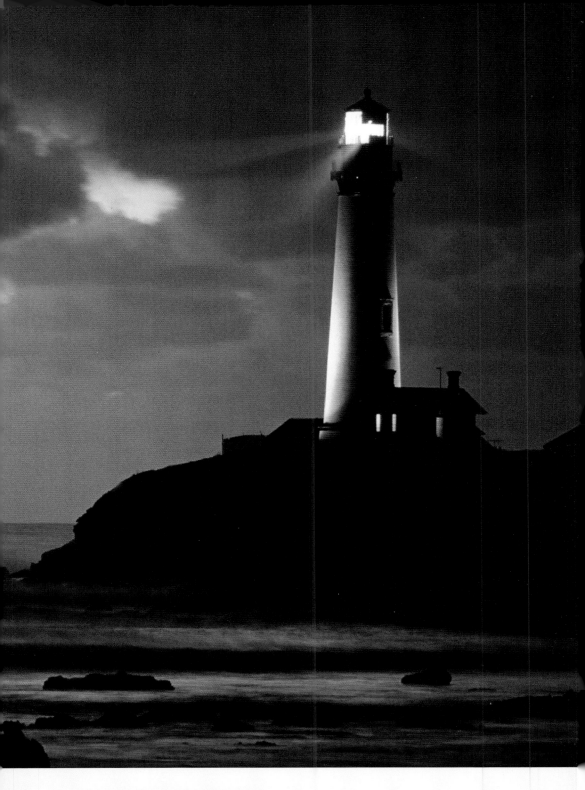

(28) PIGEON POINT
USA | California | Pescadero
1872 | 35m | White flashes | Site accessible | Night stay

Pigeon Point takes its name from an American clipper, one of the many couriers that supplied and tooled up the gold diggers and pioneers before the railroad took over. In 1853, five years after the start of the gold rush, the *Carrier Pigeon* left Boston bound for San Francisco on its maiden voyage. Losing her way in the mist, she impaled herself on the reefs near Punta de las Ballenas (whale point). The cargo was lost, but the crew was saved. The headland then changed its name, but the grey whales continue to migrate towards the Arctic, rounding the cape from March to May between Half Moon Bay and Santa Cruz.

In the early days, the five wicks for the lamp sat in melted pork fat (lard), which was less dear than spermaceti (sperm whale) oil. Later on, the lighthouse consumed kerosene, a light fuel oil, improving on its performance until its electrification. Its first-order Fresnel lens (1863), transferred over from Cape Hatteras, is inactive, but an aeronautical light was installed on the railings of the balcony.

A collection has been started to renovate the tower, which is owned by the California State Parks. It has been closed to visitors since 2001 when two pieces of cornice broke away, but the site itself has remained open and guided walks are offered. Three buildings were added in 1960 and were developed into seaside holiday houses with private bedrooms and dormitories.

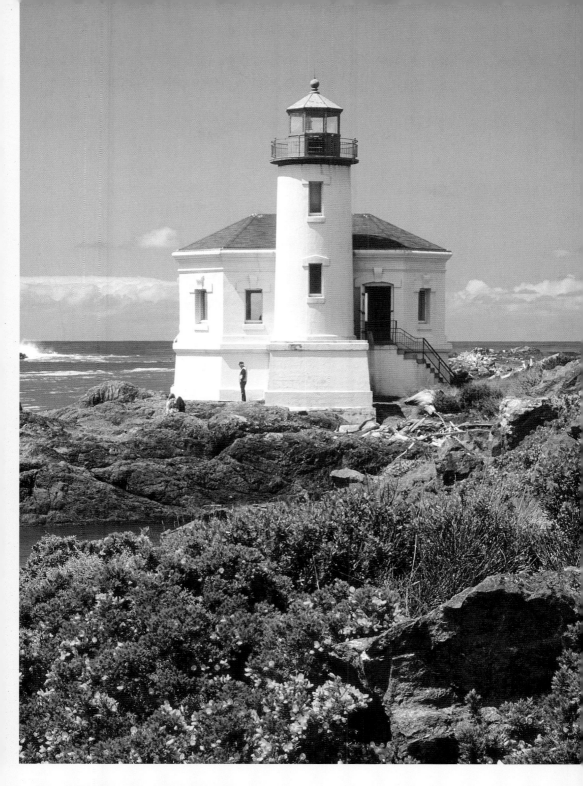

(29) COQUILLE RIVER
USA | Oregon | Bandon

1896 | 12m | Inactive | Guided tour (summer)

Created as a fluvio-maritime free port at the mouth of the Coquille River, Bandon derived more profit from its situation once the colonialists found a way around the problem of the sandbar hindering its access, building a jetty to the south (1887) and then the north (1905). An added bonus of constructing a lighthouse here, albeit the last and the smallest in Oregon, is that it guaranteed the ease of passage of steamships and schooners, thus encouraging trade. Tree trunks and sawn wood were carried upstream, as were cranberries, which Bandon made into a speciality.

The brick, stucco tower is flanked by a massive building; this is not the keepers' house, which along with the stable was demolished, but rather the shelter for the foghorn. Its Victorian shape was Italianised according to the American fashion of the day. At the end of the four-teenth century, Oscar Langlois, son of the keeper, was born in the neighbouring lighthouse of Cape Blanco; he married Marie Amundsen, daughter of the keeper of another neighbour at Cape Arago. In 1936 this couple of keepers in Coquille River were shocked to witness the gigantic fire, which reduced Bandon to cinders on the other bank for the second time since 1912. Three years later, an automatic mark took over and the structure has been enjoying a restful retirement for some time. Since 1991, it has been lit up in December like a Christmas tree. Located to the south-west of Eugene, it belongs to the Oregon State Parks and its restoration is currently under study.

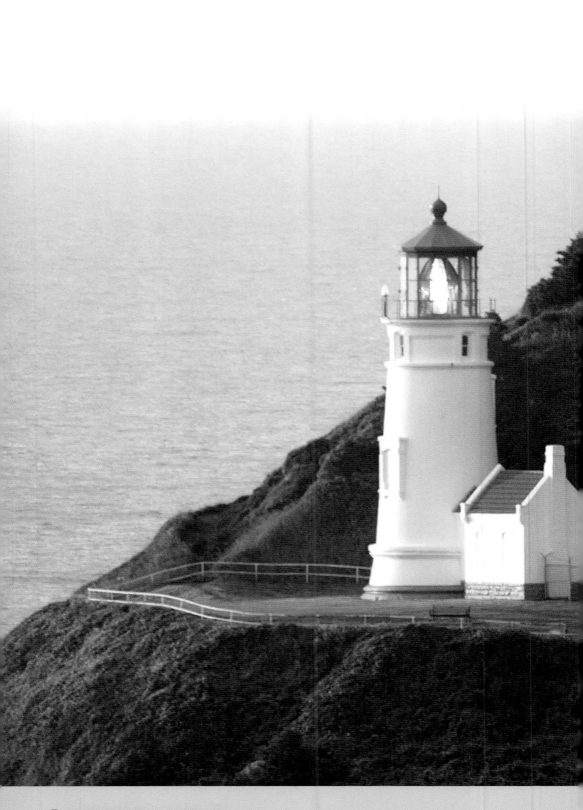

HECETA HEAD
USA | Oregon
1894 | 17m | White flashes | Visit

The stunning cliffs, forests and dunes that fringe Oregon contribute to its wildness. The Heceta Head lighthouse is the most powerful in the state. It emits its light beam up to 21 miles away by means of its original Fresnel lens, entirely repaired and revised by the Coastguards after the rotation mechanism gave up in 2000. Its name perpetuates the memory of a Spanish explorer who was the first to plot the position of the promontory in 1775.

An entablement was cut out of the cliff with a mass of explosives, in order to accommodate the station. Today, the site comprises a brick tower, which the foghorn shelter is built alongside, two oil tanks, one of which houses a generator, and accommodation.

Until Route 101 linked the site to the 'civilised world' (1932), two years prior to the arrival of

electricity, the isolation was immense; however, the lighthouse was not automated until 1963. The sole, spacious residence that has stood the test of time is the accommodation for the assistants and their families. Not visible here as it is set further back, this wooden house is now both an interpretive centre and a renowned bed and breakfast. The tower and its outbuildings belong to the Oregon State Parks, but the keepers' house is owned by the US Forest Service. The rather good-natured ghost at the lighthouse is called Rue.

The station is situated in the Siuslaw National Forest nature reserve to the north of Florence. Here the salmon leap, the eared seals frolic in the sunshine, and the whales, on their way to Alaska, cross paths with the ocean vessels trading with Portland, Seattle, Victoria and Vancouver.

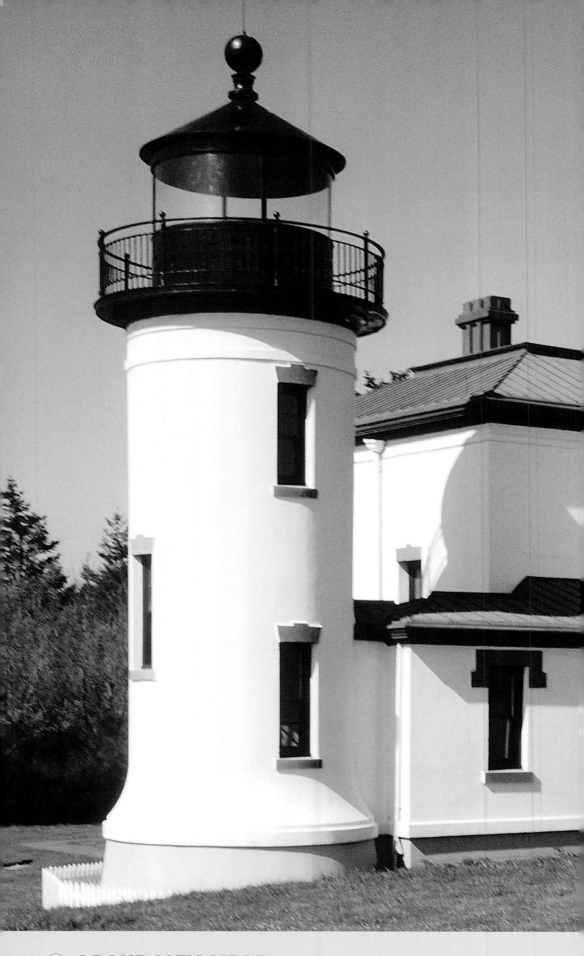

③¹ ADMIRALTY HEAD
USA | Washington | Whidbey Island
1903 | 9m | Inactive | Guided tour | Museum

'Full to starboard!' is the order shouted aboard vessels expected in Seattle or Tacoma. You leave the Strait of Juan de Fuca behind you, which borders Vancouver Island and Washington State, and enter the Admiralty Inlet. This is connected to a deep gulf (Puget Sound), at the end of which the two large ports open up before you. Built specifically to prevent confusion in this area, this directional lighthouse was built on Whidbey Island, so as to dominate the entrance to the Admiralty Inlet.

This construction replaced another light that dated back to 1861. Of Hispanic style, this is a coura-geous work from a renowned German architect, Carl Leick. The tower is linked to the residence

by an arched porch and the entire structure was built in traditional fashion with stucco brickwork. Sadly, the lighthouse was seldom used, the events of the 1920s constraining the large sailing boats that it was designed to support. These boats previously lined themselves up with this building in order to position themselves correctly for entering the Admiralty Inlet. From 1922, it fell into disuse. Five years later, its lantern (replaced by a replica) was transferred to the New Dungeness lighthouse (Strait of Juan de Fuca). The last war saw Admiralty Head converted into olive green barracks, due to its proximity to Fort Casey (1897), it too coming out of its slumber. Today the lighthouse serves as the backdrop for countless wedding photos, and Whidbey Island itself is served by ferries and a road bridge.

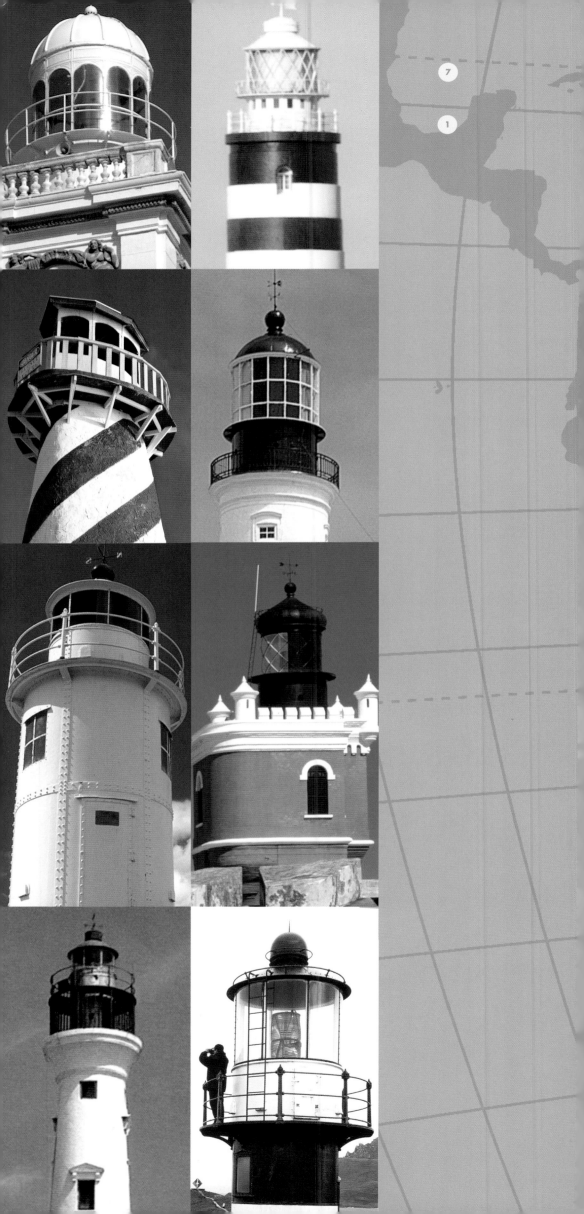

SOUTH AMERICA

VENUSTIANO CARRANZA
MEXICO | Veracruz
1910 | Inactive | Visit

When this amazing building was opened, on the pretext of celebrating the centenary of Mexican independence, Dictator Porfirio Díaz couldn't have known that this noble structure would one day embody the sovereignty of its people. After all, he only had the brand-new headquarters for the lighthouse administration in his sights for a few months, prior to his hurried escape to France. Veracruz, a town founded by Cortés and the largest port of the country, thus saw a vast improvement to its harbour infrastructure. To blend the useful and the pleasing, a light crowned the building, which was built on ground reclaimed from the sea.

The whole construction initially took the name of a former president, Benito Juárez, spiritual father to all guerrillas. In 1914 Venustiano Carranza installed his government here during the American invasion, and inspired the Constitution (1917) of his country. On the strength of this the building today houses a museum about the Revolution as well as being the headquarters of the third Military Zone for the Mexican navy.

This lamp too has strayed so the current light is purely decorative. The original one was transferred to the new Pemex tower back in 1952, which then housed the Bank of Mexico, prior to finding refuge at the top of one hotel and then another.

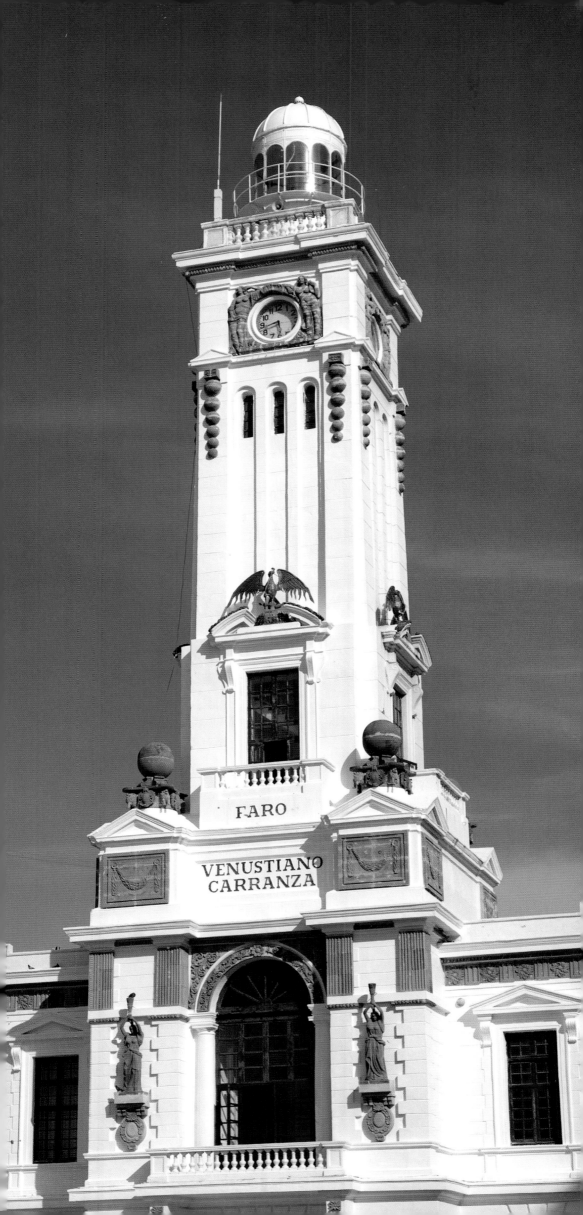

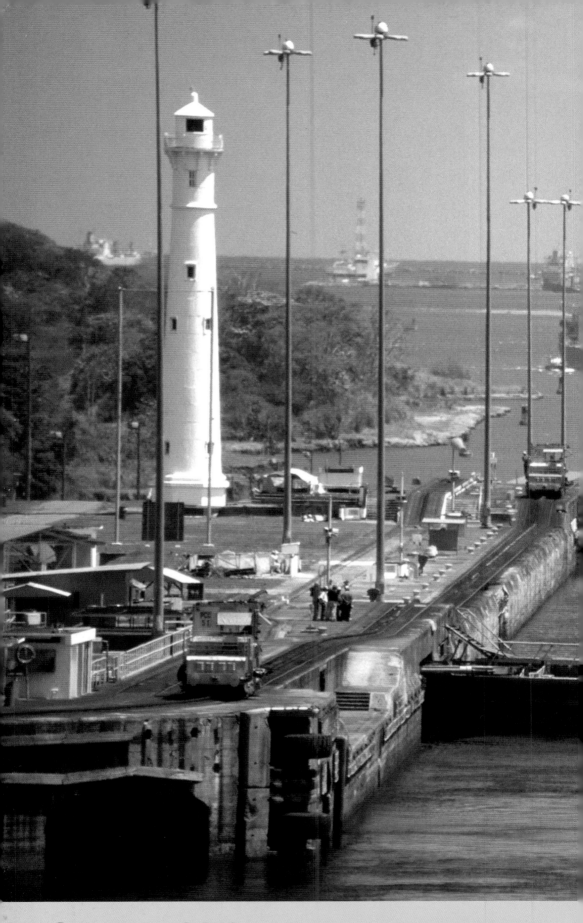

(2) GATUN LOCKS
PANAMA

1914 | Around 27m | Green occulting light

A vessel coming from the Caribbean is preparing to enter the upper chamber of the Gatun locks, which control the access to the lake of the same name. The normal height of the water in this artificial lake exceeds the sea level by around 26m. Fairly high up here, the vessel will be lowered further along the locks as it passes through the lock gates of Miraflores and Pedro Miguel, before being released into the Pacific after a transit lasting some eight to nine hours.

At 77km long, the Panama Canal was opened to navigation on 15 August 1914, a fortnight after hostilities broke out in the old Europe. A link between two oceans, this short-cut to the Pacific is a colossal feat of engineering. Funded by the French (Ferdinand de Lesseps) between 1879 and 1899, the work was carried out under the American flag from 1904 to 1914.

Its lighting programme resulted in 35 lighthouses of varying sizes to guide the acrobatic

navigation through the isthmus. A notable fact in this seismic zone is that 34 of these structures still remain and 28 are still operational. This particular lighthouse is the tallest of all of them. It has a rear alignment light, which guides vessels travelling from the large artificial Gatún Lake towards the Atlantic. Repainted, it now has window surrounds, a base and a band around it painted royal blue. The front light, not visible, is situated at the end of a jetty entering into the lake.

The United States ceded the Panama Canal in 1999. Its widening was approved by referendum in 2006, to play host to vessels exceeding the Panamax format.

③ ELBOW REEF
BAHAMAS | Abaco Island | West Indies
1864 | 27m | White flashes | Visit

The Bahamas archipelago comprises a stream of isles and islets, stretching across 1200km, often just above the surface of the water off Florida, a maze into which sand-banks and reefs drain. This configuration proved to be challenging to the increased western maritime trade in the nineteenth century, and there were correspondingly numerous shipwrecks. Under the cover of a salvage operation, the area was patrolled, and everyone, including Her Majesty of the United Kingdom, benefited, at varying degrees of course, from the auctioning off of merchandise 'rescued' in Nassau.

Suffice to say, the decision to erect a lighthouse was censured. Elbow Reef, a treacher-ous string of reefs decorating the entrance to the port of Hope Town, was profitable – the site even suffering a few acts of sabotage. Besides this, the service offered by the British lighthouses, here like elsewhere, was not free of charge and remains that way: vessels and keepers communicated with flags and once the boat was identified, the amount for the passage was invoiced to the navigation company.

This decorative white and red striped tower is visible on Great Abaco Island, to the west of the port of Hope Town. It is still equipped with a petrol burner, and every two hours a keeper manually winds the clockwork mechanism. The Bahamas Lighthouse Preservation Society ensures its safekeeping.

④ HIGH ROCK
BAHAMAS | Grand Bahama | West Indies
1998 | Site accessible

Beside a warm sea, which caresses the Gulf Stream, this red and white structure, decorated with pretty balusters, is reminiscent of a lighthouse.

This is not the case, however, even though this was the inspiration behind the building. Instead it is actually a kind of oratory. This 'house of light' is the work of the Reverend Cecil Kemp, his sons and a handful of friends, to guide lost souls, sailors or otherwise. High Rock is the name of the closest village, and its inhabitants are proud of their 9m-high structure.

⑤ LE PRÊCHEUR
FRANCE | Martinique | West Indies
1927 | 12m | Red flashes | Site accessible

Martinique forms part of the Lesser Antilles or the Windward Islands, and is blown by the tradewinds. Between harbours of black sand coves and mounds, Le Prêcheur is the last village you can see to the north-west, as you follow the coastline of the Caribbean Sea. It is situated near Montagne Pelée (Bald Mountain), where there was an eruption in 1902. This was followed by a pyroclastic flow that destroyed the whole area around St-Pierre, both at sea and on land, causing some 28 000 deaths.

The tower, with a balcony and lantern, is made from an assembly of metal plates; its truncated foundation is coated in cement, and pointed very boldly. Electrified in 1939, this lighthouse has been automated since 1990. Its geographical range is 18 miles.

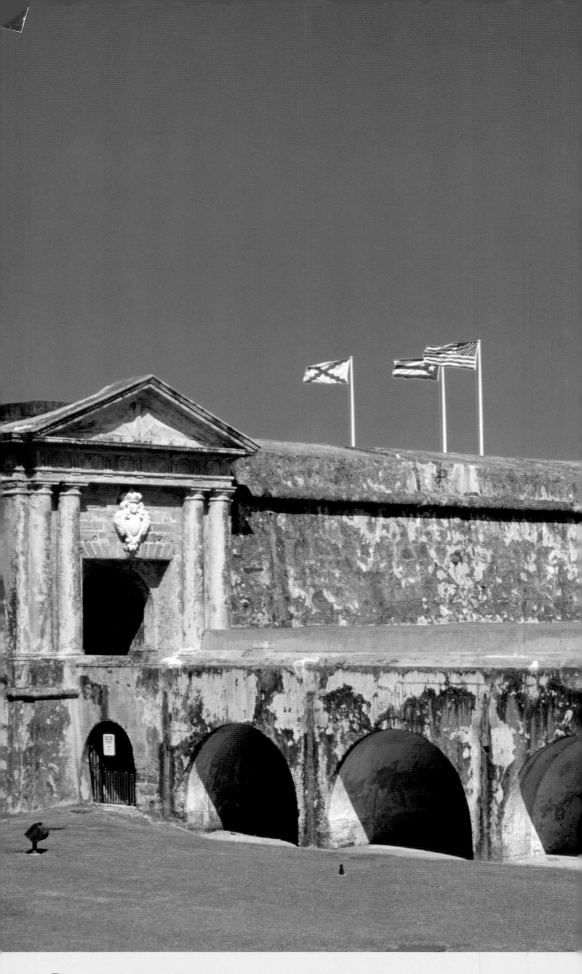

⑥ EL MORRO
PUERTO RICO | San Juan

1908 | 15m | White flashes | Site accessible

Puerto (or Porto) Rico is an island in the Greater Antilles. A Spanish colony until the Hispano-American war of 1898, it is now a free state associated with the United States. San Felipe del Morro, a Spanish citadel from where the lighthouse emerges, dominates the Atlantic; Morro means 'extremity or cape'. It is situated at the entrance to the port and capital of San Juan, and Steven Spielberg filmed a few scenes from *Amistad* here in 1996.

The square brick tower is Moorish in style. Dark grey in colour, it is trimmed with white

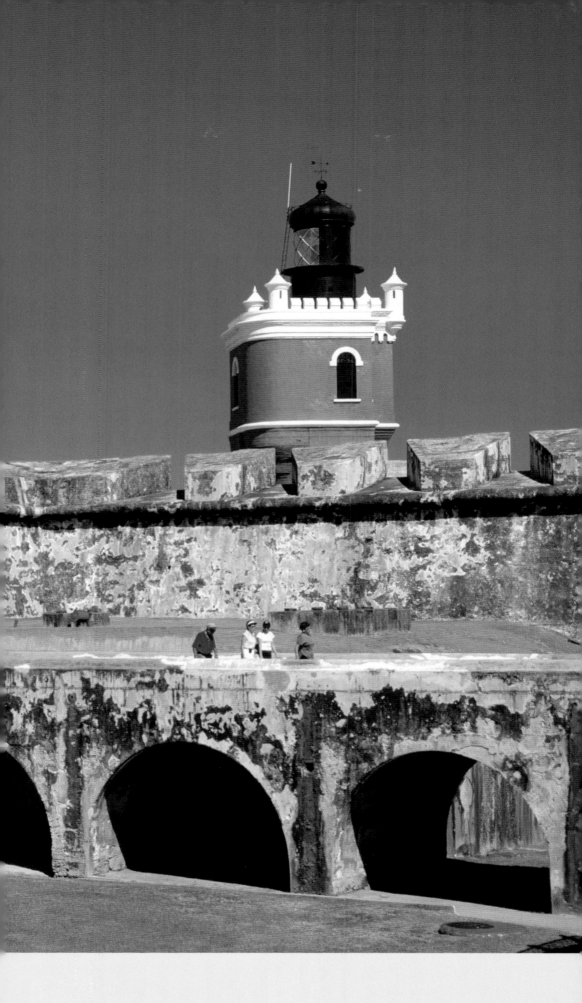

decorative elements and a black lantern. It sports a third-order Fresnel lens (1908) and its light is visible for up to 24 miles.

It is the oldest station in Puerto Rico. In fact, three buildings were built in fairly quick succession here (1846, 1876 and 1908), with the second suffering considerable damage during the 1898 conflict. In 1913, two years prior to electrification there was a change of fuel from vegetable oil to vaporized petrol; the lighthouse was automated in 1962. The property of the National Park Service, which restored it in 1991, it comes under the jurisdiction of the San Juan National Historic Site.

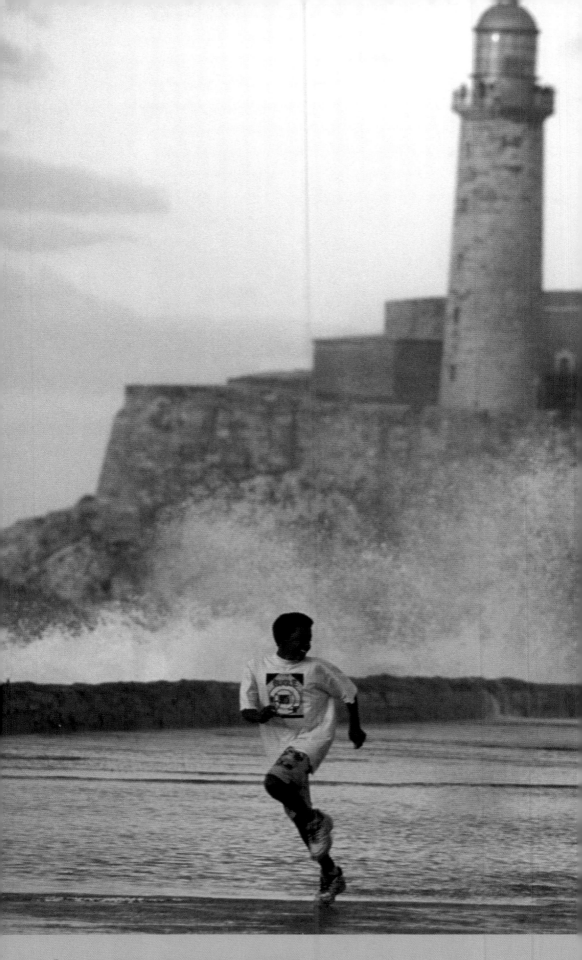

⑦ CASTILLO DEL MORRO
CUBA | Havana

1845 | 25m | White flashes | Site accessible

Like Puerto Rico, this major island in the Greater Antilles was under Spanish domination until the Hispano-American war of 1898. During the infamous attack in 1762, the first lighthouse in Havana disappeared under a hail of English bullets, but it was rebuilt in 1764. Its lamp functioned with charcoal until 1820, prior to the use of rapeseed oil and then acetylene gas (1928). Like its predecessor, this fine exposed stone tower stands on the ramparts of the Castillo de los Tres Reyes del Morro (sixteenth to seventeenth centuries), at the entrance to the bay of Havana. This fortress served as a prison until the 1970s and can be visited. It stands opposite

another defensive work on the other side of the bay, the Castillo de San Salvador de la Punta. Though it was electrified in 1945 on the year of its 100th anniversary, this lighthouse maintained its original clockwork mechanism as well as its Fresnel lens. It must be wound up manually every five hours for ten minutes, so as not to hold up the rotation of the lens. As a result, the building is guarded by four *torreros*, as are other Cuban lighthouses, and the range is 18 miles.

⑧ CALIFORNIA POINT
ARUBA | Netherlands Antilles
1916 | 30m | Site accessible

An island in the Caribbean Sea, Aruba is situated 20 or so kilometres from the coast of Venezuela. Formerly a Dutch colony, it has been an autonomous territory for the past 20 years.

The conical tower and its octagonal base are made from stone. The windows in the main section of the tower are enhanced by triangular pediments, resting on brackets in a neoclassical style. A black lantern caps the whole structure. Surrounded by undulating dunes, the lighthouse occupies the most southerly point of the island on the coast exposed to the wind and the strong currents. It was renovated in 2004.

The building (north-west tip of Netherlands Antilles) would have been built and named in this way with reference to the shipwreck of the *California* in 1891, now a renowned dive site. The steamship was stigmatised for supposedly having ignored the distress calls of the *Titanic* in 1912. The anachronism is patent and there is no way it could be the same *California*. A more plausible hypothesis is linked to the discovery of gold here in 1824. This attracted a flood of prospectors to Aruba, which only dried up at the beginning of the twentieth century.

COROA DO MEIO
BRAZIL | Aracajú
1991 | 40m | Site accessible

The Aracajú lighthouse stands at the junction between the Atlantic Ocean and the Sergipe River, which washes the capital of the smallest state in the Brazilian federation. Lying between two fine beaches, it doesn't detract from the planned urbanisation of the town where modern architecture is welcome. Looking like something you might build out of Lego and painted as a trompe-l'œil with black and white bands, decorated with wide arched openings, the concrete structure disrupts the usual perspectives. The square tower surmounts a two-floor keepers' house, which is dealt with in the same way.

This lighthouse replaced a truncated pyramid with a metal structure (1888), which was abandoned, and its original French lens was transferred across to the new light. Founded in 1855, Aracajú has been 'illuminated' since 1861. The port has now discovered a more lucrative wealth than the textile industry of yesteryear: petrol.

⑩ FAROL DA BARRA
BRAZIL | Salvador

1839 | 22m | Red and white flashes | Site accessible | Museum

Salvador, formerly Bahia, lies in the north-east of the country, and a great history has been etched into the stone here. Even though there are other pretenders, the site is generally considered as being the first to be illuminated (1698) on the American continent. The baroque Bahia, capital of the country for a long time, is the cradle of this country in some ways as this is where the first colonialists set foot on dry land. Santo Antônio da Barra, the Portuguese fortress that forms a tight circle around the lighthouse, is also the oldest in Brazil: its first stones were laid in 1536, three long decades after the arrival of Cabral.

The stone tower, electrified in 1937, marks the northern entrance to All Saints' Bay (Bahia de Todos os Santos), the largest bay in Brazil. The latter structure stands between two headlands; one of which is none other than the port of Salvador. Owned by the Navy, the whole fort and tower, surrounded by beaches, were restored in 1998. A maritime museum (Museu Náutico da Bahia) and a restaurant have been opened here. At the end of the peninsula, the lighthouse backs onto an army of skyscrapers.

(11) **LES ÉCLAIREURS**
ARGENTINA | Ushuaia | Tierra del Fuego
1920 | 11m | Red and white sectors | Site accessible

Around 150km north of the Horn, the peaceful Beagle Channel provides an alternative for navigators who wish to pass from one ocean to the other, though there is a risk of getting lost. Some 240km long, this maze of a route, scattered with islets and shallows, has countless arms with dead-end sounds.

To the north-east of the channel, Les Éclaireurs lighthouse marks the entrance to Ushuaia Bay, a mountainous amphitheatre always capped with snow. This town of 45 000 inhabitants, situated in the Argentinean section of Tierra del Fuego, is the southernmost town in the world. However, its lighthouse is not the 'lighthouse at the end of the world', a title reserved for San Juan de Salvamento (Isla de los Estados).

Resembling a pawn on a chessboard, the two-coloured brick tower, powered by solar panels, is positioned on an islet in Les Éclaireurs archipelago. This French name dates back to 1882–3, when these islands were plotted by the sloop *La Romanche* during a hydrographical exploration mission. Excursions were organised here from Ushuaia. The nearby Beagle Channel owes its name to two scientific expeditions, which led the English brigantine *Beagle* here between 1825 and 1836; this expedition included a naturalist on its second voyage – the infamous Charles Darwin.

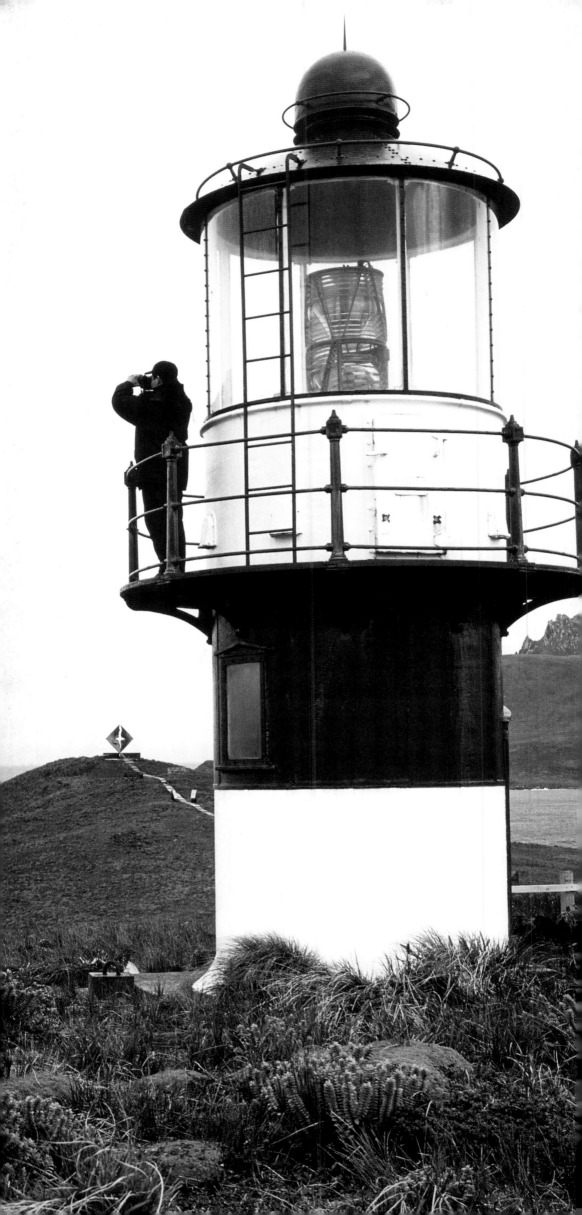

12 ISLA HORNOS
CHILE

1991 | 7m | White flashes | Site accessible

In the confines of the long coastal ribbon of land that is Chile, trimmed with its myriad of islands, Tierra del Fuego is separated from the American continent by Magellan's Strait. Isla Hornos and its infamous cape round it off. Confronting the Atlantic and Pacific Oceans, the zone frequently bears witness to sudden storms, shifting fog and foul winds (the furious 50s) capable of picking up ferocious seas, not to mention countercurrents and a really bitter, icy cold.

Until the opening of the Panama Canal (1914), ocean-going vessels rounded Cape Horn in order to trade with the port along the west coast of America (Iquique, Valparaiso, San Francisco, etc) or with Australia. At the time there were no lighthouses to guide these Cape Horners (you can see their memorial in the background, which is a metal silhouette of an albatross mid flight). This trip can take a yacht several weeks, but the record still belongs to the German yacht *Susanna*, which in 1905 took 99 days to round the 'hard cape', between the end of August and the end of November.

Don't believe the apparent modesty of this squat, steel turret, put up by the Chilean Navy, 57m above sea level to the south-west of Isla de Hornos. Thanks to a powerful lens, its light carries as far as 23 miles. The keeper and his family, supplied every eight weeks, are the only permanent inhabitants of this rock so far south. They provide a warm welcome for sailors passing through, and some excursions to this area are organised from Ushuaia. Before you, you can see the most southerly lighthouse in the world (in the strictest sense of the term 'lighthouse'). If we were to speak of lights alone, however, two little glass-fibre composite lights would have the right to claim this title: one has shone at Cape Horn since 1962 (a cliff of over 400m) with a range of around 1 mile, and the other in the Diego Ramirez archipelago, 30 miles further south, opposite Drake Channel.

Beyond that it's the Antarctic, where lighthouses have no place, so this concludes our circumnavigation of the globe, even if there are a lot more lighthouses to discover...

Index

Works Consulted

Bay Beacons: Lighthouses of the Chesapeake Bay, Linda Turbyville, Eastwind Publishing, 1995.

Beacon on the Rock: The Dramatic History of Lighthouses from 1600 to the Present Day, Peter Williams, Aurum Press Ltd, 2001.

Guide des Phares des Côtes de France, Xavier Mével, Chasse-Marée, 2004.

Leuchttürme der Welt, F.-K. Zemke, Koehler. 3 volumes, 1992.

The Lighthouse Stevensons, Bella Bathurst, Flamingo, 1999.

The Lighthouses of Trinity House, Richard Woodman, Jane Wilson, Thomas Reed Publications, 2002.

Pacific Northwest Lighthouses: Oregon, Washington, Alaska and British Columbia, Bruce Roberts, Ray Jones, Chelsea House Publishers, 1997.

Le Phare d'Alexandrie: La Merveille Retrouvée, Jean-Yves Empereur, Découvertes Gallimard, s.d.

Phares de l'Atlantique Nord, Jean Guichard, Ken Trethewey, Ouest-France Editions, 2002 (English version: *North Atlantic Lighthouses*, Flammarion, 2002).

Phares de France, Xavier Mével, Chasse-Marée, 2006.

Phares, Histoire du Balisage et de l'Éclairage des Côtes de France. Jean-Christophe Fichou, Noël Le Hénaff, Xavier Mével, Chasse-Marée, 1999. Distinction from the Marine Academy and 'Armateur' Prize (2000).

Les Phares de la Mer du Nord, Philippe Warzée and Éric Valenne, Editor Bernard Gilson, 1999.

Phares du Monde, Association Internationale de Signalisation Maritime (AISM), Ouest-France Editions, 1998.

Phares Ouest: Les Phares Majeurs de L'arc Atlantique, Philip Plisson, Guillaume Plisson, Daniel Charles, Du Chêne Publications, 1999.

Photo Credits

Published by Adlard Coles Nautical

an imprint of A & C Black Publishers Ltd

38 Soho Square, London W1D 3HB

www.adlardcoles.com

First English language edition published 2008

First published in French as *Phares du Monde* by Éditions du Chasse-Marée

Copyright © Éditions du Chasse-Marée 2007

ISBN 978-1-4081-0635-8

A CIP catalogue record for this book is available from the British Library.

Typeset in 9/12pt Dax-Medium

Printed and bound in Slovenia by MKT